PICTURING THE BANJO

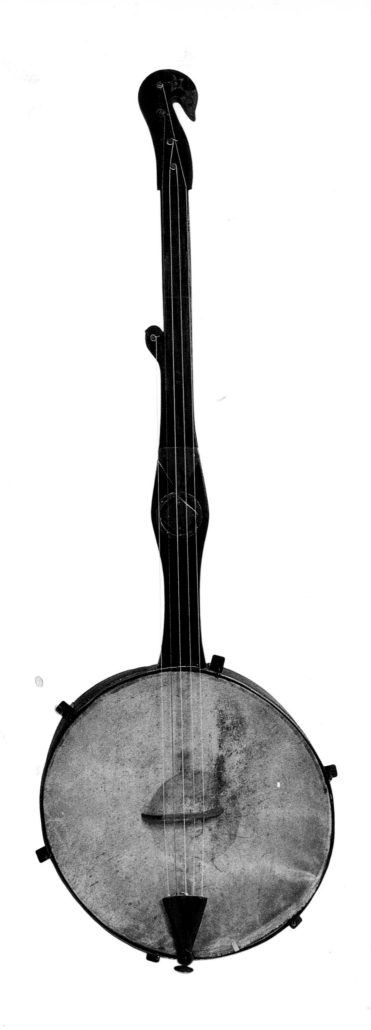

PICTURING THE BANJO

LEO G. MAZOW

with contributions by

SARAH BURNS

JOHN DAVIS

MICHAEL D. HARRIS

JOYCE HENRI ROBINSON

CECELIA TICHI

PALMER MUSEUM OF ART
THE PENNSYLVANIA STATE UNIVERSITY PRESS

UNIVERSITY PARK, PENNSYLVANIA

Library of Congress
Cataloging-in-Publication Data

Mazow, Leo G.
 Picturing the banjo / Leo G. Mazow ; with
contributions by Sarah Burns . . . [et al.].
 p. cm.
 "Picturing the Banjo accompanies an exhibi-
tion of the same name organized by the
Palmer Museum of Art, The Pennsylvania
State University, University Park, Pennsylva-
nia, and held at the Corcoran Gallery of Art,
Washington, D.C., 10 December 2005–5
March 2006; the Palmer Museum of Art, 30
March–25 June 2006; and the Boston
Athenaeum, 26 July–21 October 2006." —
T.p. verso.
Includes bibliographical references and index.
ISBN 0-271-02710-X (cloth : alk. paper)
 1. Banjo—Exhibitions.
 2. Musical instruments in art—Exhibitions.
 3. Music—Social aspects—Exhibitions.
 I. Burns, Sarah.
 II. Palmer Museum of Art (Pennsylvania State
University).
 III. Corcoran Gallery of Art.
 IV. Boston Athenaeum.
 V. Title.

ML1015.B3M39 2005
704.9'49787881973'07473—dc22
2005013498

Copyright © 2005 The Pennsylvania State
University
All rights reserved
Printed in Canada
Published by The Pennsylvania State University
Press, University Park, PA 16802-1003

Designed by Regina Starace
Printed by Friesens Corp.

The Pennsylvania State University Press is a
member of the Association of American
University Presses.

Picturing the Banjo accompanies an exhibition
of the same name organized by the Palmer
Museum of Art, The Pennsylvania State
University, University Park, Pennsylvania,
and held at the Corcoran Gallery of Art,
Washington, D.C., 10 December 2005–
5 March 2006; the Palmer Museum of Art,
30 March–25 June 2006; and the Boston
Athenaeum, 26 July–21 October 2006.
This publication is made possible by generous
support from the Friends of the Palmer
Museum of Art and the George Dewey and
Mary J. Krumrine Endowment. The Corcoran's
presentation is supported by the Steve Martin
Charitable Foundation, Catherine Dail, and the
President's Exhibition Fund.

Frontispiece: Unknown maker, shepherd's crook
banjo, c. 1846, 37 × 12½ inches. Collection of
Peter Szego. Photo: Peter Szego.†

Illustration page xviii: John C. Haynes, Bay State
Banjo made for William E. Stratton, c. 1895,
35½ × 11½ inches. Collection of James. F.
Bollman.

Chapter 5 includes quotations from *Black
Misery* by Langston Hughes, text copyright
1969 by Arna Bontemps and George Houston
Bass as Executors of The Estate of Langston
Hughes, illustration copyright 1969 by Arouni,
used by permission of Oxford University Press,
Inc.; from "Ma Man," "Minstrel Man," and
"The Cat and the Saxophone," from *The
Collected Poems of Langston Hughes* by Langston
Hughes, copyright © 1994 by The Estate of
Langston Hughes, used by permission of
Alfred A. Knopf, a division of Random House,
Inc.; and from "A Banjo Song," from *Fifty Years
and Other Poems* by James Weldon Johnson,
used by permission of AMS Press.

It is the policy of The Pennsylvania State
University Press to use acid-free paper.
Publications on uncoated stock satisfy the
minimum requirements of the American
National Standard for Information Sciences—
Permanence of Paper for Printed Library
Materials, ANSI Z39.48–1992.

CONTENTS

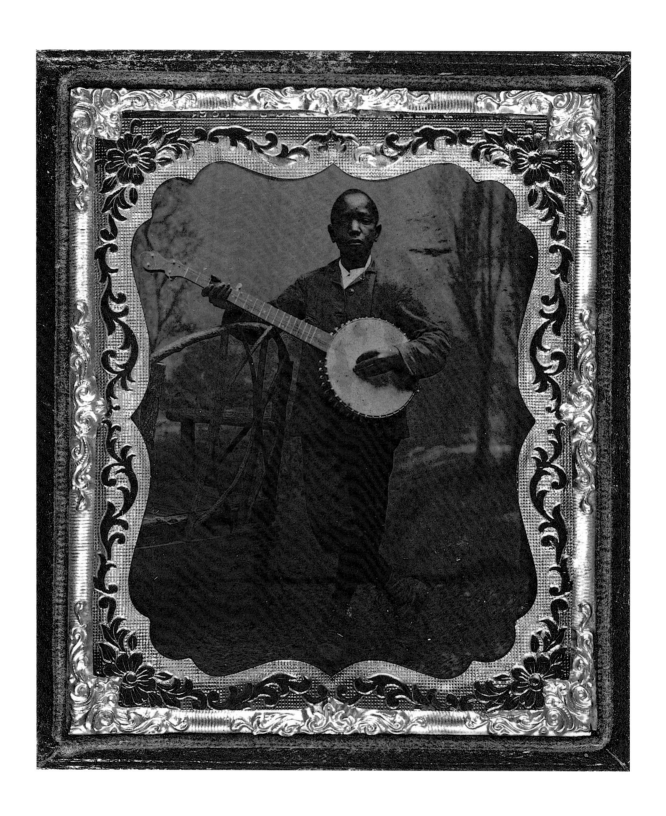

LENDERS TO THE EXHIBITION

The Academy of Natural Sciences, Philadelphia

Albright-Knox Art Gallery, Buffalo, New York

James F. Bollman

Carnegie Museum of Art, Pittsburgh, Pennsylvania

Steve Carver

Chrysler Museum of Art, Norfolk, Virginia

Cooper-Hewitt, National Design Museum, Smithsonian Institution, New York

Corcoran Gallery of Art, Washington, D.C.

Country Music Hall of Fame® and Museum, Nashville, Tennessee

di Rosa Preserve, Napa, California

Duke University Libraries, Durham, North Carolina

Florence Griswold Museum, Old Lyme, Connecticut

The Free Library of Philadelphia

Hammer Galleries, New York

Howard University Gallery of Art, Washington, D.C.

Mary Hufford

Allan and Penny Katz, Woodbridge, Connecticut

Library of Congress, Washington, D.C.

The Long Island Museum of American Art, History & Carriages, Stony Brook, New York

Mead Art Museum, Amherst College, Amherst, Massachusetts

Memorial Art Gallery of the University of Rochester, Rochester, New York

Mint Museum of Art, Charlotte, North Carolina

National Afro-American Museum and Cultural Center, Wilberforce, Ohio

National Gallery of Art, Washington, D.C.

The Pennsylvania State University Libraries, University Park, Pennsylvania

The Philadelphia Museum of Art

Post Road Gallery, Larchmont, New York

Private collections

David Robbins

Judy Rojas

Schomburg Center for Research in Black Culture, The New York Public Library

Joseph M. and Janet D. Shein, Philadelphia

Shelburne Museum, Shelburne, Vermont

Peter Szego

Daniel K. Tennant

Emily Leland Todd

Valentine Richmond History Center, Richmond, Virginia

Van Every/Smith Galleries, Davidson College, Davidson, North Carolina

Wadsworth Atheneum Museum of Art, Hartford, Connecticut

Wells Fargo Bank, N.A.

Winterthur Museum, Winterthur, Delaware

Untitled studio portrait of young African American musician, c. 1885, tintype photograph, 8 × 5 inches. Collection of James F. Bollman.*

William H. Johnson, *Three Generations,*
c. 1941, opaque watercolor with pen and ink
on medium-weight wove paper with ink and
graphite drawing on verso, 14$\frac{1}{8}$ × 17$\frac{3}{16}$
inches. Collection of the Howard University
Gallery of Art, Washington, D.C.*

ILLUSTRATIONS

Illustrations marked with an asterisk (*) are featured in all three venues of *Picturing the Banjo*. Those marked with a dagger (†) appear only at the Palmer Museum and Corcoran Gallery; those with a double dagger (‡), only at the Palmer Museum.

PREFACE AND ACKNOWLEDGMENTS

The Palmer Museum of Art of The Pennsylvania State University is pleased to present *Picturing the Banjo,* an exhibition and publication examining the visual representation of this unique stringed instrument in American paintings, drawings, prints, photographs, and artifacts. This project has been several years in the making, and we have accumulated debts to a number of individuals and institutions across the arts and humanities. Our profound thanks go to the Friends of the Palmer Museum of Art, who stepped forward early to commit funds for the exhibition. The George Dewey and Mary J. Krumrine Endowment also provided critical early support for the publication. We acknowledge with deep appreciation Bruce Roth, a key supporter of the educational programming accompanying this exhibition. Our equal gratitude is extended to the many museums, collectors, artists, and dealers who have so generously lent their works to the exhibition. Thanks to their participation, we are able to illuminate some complex and fascinating chapters in the ongoing history of American art and culture.

We are particularly pleased that *Picturing the Banjo* will open in late 2005 at the Corcoran Gallery of Art in Washington, D.C., where its presentation is supported in very generous measure by the Steve Martin Charitable Foundation. At the Corcoran, the following individuals have offered collegial assistance and have facilitated many aspects of the project: Jacquelyn Days Serwer, Chief Curator; Sarah Cash, Bechhoefer Curator of American Art; Emily Shapiro, Assistant Curator of American Art; Elizabeth Parr, Exhibitions Director; and Nancy Swallow, Registrar. We are equally pleased that a modified version of the exhibition will travel to the Boston Athenaeum in late summer–early autumn 2006. At that institution, the exhibition has benefited from the instrumental efforts of David Dearinger, Susan Morse Hilles Curator of Paintings and Sculpture; Hina Hirayama, Associate Curator of Paintings and Sculpture; and Richard Wendorf, Director and Librarian.

At the Palmer Museum of Art, *Picturing the Banjo* has relied on the steadfast support of several individuals, including Richard Hall, Ronald Hand, Dana Carlisle Kletchka, Patrick J. McGrady, Joyce Henri Robinson, Robin Seymour, Beverly Balger Sutley, Elizabeth Warner, and Barbara Weaver. The counsel and generous assistance of John Driscoll of the Palmer Museum of Art Advisory Board has been most helpful. We have also relied in no small measure on the integral participation of the following graduate assistants and interns: Janalee Emmer, Sarah

Holloran, Elizabeth Hoorneman, Courtney Jordan, Margaret Monrad, Ellen Rose, and Gabriella Szalay. Others in the Penn State community have generously facilitated this exhibition, and we acknowledge the assistance of Carolyn Lucarelli, Sarah K. Rich, and Craig Zabel of the Department of Art History as well as William Joyce and Sandra Stelts, Special Collections Library, University Libraries.

Leo Mazow, Curator of American Art at the Palmer Museum and author and curator of *Picturing the Banjo*, began his research on this subject when he was Director of the Suzanne H. Arnold Art Gallery and Assistant Professor of Art at Lebanon Valley College. Given access to James F. Bollman's rich collection of banjos and related materials, he organized a small exhibition titled *Strummin' on the Banjo in Nineteenth-Century America* in early 2001. Soon after his move to the Palmer Museum of Art in January 2002, he proposed this current project to me, the museum staff, and the Advisory Board. We enthusiastically endorsed his idea and now, more than three years later, his diligence and devotion are unquestionably evidenced in this volume and exhibition.

When Leo initially conceived the exhibition and publication, he and the museum staff knew that tackling a subject with ties to myriad disciplines—art history, musicology, American and African American history, and folklore, to name but a few—would require special care and thoughtful organization. In this we have been generously assisted by the essayists in this book, whose profound insights have helped us shape and understand what otherwise can be an unwieldy topic. We thus acknowledge the scholars whose contributions appear here: Sarah Burns, Ruth N. Halls Professor of Fine Arts, Department of History of Art, Indiana University; John Davis, Alice Pratt Brown Professor of Art and Chair, Department of Art, Smith College; Michael D. Harris, Associate Professor of African and African American Art History, Department of Art, The University of North Carolina at Chapel Hill; Joyce Henri Robinson, Curator, Palmer Museum of Art and Affiliate Associate Professor, Department of Art History, The Pennsylvania State University; and Cecelia Tichi, William R. Kenan Jr. Professor of English, Vanderbilt University.

As one of the most common and readily identified symbols in the annals of American culture, banjos have been the subjects of several studies past and present. (See, for example, the works by Philip F. Gura and James F. Bollman, Cecelia Conway, Dena J. Epstein, Karen S. Linn, and Robert Lloyd Webb as well as *The Birth of the Banjo* in the selected bibliography at the back of this book.) But where those projects have largely focused on the material culture and social history of banjos themselves, *Picturing the Banjo* explores the instrument's symbolism in American art. Further, where those exhibitions and books have emphasized the late nineteenth century, *Picturing the Banjo* is the first to probe the banjo's iconography from the eighteenth century to the present. Our goals are thus somewhat

different, but these earlier projects nonetheless provided essential groundwork upon which the present book and exhibition expand.

Although this project spans the early Republic to the present, it makes no claims for comprehensive breadth. It should be said at the outset that the presence of a banjo in an artwork does not guarantee its reproduction in these pages. We have opted instead to focus on selected monuments in art and cultural history that illuminate particularly rich and often problematic episodes in the production and reception of banjo imagery. As of the writing of this publication, a database of banjos in American art—maintained since 2002 at the Palmer Museum of Art— identifies more than 550 works, and it is surely impossible to highlight each of them in a single book or exhibition. Moreover, many of these pieces offer cultural insights and suggest visual traditions beyond the scope of *Picturing the Banjo*. Other works—items indeed relevant to our topic—were either not located or were unavailable for loan. We have attempted to reproduce as many as possible in this volume, however.

Because of the sheer number of "banjo pictures" produced in the second half of the nineteenth century, materials from this period dominate these pages, even though one finds numerous pictures from long before and after this time as well. Of course, many of these works—e.g., William Sidney Mount's *The Banjo Player* (1856, fig. 80), or Eastman Johnson's *Negro Life at the South* (1859, fig. 45)—are well known and have been subjects of several previous studies. In order to understand the role of these and other monuments within the art-historical canon, and to provide a forum for the multiple interpretations they suggest, several pieces, canonical and otherwise, are indeed discussed in two or more essays in this book. Some readers may be surprised to find advertisements, books, musical instruments, furniture, and toys as objects of inquiry in *Picturing the Banjo* as well. As this project demonstrates, these materials are artistic in their own right, and they contribute to the banjo's visual meanings as much as more traditional media do.

In exploring the visual culture of the banjo—an investigation that invariably takes one deep into the social and manufacturing histories of the instrument—this book and exhibition have in no small way profited from the expertise of the banjo collectors and leading authorities on the instrument's early history, James F. Bollman and Peter Szego. We are grateful for their generous loans of art and instruments to the exhibition; they have also selflessly given of their time, knowledge, and advice at every stage of the planning of *Picturing the Banjo*. Their enthusiasm and keen understanding of the banjo have sustained this project.

We offer our sincere thanks to the following individuals who provided research assistance: Margaret Conrads, The Nelson-Atkins Museum of Art; Susan Danley, Mead Art Museum, Amherst College; Rachael Ziady DeLue, Princeton University; Erika Doss, University of Colorado, Boulder; Robin Jaffee Frank, Yale University

Art Gallery; Vivien Green Fryd, Vanderbilt University; Michael R. Gannett, Cornwall Historical Society; Amanda Glesmann, Stanford University; Mary Hufford, University of Pennsylvania; Carol Irish, Carol Irish Fine Art, New York; Cheryl Leibold, Pennsylvania Academy of the Fine Arts; Diana Linden, Claremont Colleges; Paul Martineau, the J. Paul Getty Museum; Ray Montana; David Robbins; Joyce Schiller, Delaware Art Museum; Clarence Burton Sheffield Jr., Rochester Institute of Technology; and Jennifer Watts, The Huntington Library, Art Collections, and Botanical Gardens.

We also give special thanks to those artists, curators, dealers, and collectors who so kindly helped us locate works of art and obtain photographs and permissions, and who otherwise went out of their way to facilitate loans: David Bahssin and Robert Bahssin, Post Road Gallery, Larchmont, New York; Steven Carver; Trinkett Clark, Mead Art Museum, Amherst College; Ben Cooper, di Rosa Preserve; Don Eaton; Martha Fleischman and Lillian Brenwasser, Kennedy Galleries, New York; Lynn M. Herbert and Marti Mayo, Contemporary Arts Museum Houston; Patricia Junker, Amon Carter Museum of Art; Allan and Penny Katz, Woodbridge, Connecticut; Franklin Kelly, National Gallery of Art; Keri Koehler, Wells Fargo Historical Services; Martha Mayberry, Mint Museum of Art; Lizabeth Oliveria, Lizabeth Oliveria Gallery, Los Angeles; Clare Rojas; Michael Rosenfeld Gallery, LLC, New York; Elizabeth Schwartz, Deitch Projects, New York; Mike Seeger; Emily Leland Todd; Thomas R. Toperzer, Amarillo Museum of Art; Joan Whalen, Joan Whalen Fine Art, New York; Janay Wong; and Christa Zaros, The Long Island Museum of American Art, History & Carriages. We also wish to thank Julia Wolf Mazow for her editorial and research assistance.

We thank Gloria Kury, Laura Reed-Morrisson, Stephanie Grace, and Jennifer Norton at Penn State Press for their expert assistance with the publication of this book. We further acknowledge Regina Starace for her creative design work.

One final note of appreciation goes to Leo Mazow for his dedicated work as editor, author, and curator. I also join Leo in thanking Alissa and Asa Mazow for their unfailing support of this project over the past several years.

JAN KEENE MUHLERT
Director, Palmer Museum of Art

William T. Wiley, *Banjo for J. B.*, 1985, mixed media, 38 × 11½ × 4½ inches. Collection di Rosa Preserve, Napa, California. Photo: Carl Duncan.

A. Peghead
B. Pegs (for tuning)
C. Nut
D. Fifth-string peg
E. Frets and decoration
 inlaid in fingerboard
F. Heel
G. Bracket assembly
 (shoe, nut, and hoop)
H. Head
I. Tailpiece
J. Bridge

PICTURING THE BANJO

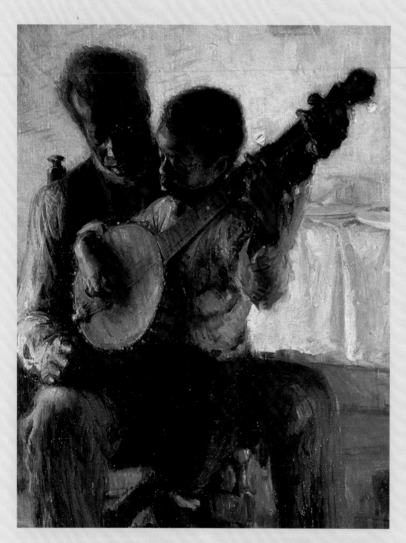

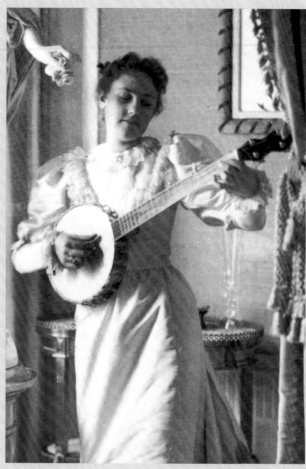

Henry Ossawa Tanner, *The Banjo Lesson,*
1893, oil on canvas, 49 × 35½ inches (detail
of fig 112). Hampton University Museum,
Hampton, Virginia.

Frances Benjamin Johnston, ["Miss Apper-
son" playing banjo beside statue of "Flora" in
niche of Sen. George Hearst's residence,
Washington, D.C.], c. 1895, platinum print
(detail of fig. 67). Library of Congress, Prints
and Photographs Division, Washington, D.C.
LC-USZ62-63501.

Banjo Cultures

LEO G. MAZOW

IN 1893, Henry Ossawa Tanner painted *The Banjo Lesson,* a depiction of an African American gentleman carefully supporting on his lap a boy playing the banjo. The child's tender, absorbed embrace of the instrument repeats his own position within the engulfing form of the older man. Reversing the typecasting of over a century of banjo iconography, Tanner's painting has influenced several generations of American artists who have enlisted the icon to signify racial uplift, familial continuity, and intellectual fortitude. Less than two years after Tanner painted *The Banjo Lesson,* photographer Frances Benjamin Johnston created a very different banjo picture: a *tableau vivant* of a sculpture of Flora, in which the woman at right discards her bouquet in favor of a banjo. The classically garbed woman is Ann Apperson, niece of

fig. 1
William Wegman, *Blue Period with Banjo*,
1980, Unique Polaroid Polacolor II print, 24 ×
20 inches. Collection of Emily Leland Todd.
Courtesy Contemporary Arts Museum Houston. Photo © Rick Gardner, Houston.

the philanthropist Phoebe Apperson Hearst, whose home we see in the photograph. Although not nearly as well known as Tanner's canonical painting, Johnston's composition epitomizes an equally popular set of conventions—seen in the work of Mary Cassatt and several other artists—subtly linking the instrument to feminist reform ideals.

How could these two pictures, produced contemporaneously, assign such different sensibilities to the same musical instrument? How might we account for this disjunction? And as we consider a work like William Wegman's densely loaded *Blue Period with Banjo* (1980, fig. 1), how might we explain the persistence, to the present day, of the contradictory meanings assigned to ever-popular banjo imagery? The banjo is one of the most frequently encountered symbols in American art and cultural history. Yet the instrument is also one of the most elastic and contested signs in that history, its meaning readily appropriated to disparate ends. Wegman's photograph reminds us that race and gender, as engaged in Tanner's and Johnston's works, are only two among many issues that have been addressed via the banjo. Historians and curators have amply documented the complex evolution and cultural meanings of the instrument itself, yet its charged, recurring imagery in American paintings, drawings, prints, sculpture, and decorative arts has escaped prolonged scholarly discussion.[1] The present book—and the exhibition it accompanies—joins this field of inquiry, exploring the banjo's symbolism in American art from the eighteenth century through the present.

By the time of Tanner's *Banjo Lesson* and Johnston's photograph, the instrument had come a long way from its origins in West Africa, whose citizens brought stringed gourd instruments with them when they were forcibly removed to lives of slavery in the New World between the seventeenth and nineteenth centuries. The banjo, as we know it today, bears some resemblance to the Senegalese *xalam*, the West African *molo*, and the *nkoni* of the Manding peoples. All are plucked instruments with a gourd body and shortened fourth string (fig. 2). Unlike those instruments, however, the banjo—which first took such names as *banza*, *banja*, and *bandore*—has a flattened fingerboard, reflecting the simultaneous introduction of European instruments, such as the guitar and mandolin, into North America.[2]

Although there is no consensus as to precisely when the *molo* and *xalam* took on the look and sound of the banjo, scholars agree that the banjo, through more than a century of folk diffusion, provided a means by which transplanted Africans could maintain native cultural expressions—and by which their captors could identify them. As Thomas Jefferson famously wrote in *Notes on the State of Virginia* (1781), "the instrument proper to them [i.e., enslaved Africans] is the Banjar." Through the efforts of Joel Walker Sweeney, Daniel Emmett, and other mid-nineteenth-century entertainers, traveling minstrel shows brought banjo music to large urban audiences. These enormously popular performances coupled the banjo with cork-

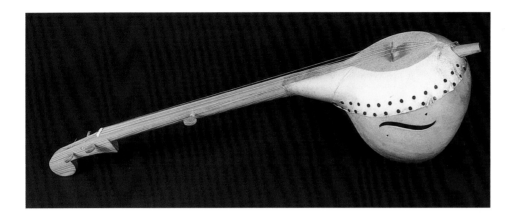

fig. 2
Peter Ross, reproduction four-string gourd
banjo, 2003, 36 × 10 inches. Collection of Mike
Seeger. Photo courtesy Peter Szego.

blackened faces and purposefully strained "Jim Crow" dancing in a wholesale par-
ody of all things African.[3]

From the stringed gourd instrument brought over by African slaves to the
nineteenth-century minstrel show to the twentieth-century signifier of the vernac-
ular and old-fashioned, the evolution of the banjo illuminates several national
sagas and histories, including racial typing, minstrelsy, and the rise and fall of
vaudeville and other entertainments. Accordingly, the banjo has inspired an eclec-
tic array of artists who have seen it as a Janus-faced cultural monument, capable of
denoting such themes as simplicity, ridicule, nostalgia, and authenticity. From the
earliest known banjo painting, *The Old Plantation* (see fig. 97), to Kara Walker's
monumental banjo drawings (see fig. 111), the instrument figures prominently in
the stories Americans have told—and continue to tell—themselves.

Why the Banjo?

Why the banjo? Why not an exhibition exploring the artistic representation of
other musical instruments? With their distinctly African heritage, banjos have an
altogether different set of associations than the violins, guitars, and pianos that one
also finds in nineteenth- and twentieth-century American art. Early American and
European travelers alike invoked what they understood to be the harsh sounds and
uncivilized nature of the *bandore* to differentiate it from other instruments, and
several early artists followed their example. Beginning in the late 1840s, however,
amid the popularization of minstrelsy, banjo images depict not *bandores* but
tonally modulated, mass-produced, self-consciously artistic banjos. The fault line
between the artistic and the indigenous is usually not as pronounced in guitar and
violin imagery. *Picturing the Banjo* explores in some depth the visual construction
of these vernacular and classical types.

Since the folk music revival of the 1950s and 1960s, banjo music and perform-
ance have come to project a distinct set of metaphors, a constellation of traits that

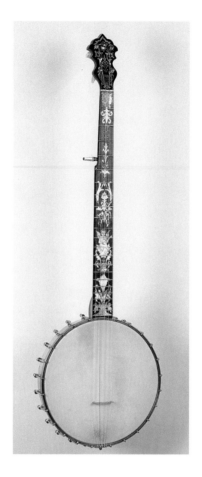
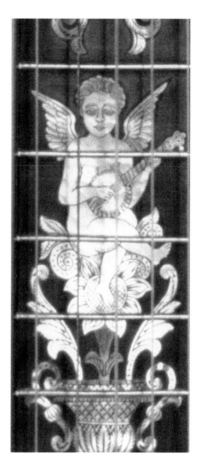

informs our understanding of the instrument's visual symbolism. Historian Robert Cantwell has suggested that the "voluptuous" guitar tends to project a mood of "pastoral romance," while the "maidenly" violin has often been enlisted to grant popular music a sense of legitimacy. But the banjo, as Cantwell puts it, is "like a tomboy sister or spinster aunt, full of gristle and sass."[4] For even the most enlightened twenty-first-century audiences, the banjo—whether incorporated into a racially, sexually, or otherwise charged work of art—seems to elicit the antiquated, the anachronistic, the obsolete, and the rustic. Banjos, one might argue, prematurely age the paintings in which they appear.

Another distinction between the representation of banjos and that of violins, pianos, guitars, and drums is the visual history of the instrument itself. Banjo imagery proliferated in the popular press, and many nineteenth-century individuals likely saw the instrument before they heard it. Minstrel shows were enormously popular by the 1860s, and hundreds of plates in illustrated books and articles in *Harper's Weekly Magazine* and *Frank Leslie's Illustrated Weekly* also depicted the instrument, giving prospective audiences an idea of what to expect at live performances.[5]

Moreover, especially in the years following the Civil War, many people would have encountered the increasingly popular "presentation banjo." Manufacturers

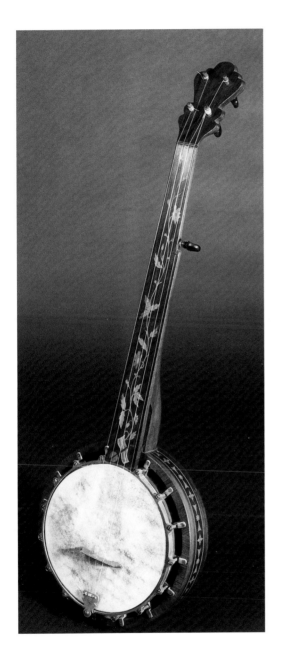

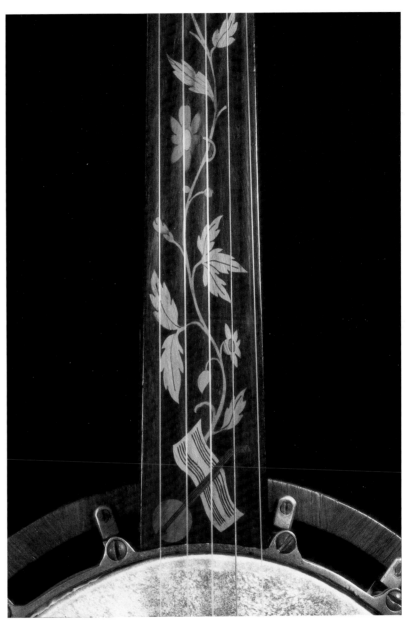

and luthiers produced presentation-grade instruments to be given as gifts on spe-
cial occasions. They were not necessarily meant to be played; indeed, very few sur-
viving presentation instruments show evidence of having been played. One might
pose with these instruments, or perhaps arrange them in a parlor. Sometimes these
banjos were transformed into *objets d'art* by way of intricately modeled and ideal-
ized nudes and gargoyles carved into the neck, crafted wood marquetry on the
back, or jeweled motifs inlaid in the fingerboard (figs. 3–6). Often, the instrument
designs were highly individualized. Included in the present exhibition are several
such instruments, including a fretless banjo from c. 1870 with Masonic devices in

fig. 5 *(left)*
Henry C. Dobson, banjo, 1860s, wood mar-
quetry, 36 × 12 inches. Collection of Peter
Szego. Photo courtesy Peter Szego.

fig. 6 *(right)*
Henry C. Dobson, banjo (detail). Photo cour-
tesy Peter Szego.

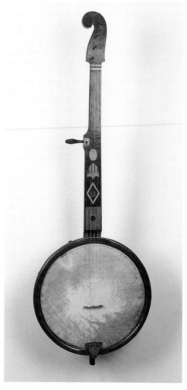

(clockwise from left)
fig. 7
Unsigned fretless banjo with inlaid Masonic
devices in fingerboard, c. 1870, 37 × 12 inches.
Collection of James F. Bollman.

fig. 8
Unsigned fretless banjo with tintype portrait in
fingerboard, c. 1860s, 36 × 12 inches. Collec-
tion of James F. Bollman. Photo courtesy Don
Eaton.

fig. 9
Unsigned fretless banjo with tintype portrait in
fingerboard (detail). Photo courtesy Don
Eaton.

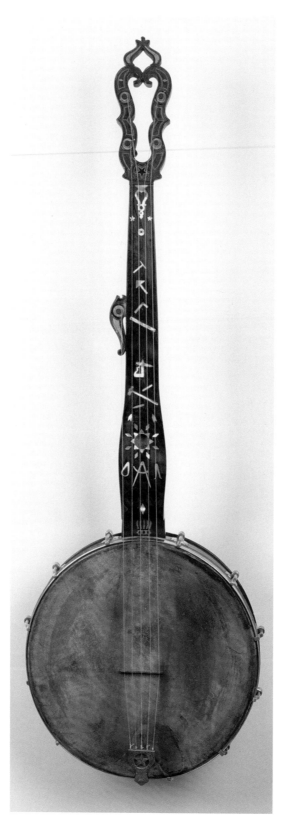

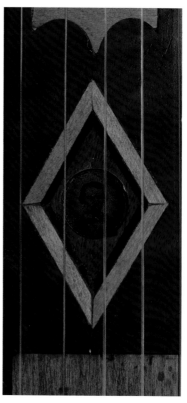

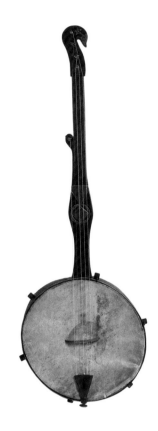

fig. 10 *(left)*
Unknown maker, inlaid tiger maple banjo (back), c. 1835–40, 41 × 12 inches. Collection of Peter Szego. Photo courtesy Peter Szego.

fig. 11 *(right)*
Unknown maker, shepherd's crook banjo, c. 1846, 37 × 12½ inches. Collection of Peter Szego. Photo courtesy Peter Szego.

the fingerboard and a Civil War–era banjo with a wooden crescent and a tintype photographic portrait in the neck (figs. 7–9). Significantly, even non-presentation banjos borrowed designs from the fancy models.

Several banjos produced decades before the presentation vogue also suggest the instrument as a site for pictorial and sculptural expression and experimentation (figs. 10, 11). One of the earliest known extant instruments, the scroll tackhead banjo reproduced here, exemplifies the lengths to which antebellum luthiers would go to treat the banjo as an artistic medium in its own right (figs. 12, 13). (Tackhead banjos have tacks, rather than hooks, joining the banjo head to the rim.) Several elements of the piece are strictly aesthetic and serve no structural purpose: the articulated nut, the thumbnail scalloping in alternating dark reds and greens, the tapered neck—with which the peghead and fifth-string peg are flush— and the bone-inlaid diamonds at quarter and half positions on the fingerboard. With the double-ogee limned in gold and the scroll design painted on the heel, one is tempted to call the instrument a neoclassical banjo.[6] This aestheticizing tendency usually does not figure so prominently in the visual tradition of other instruments.

Related to the idea of the instrument as showpiece and gift commodity is the banjo's recurrence in design principles in furniture and other decorative arts, a

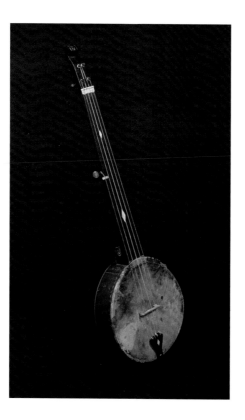

fig. 12 *(left)*
Tackhead banjo with polychromed thumbnail scalloping, paint-decorated wood with bone inlays, c. 1830s, 33½ × 10½ inches. Collection of Peter Szego. Photo courtesy Peter Szego.

fig. 13 *(right)*
Tackhead banjo with polychromed thumbnail scalloping, (detail). Photo courtesy Peter Szego.

phenomenon that probably dates from the end of the nineteenth century. In the present exhibition, a banjo chair (c. 1875–1900, fig. 14) allows one to sit on (or perhaps "in") the instrument and to prop one's feet on the accompanying tambourine stool. Front halls, sitting rooms, and other domestic spaces in Gilded Age and Progressive-era homes regularly featured not only paintings depicting banjos and presentation instruments but also three-dimensional works incorporating the banjo. The historic Blanchard house in New Orleans, for example—designed by that city's architectural firm W. C. Williams and Brothers (flourished c. 1885–1925)—showcased in its parlor a terra-cotta bust of an African American banjo player.[7]

Attesting to the instrument's aesthetic evocations, both early American and modern product designs have appropriated the term "banjo" to align commodities with an instantly recognizable point of reference. In the early 1800s, Aaron and Samuel Willard of Boston began producing tall case clocks that, by the turn of the century, would be called "banjo clocks." With its circular head, long conical throat, and rhomboidal lower box, the banjo clock bore a remarkable resemblance to the instrument.[8] In the automotive industry, hollow bolts and elongated hoses for oil and fuel lines have long taken the names, respectively, of "banjo bolts" and "banjo fittings." Because of the ready association with the instrument's visual and physical properties, one could conceivably identify a banjo bolt or banjo clock without previously having seen either or having any idea of their respective functions.

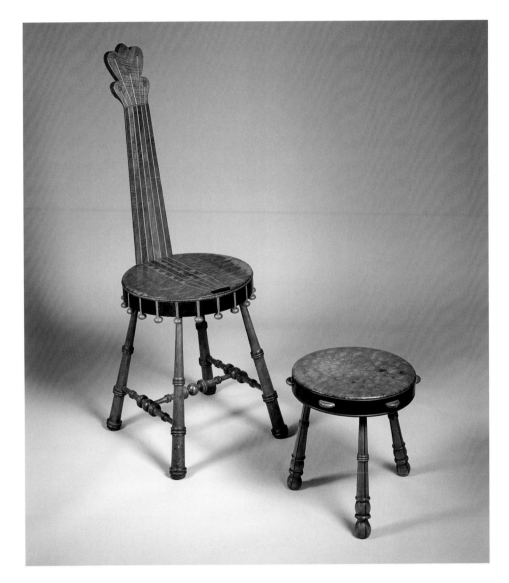

fig. 14
Banjo chair [with tambourine stool],
c. 1875–1900, turned, inlaid, painted, stained,
and varnished wood, 41 × 15⅜ × 20⅝ inches
(chair). Collection of Penny and Allan Katz,
Woodbridge, Connecticut. Photo: Luigi
Pelletieri.

Banjos Unique and Ubiquitous

Today, it remains difficult to escape the visual culture of the banjo. Retailers now peddle banjo clocks, banjo jewelry, banjo-bedecked picture frames, miniature pewter banjo-playing cherubs, and banjos doubling as American flags. We find appropriations of the instrument in public sites across the United States. In Branson, Missouri, a sixty-two-foot-high installation at Grand Country Square claims to be (and surely is) the "World's Largest Banjo." With television programs like *Hee Haw,* and movies like *Deliverance* and *O Brother, Where Art Thou?*, perhaps we have become culturally conditioned to expect banjo iconography and paraphernalia in Branson, country music's second home. Yet the imagery pervades less obvious locales as well. North of Branson, in Columbia, Missouri, we find a larger-

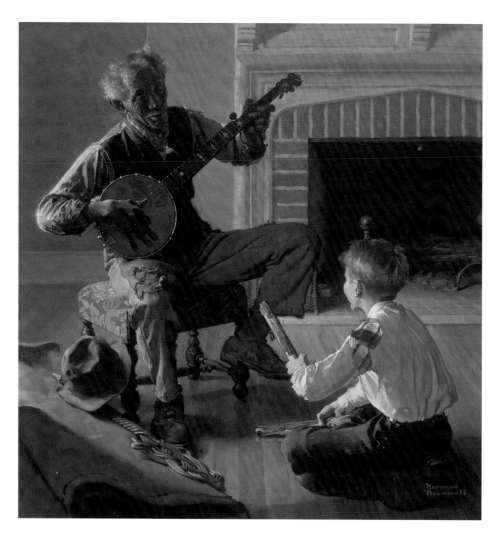

fig. 15
Norman Rockwell, *The Banjo Player,* 1926, oil
on canvas, 29¼ × 28¼ inches. Albright-Knox
Art Gallery, Buffalo, New York. Gift of the Man-
agement, Associates and Shareholders of
Pratt and Lambert United, 1995.

than-life bronze statue of a banjo-playing gecko in front of the Boone County
courthouse. Continuing the trek a little more than three hundred miles southwest
to Wichita, Kansas, we find Randall Charters's sculpture *Fusion Journey* (1993–94),
an enormous tree trunk carved with banjo imagery, in a city park.[9]

This imagery is not limited to the South and Midwest. Southern Californians
may well have seen the storefront display at G&R Mufflers on Grand Avenue in
Lake Elsinore, California, where a muffler-morphic banjoist—made by Gary Kop-
penhaver and Duncan Turrentine, the so-called Muffler Men—props the instru-
ment on his knee. Farther out, in the resort town of Palm Desert, *Passing It
Along*—a five-foot-high bronze sculpture by Dee Clements—stands in front of the
Joslyn Cove Communities' Senior Center. The sculpture depicts an elderly man
giving a little boy a banjo lesson, offering a late-twentieth-century update of the
earlier pedagogical and performative imagery found in works in this exhibition by
Norman Rockwell, Mary Cassatt, and others (see figs. 15, 72, 73).[10]

Although *Picturing the Banjo* endeavors to document and understand the instrument's lingering persistence in art, it does not claim the banjo as some truly one-of-a-kind phenomenon. We must think carefully about, and not overstate or misinterpret, the instrument's uniqueness when we seek to understand the banjo's singularity. Indeed, we may paradoxically find ourselves discussing its ubiquity, even its commonness. Although sometimes presented in high-art contexts, the banjo is typically laden with populist sensibilities. The exceptional and the ordinary frequently overlap. Individuals who otherwise might have little in common are linked by their knowledge of the instrument: they own one, or they know someone who plays one, or they have a friend or relative who boasts of possessing an old banjo. Perhaps, having seen Béla Fleck or the Dixie Chicks perform live, they feel a special connection with the banjo, which somehow acts as an intermediary between a folksy, all-but-forgotten yesterday and a hypermodern right-now. Few symbols, past or present, can match the banjo in signifying simultaneously the modern and the antiquated.

The banjo can sustain disparate and contradictory meanings because, as a visual emblem, it often suggests two contrasting definitions of culture—definitions that date back to the nineteenth century and still bear weight today. For the conservative Victorian critic Matthew Arnold, "culture" was a humanistic concept encompassing a civilization's very best, most learned, and most polished productions in art, literature, the sciences, and elsewhere. If Arnold's highbrow culture merits a capital C, the model proposed by his contemporary, anthropologist Edward Tylor, is a lowercase, more populist one. For Tylor, "culture" meant a "shared system of values" produced by the integrated whole of society. Where Arnold's "Culture" belongs in a cloistered art museum, Tylor's can scarcely be contained and collected in the first place, for it is the stuff of everyday life. The former is a trophy; the latter, a record.[11] Straddling these two cultural conceptions, banjo iconography can infuse the most vernacular and abject media and genres with a rarefied sensibility. It can also, conversely, suggest a popular, collective—i.e., Tylorian—ethos amid the most elite artistic themes and styles. Throughout the last two centuries, apologists for racism have exacerbated the confusion over culture by denying the instrument's Africanness, rendering the banjo at once all-American and inexplicably Other.

Banjo iconography also readily facilitates potentially contradictory worldviews because it has been situated at a socioeconomic crossroads, one where poverty and riches lie in close proximity. As with other stringed instruments, manufacturers have long produced both high-grade and basic banjo models. In the late nineteenth and early twentieth centuries, just when wealthy patrons were purchasing expensive presentation instruments, Sears, Roebuck and Co., Montgomery Ward, and other retailers began making inexpensive banjos available to remote rural and

poverty-stricken areas through department stores and mail-order catalogues (see fig. 119).[12] The profusion of "high" and vernacular images illustrated in this volume demonstrates that banjos have indeed found their way into a remarkably wide range of social strata.

In considering the works reproduced in *Picturing the Banjo,* many readers may attend to such matters as modeling of form and cultural symbolism. Gallery and museum audiences would probably not, however, consider the presence of a mass-produced, markedly nonartistic banjo as a fault in a work of art. To put it another way, the depiction of a cheap instrument does not make the work in which it appears cheap. In Thomas Hope's illusionistic *Still Life with Banjo* (1884, fig. 16), for example, a romantic landscape study, turquoise porcelain urn, and leather-bound books suggest the possessions and creature comforts that money makes available. These items join the sumptuous surfaces of a pink taffeta ribbon and brocaded, paisley-patterned tablecloth to evoke a vision of Gilded Age wealth defined by costly commodities. As expensive as such items can be, however, the banjo could hardly be more common. The so-called 38-bracket Buckbee banjo in the Hope painting was among the less expensive musical instruments one could purchase at the time.[13] Hope's still life exemplifies the blurring of class, cost, and value that facilitates the easy give-and-take of "culture"—both uppercase and lowercase—permeating banjo iconography.

We can isolate three additional factors contributing to the way in which banjo symbolism straddles elite and popular conceptions of culture. In the first place, the modern history of the instrument—like the folk and bluegrass music of which it has traditionally been a part—is replete with attempts to elevate its status. Many of the most significant practitioners of the instrument have devoted their careers to infusing the banjo's perceived vulgarity with gentility. Second, some individuals may think of banjos as rural destitution made manifest, but the music the banjo has helped define is steeped in a modern culture of commerce and consumption, a pecuniary consciousness evident in the careers and contributions of its earliest promoters, including Ralph Peer and Polk Brockman. When the "king of blue-grass," Bill Monroe, was not touring his self-consciously down-home Bluegrass All-Stars, he was raising purebred horses and indulging in other leisurely activities at great remove from the image of rustic populism he so masterfully cultivated and used to publicize his stable of stars. Monroe's example points to a third foundation for the banjo's commingling of the high- and lowbrow. Monroe was only one of many wealthy individuals who brought a humble look to the music he promoted. Like other banjo enthusiasts, he was adept at "fabricating authenticity," to borrow Richard A. Peterson's phrase.[14]

The remainder of this essay explores such cultural fluidity in three broad classi-fications of banjo representations: those alluding to race, rural and folk life, and

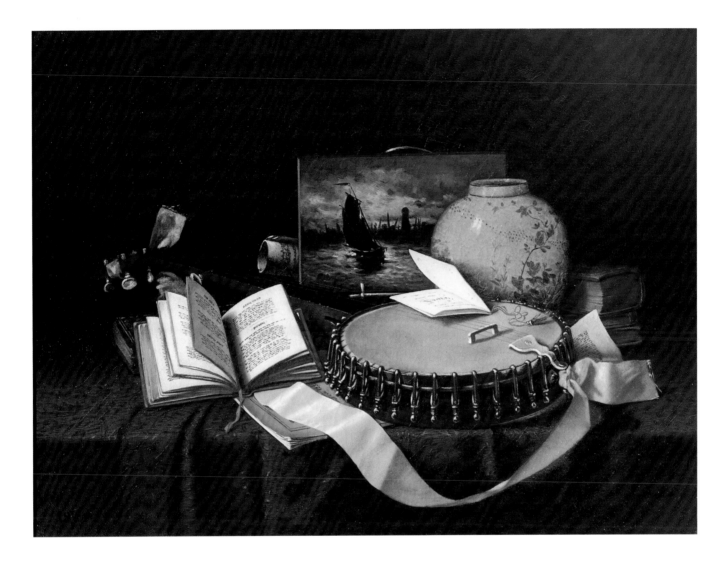

fig. 16
Thomas Hope, *Still Life with Banjo,* 1884, oil
on canvas, 18 × 24 inches. Post Road Gallery,
Larchmont, New York. Photo: David Bahssin.

gender and sexuality. (It should also be stated that although race constitutes only one of these categories, it infuses the other two as well.) The banjo, as an icon, often renders palatable and socially acceptable a discussion of sexually and otherwise charged themes. We seem more comfortable addressing such issues through the banjo than through other equally troublesome props and emblems.[15] Popularly valorized but racially vexed, the visual motif has played on the interstices of social signification; it easily occupies the realms of art and artifact alike. It accords with a mindset, perhaps most clearly articulated by Alexis de Tocqueville in his *Democracy in America* (1835–40), that couples American democracy with pluralism and inclusiveness, as fraught with peril as with promise.

Banjo studies past and present have confronted a popular conception that the antebellum, Civil War, and Reconstruction years represent a sort of Golden Age for the instrument and its representation in art. During this lengthy period, the

fig. 17 (above)
A Mule Train on an Up Grade, 1881, color lith-
ograph, 14¾ × 19 inches. Published by Currier
and Ives, New York. Collection of James F.
Bollman. Photo: Dana Salvo.

fig. 18 (right)
Child's tambourine, c. 1890, mixed media, 7½
inches (diameter). Collection of James F. Boll-
man. Photo courtesy Don Eaton.

banjo provided countless artists and other individuals with a tool with which to address slavery and other racial issues, often in ways now deemed inexcusably ignorant and bigoted (see figs. 17 and 18, for example). One also thinks of canonical masterpieces by Henry Ossawa Tanner, Thomas Eakins, Eastman Johnson, and William Sidney Mount as well as lesser-known but equally revealing pictures by such artists as Helen Corson, William Ludwell Sheppard, William Henry Snyder, and Richard Norris Brooke (see figs. 19, 20, 21, 60). There simply are more banjo pictures from this era than from any other, and indeed, most of the essays in the present volume consider, to varying degrees, American art from the second half of the nineteenth century. Yet the life cycles of slavery, minstrelsy, and (later) vaudeville did not bring an end to racial encodings of the instrument in fine art and popular culture. From the turn of the century to the present day, the instrument's symbolism has become, if anything, more loaded and even less politically correct. Further, in this stretch of time, it has merged race with sexuality in a forthright manner seen in few other emblems. Students of musical imagery in American art would thus do well to consider the banjo in twentieth-century art, even though it appears there less frequently than it does in art from the previous century.

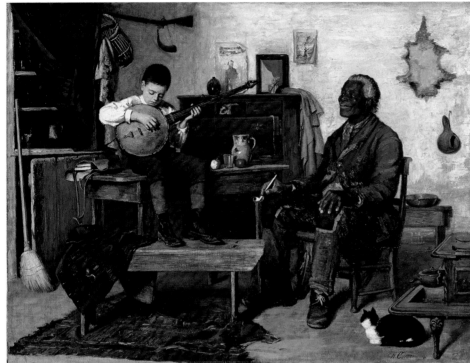

(clockwise from top left)
fig. 19
Helen Corson, *Uncle Ned and His Pupil,* 1881,
oil on canvas, 20¼ × 26½ inches. Wells Fargo
Bank, N.A. Photo used with permission of
Wells Fargo Bank, N.A.

fig. 20
William Ludwell Sheppard, *An Artist Selecting
an Instrument,* wood engraving, 6⅞ × 6¹³/₁₆
inches. Published in *Frank Leslie's Illustrated
Newspaper,* 3 June 1871, 192. The Pennsylva-
nia State University Libraries, University Park,
Pennsylvania.

fig. 21
William Henry Snyder, *Untitled,* 1871, oil on
canvas, 23 × 29 inches. Collection of Peter
Szego. Photo: Peter Szego.

We encounter even fewer banjo images in American art prior to the instrument's Golden Age—that is, from the early eighteenth century through the Jacksonian era. Yet these pictures demand especially heavy scrutiny. They offer meditations on then-current events that, when addressed through the lens of the banjo, take on new, critical, and startlingly clear meanings. Moreover, they offer crucial insights into the instrument's African roots.[16] This book and exhibition probe banjo imagery from the Golden Age as well as the banjo cultures of two eras that are often overlooked—the eighteenth and mid-twentieth centuries.

Music, Race, Control: Eighteenth-Century Artistic Prototypes

The first known visual documentation of the African instrument that would become the banjo appears in Sir Hans Sloane's travel narrative *A Voyage to the Islands Madera, Barbados, Nieves, S. Christophers and Jamaica* (1707–25). A natural historian and, later, the founder of the British Museum, Sloane was in Jamaica in 1687 as physician to Christopher, Duke of Albemarle. There, Sloane and a friend attended a festival on a sugar plantation at which several slaves gave musical performances; the physician sketched a number of the string and gourd instruments and dances he observed.[17] Upon the death of the duke, Sloane returned to England and, over the following decades, published the two-volume *Voyage to the Islands*, which his fellow countrymen could use as a guide for trade, internal development, and navigation in this unsettled British territory. Slavery figures prominently in Sloane's narrative. In the only plate that appears in both volumes, he engraved some of the musical instruments he had witnessed at the sugar plantation festival, alongside some vines (fig. 22).

Sloane's detached, graphic tone rationalizes and imparts makeshift unity to chaotic, unthinkable violence to slaves. His language and imagery only slightly veil a larger effort to "catalogue" and "contain" unknown and wildly unpredictable landscapes of flora, fauna, and slaves that did not permit tidy classification. Such encapsulation and modification transpires in this engraving, with the identifying numbers compositionally stabilizing the instruments and vines. The plate is only one of many images in the *Voyage to the Islands* that place organic and man-made objects side by side, with racially vexed consequences. The stringed instrument marked *1* is compared to, and is a pun on, the circular, intertwined *luteus* plant below, marked *4*. The fibrous twines are ostensibly musical strings and/or toothbrushes, but they also closely resemble the switches with which Jamaican slaves were whipped.[18] Detached from their cultural context, the specimen-like array of materials subdues any suggestions of music, noise, and ensuing punishment. All is orderly and under control.

Perhaps most disturbing in this droll racist wit, however, is that a native culture—symbolized by the "strum thump" banjo—is no sooner represented than

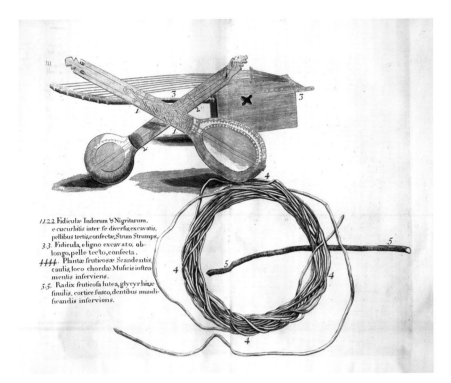

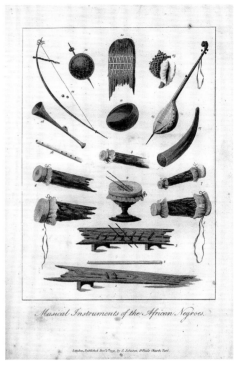

lost. In what "appears to be a cultural record of first-generation transatlantic slaves from several distinct African regions," music becomes part of a larger system of acculturation. Sloane simplifies vastly different expressions so that they fit a cre-olized, New World ideology of expansion and containment. Something similar transpires in William Blake's etching *Musical Instruments of the African Negroes,* from John Gabriel Stedman's *Narrative of a Five-Years' Expedition, Against the Revolted Negroes of Surinam* (1796, fig. 23), in which we find a *banja* in the upper right-hand corner. As the second-largest instrument on the page, the axially radi-ating *banja* beckons our attention, even though author and artist alike have manipulated its meaning. One art historian has noted with irony that Stedman's *Narrative,* the "first extensively illustrated" documentation of a "black slave rebel-lion," is in fact "an account of its suppression." (Stedman originally came to the South American plantation colony in early 1773 with troops summoned by the Dutch States-General to help stabilize the region.)[19]

Perhaps it is to be expected, then, that a theme of suppression also informs his friend Blake's prints in the volume, with the artist de-Africanizing his subject mat-ter. Blake based the *banja* on one of Stedman's watercolors (now lost), which, in turn, depicted several artifacts he encountered in Suriname. As in Sloane's narra-tive, the instrument is stripped of some of its cultural connectedness. With its flat-tened peghead and elongated tailpiece, the reproduced instrument generalizes considerably the instrument to which Stedman had access.[20] The *banja* is relegated

fig. 22 *(left)*
Sir Hans Sloane, illustration from *A Voyage to the Islands Madera, Barbados, Nieves, S. Christophers and Jamaica* (London: Printed by B. M. for the author, 1707–25), vol. 2, plate 232. The Academy of Natural Sciences, Philadelphia, Ewell Sale Stewart Library.

fig. 23 *(right)*
William Blake, *Musical Instruments of the African Negroes,* 1796, etching, 7¹/₁₆ × 5¼ inches (image). From John Gabriel Stedman, *Narrative of a Five Years' Expedition, Against the Revolted Negroes of Surinam* (London: Printed for J. Johnson, 1796), vol. 2, plate 69. Special Collections Library, The Pennsylvania State University Libraries, University Park, Pennsylvania.

fig. 24
Samuel Jennings, *Liberty Displaying the Arts and Sciences,* 1792, oil on linen, 15½ × 18½ inches. Courtesy Winterthur Museum, Winterthur, Delaware.

to mere decoration, mirroring the arc of the *benta* at upper left and thus providing lateral symmetry in Blake's print.

Blake's inventory of musical instruments stands out in a book in which the remaining plates depict slave lynchings, flagellations, and other punishments in graphic detail. In relation to the screaming and commotion one might associate with Blake's torture scenes, the tidy array of unused musical instruments appears muted. By generalizing the *banja*'s structural components, and by removing it from a performative context, the artist streamlines the instrument's native identity, effectively "suppressing" its potential sounds.[21]

Foreshadowing over a century of portrait and genre painting, Sloane's and Blake's proto-banjo images transform musical instruments into orderly surrogates for participants in a not-quite-understood and not-yet-contained African culture on American shores. They show how a process akin to the pidgining of a language transformed a symbol that might otherwise have connoted a native identity. Perhaps most obviously, however, they demonstrate how two early visual interpreters of the instrument filtered its racial charge through disguised symbolism and aesthetic modification.

Similar manipulations are evident in Samuel Jennings's painting *Liberty Displaying the Arts and Sciences* (1792, fig. 24), in which, once again, the relatively

miniature gourd instrument has disturbing consequences for the picture's overall meaning. Dominating the left foreground, the female personification of Liberty takes her place alongside attributes of knowledge and wisdom. The broken chains at the lily white redeemer's feet suggest that the Africans at right—who seem to bow in reverence—have been liberated through learning. Liberty places on the pedestal a 1789 catalogue of the Library Company of Philadelphia, which accepted this painting as a gift from Jennings, a London-based American artist, on the occasion of the Library's recent move into new quarters in the early 1790s.[22]

When the Library Company approved the artist's proposal in 1790, the directors of that institution asked that Jennings include "in the distant back Ground a Groupe of Negroes sitting on the Earth, or in some attitude expressive of Ease & Joy." Jennings, in turn, consigned a banjoist, dancers, and a liberty pole to this perimeter zone that was apparently of much concern to the directors. A counterclockwise trajectory from Liberty's face to her dutifully enlightened subjects, and to the musician and boy, suggests a hieratic scheme in which the gourd instrument is dwarfed beyond the dictates of linear perspective. With the banjo-like instrument as a miniaturized emblem of freedom, the painting implies that the "Ease & Joy" of African slaves are laudable goals so long as their respective "express[ions]" transpire at a safe distance.[23]

For all their differences in scale, subject matter, and paint handling, Jennings's foreground and background nonetheless link through a set of resemblances and visual echoes. The white woman's staff and liberty cap, for example, are replaced by the liberty pole in the right distance. Liberty's crouching position finds its foil in the woman seated just beneath the liberty pole in the background. The exchange of the lyre in the foreground for the gourd banjo in the background is probably the most loaded of these substitutions. Frequently seen in Greek vase painting, the lyre joins the Doric and Ionic columns in an evocation of classical humanism. Its mass, detail, and proximity to the viewer suggest a sonic potential lacked by the background musician, who, were he to play, would surely be inaudible to the foreground group. The space of the foreground piazza isolates Liberty from the background performer, suggesting the difficulty of elevating his art to that of the classical lyre. Moreover, Jennings's painting speaks to professional ambitions and anticipated pecuniary gain as much as it addresses race, liberty, or the arts and sciences. The artist added the British shield (beside Liberty's feet) to this version of the painting for a print to be made after the work, which he hoped to market to British subscribers. (For the larger version, see fig. 48.)[24]

Jennings's makeshift marriage of the banjo with "Ease & Joy" helped codify a set of racially charged artistic traditions that would develop in the Jacksonian era and, propelled by the mid-nineteenth-century popularization of minstrelsy, would flourish well into the twentieth century. Like Sloane and Blake, Jennings used the

banjo to help make an unwieldy culture more manageable. Modified, marginalized, and miniaturized, banjo iconography had an uncanny affinity with an emergent ideology that acknowledged but ultimately sought to hold in check a darker-skinned Other. By the nineteenth century, the problems that had previously been relegated to mere aesthetic decoration or a hazy background were now explored in a foreground—as in *The Banjo Man* (c. 1815, fig. 86)—where banjo symbolism had lost its former ambivalence.

The lone exception to this trend may be *The Old Plantation* from the late eighteenth century, generally thought to be the first American painting depicting the calabash instrument that evolved into the banjo (see fig. 97). The Gambian instrument at right evokes cultural authenticity and sensitivity not only because of its detail and placement in the foreground—and because of the work's assumed African or African American creator—but also because of the performative context. Where previous depictions transformed the instrument into a compositional device, this watercolor matches the *xalam* or *molo* with a human accomplice. The performer joins the percussionist in providing music for the bride and groom in a stick- and scarf-jumping component of a slave wedding. Far from suggesting suppression and containment, the instrument here suggests familial propagation and cultural continuity.[25]

At stake in these eighteenth-century images is nothing less than the frustratingly nebulous and yet critically specific realm of culture. It is, after all, a culture for which the banjo comes to stand in the images reproduced in this book. And it is a culture with which the Englishmen Blake and Sloane, and the Anglo-American Jennings, reckon in their depictions of African American stringed instruments. As John Davis outlines in his essay in this volume, the Golden Age of banjo pictures—including works by David Gilmour Blythe, Thomas Hovenden, Johnson, and Tanner—hardly brought an end to the cultural contests waged in and through the instrument. Some of the nineteenth-century paintings featuring the banjo that have become most familiar to us, such as Eastman Johnson's *Negro Life at the South* (1859, see fig. 45)[26] and Winslow Homer's *Defiance: Inviting a Shot Before Petersburg* (1864, see fig. 52), only updated the issues of race and control that had been introduced in pictures a century earlier. And, as Davis points out, they did so with a disconcertingly sectional twist.

Banjos for "New Women"—and Old Archetypes

Increasingly, Golden Age banjo pictures also introduced sexuality into their racially charged iconographies. In her essay for this book, Sarah Burns examines the banjo's "double life," its simultaneous evocations of modern womanhood and lingering racial anxiety. Examining Frances Benjamin Johnston's c. 1895 depiction of Ann

Apperson, Burns demonstrates a larger theme—which she dubs "whiteface"—that becomes especially clear in comparison with contemporary work by Eakins, Cassatt, and Childe Hassam, as well as Johnston's own photographs at the Hampton Institute in Virginia (see figs. 113, 74, 67, 68). Burns's discussion of the Apperson portrait is especially enlightening because it lays a groundwork for understanding subsequent sexualizations of the banjo, warranting yet further investigation of this largely unfamiliar but culturally revealing photograph.

As Burns observes, the image depicts Apperson in a corner of the Washington, D.C., home she shared with her aunt and caretaker, the philanthropist and reformer Phoebe Apperson Hearst.[27] Laterally framed by a curtain, the interior showcases on the pedestal at left Leopoldo Ansiglioni's late-nineteenth-century sculpture *Flora*. Silhouetted against an additional curtain, and placed on a parquet floor within the compressed, stage-like space, the sculpture effectively points to the elegantly attired Apperson playing the banjo.

It is not difficult to imagine the circumstances bringing together Hearst and Johnston, both of whom maintained residences in Washington, D.C. Each dedicated her life to elevating the status of women—Johnston through photography, and Hearst through educational reform. Hearst made her most significant contributions through suffrage, teacher education programs, and scholarships and job opportunities for women. As the widow of George Hearst, a mining tycoon and U.S. senator, she facilitated dozens of efforts promoting women's political parity and economic independence.[28]

Johnston's portrait of Apperson was surely one of the first she printed after opening her photographic studio in Washington, D.C., in 1894. Johnston was, in the words of one recent historian, a "socialite image maker." And among the many political celebrities living in the capital, Hearst figures as precisely the sort of individual Johnston would seek out. An original member of the Photo-Secession, and the first woman in the Washington Camera Club, Johnston gained no small renown within the almost exclusively male photographic profession. She encouraged women to enter her field and advised them on how to make a living in it, thus practicing the very gospel promoted by Hearst. Moreover, the photographer organized several social and educational gatherings at her studio, and her coterie of artists, intellectuals, and celebrities became known as The Push.[29]

In the infrequent instances in which Johnston's female subjects posed not in the studio but in their own homes, they typically embraced feminine accoutrements, such as flowers and fans, which in turn helped suggest an atelier sensibility. The present subject matter—Flora, the goddess of flowers—would render such foliage all the more appropriate. But Hearst, Apperson, and Johnston only deposit a bouquet of flowers before the sculpture in the photograph; Apperson herself chooses the banjo rather than flowers. She performs where the marble goddess

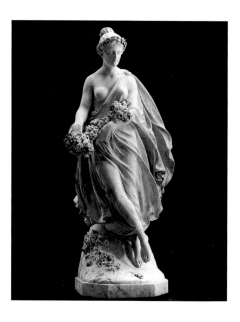

fig. 25 *(left)*
Thomas Crawford, *Flora*, 1853, marble, 86
inches (height). Collection of The Newark
Museum, Newark, New Jersey. Gift of Franklin
Murphy Jr., 1926.

fig. 26 *(right)*
Clifford P. Grayson, *Idle Hours*, c. 1891, unlo-
cated. Illustrated in The Art Club of Philadel-
phia, *Third Annual Exhibition of Oil Paintings
and Sculpture* (Philadelphia: Isaiah Price,
1891), 20. Image provided by the Smithsonian
American Art Museum/National Portrait
Gallery, Washington, D.C.

simply stands anchored and earthbound with downcast eyes. Effectively "deflow-
ering" Flora, photographer and philanthropist join forces to destabilize a time-
honored and socially sanctioned construction of fragile, fecund femininity.

Why would two pioneering feminists showcase the banjo in their restaging of
Flora? Performing, moving, and seemingly floating, Johnston's revised Flora man-
ifests a modern, liberated sensibility, the banjo her emblem of accomplishment
and even enlightenment. In keeping with Hearst's endeavors in women's clubs and
with Johnston's photographic practice and her activities in The Push, the modern
Flora has higher aims than holding flowers and dolefully staring at the earth. Such
a message was certainly clear in Mary Cassatt's *Modern Woman* mural in the
Woman's Building at the 1893 World's Columbian Exposition in Chicago. On the
section of the mural at right, Cassatt's allegorical personification of Music also per-
forms on the banjo (see fig. 71).

In conceiving their banjo-playing modern Flora, the artist and the reformer
may well have had Cassatt's mural in mind. Johnston and Hearst both attended
the World's Columbian Exposition: Hearst had lent art to the Exposition, and
Johnston was one of the three official photographers hired by the U.S. government
to document it. (She eventually took and developed several hundred prints of the
Exposition.) In the *Modern Woman* mural, the banjo joined other widely recog-
nized emblems of female autonomy—the skirt in particular—in establishing a tri-
partite narrative of self-realization.[30] Anticipating Johnston's and Hearst's rendi-
tion of the heavily skirted modern Flora breaking her floral bonds, Cassatt's
modern woman, in the guise of Music, towers over nearby plants and a potted
tree—that is, the flora around her.

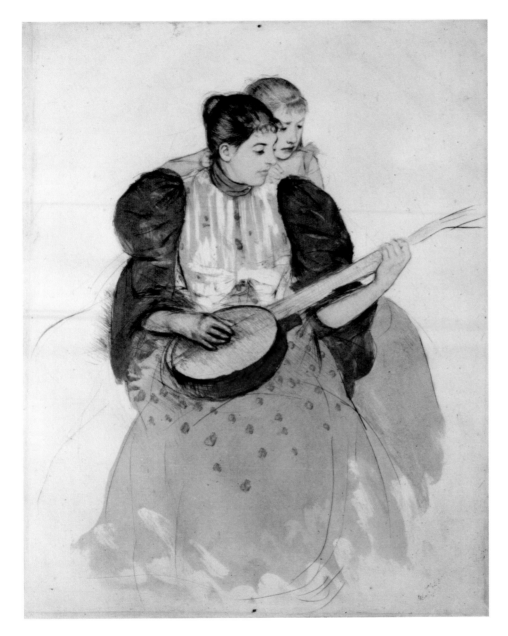

fig. 27
Mary Cassatt, *The Banjo Lesson* (iv/iv),
c. 1893, drypoint and color aquatint, 11⅝ × 9⅜
inches. Carnegie Museum of Art, Pittsburgh,
Pennsylvania. Leisser Art Fund, 50.4.3.

At the 1893 Exposition, Johnston and Hearst would also have encountered what was then probably the best-known American rendition of Flora, a sculpture by Thomas Crawford dating from 1853 (fig. 25). Crawford's *Flora* may have attracted Hearst's attention, given its remarkable formal affinities to the statue by Ansiglioni in her collection. Installations of the Crawford version had long emphasized its floral aspect. That Crawford's goddess merited an appropriately wooded and leafy setting is suggested in the statue's placement on public view in New York's Central Park from the late 1860s through 1880. Contemporary accounts sexualized the fig-

fig. 28 *(left)*
Portrait of Theresa Vaughn playing a
Fairbanks Electric No. 2 banjo, c. 1895,
photograph, 6 × 4¼ inches. Collection of
James F. Bollman.

fig. 29 *(right)*
Henry Siddons Mowbray, *Fairy Music,* 1886, oil
on canvas, 13½ × 9½ inches. Private collec-
tion. Photo courtesy Berry-Hill Galleries, Inc.,
New York.

ure, emphasizing her "passive, soft face" and "bounteously filled lap" and stressing
the manner in which the "plants and blossoms" endow her with "glad presence."[31]
The Johnston photograph becomes all the more monumental in light of the Amer-
ican critical tradition that interpreted *Flora* in patronizingly gendered vocabulary.
The trading of flowers for banjo transforms Flora from idle to performative and
from vacant to cerebral—in short, from passive to active—in Johnston's photograph.

Paintings depicting women playing the banjo became increasingly popular in
the last two decades of the nineteenth century. The instrument joined in a mission
to challenge the limits of the cult of domesticity, a sensibility often suggested in the
works' reassuringly sentimental titles. Exhibited at the 1893 Columbian Exposition,
Clifford P. Grayson's now-lost painting *Idle Hours* (c. 1891, fig. 26), for example,
depicts the subject physically and intellectually engrossed in her banjo playing. Not
unlike the women in Cassatt's print *The Banjo Lesson* (c. 1893, fig. 27), which was
based on her 1893 mural, Grayson's performer directs her gaze away from the

viewer toward her playing, creating a level of engagement—of industriousness—at odds with the painting's title.[32]

Several late-nineteenth-century photographic portraits of women convey similar meanings. Like the works by Grayson, Cassatt, and Hassam, they too remove their subjects from narrowly circumscribed theatrical sentimentality. One photograph from about 1895, for example, shows a self-possessed Theresa Vaughn; the popular songstress adeptly plays the Fairbanks Electric banjo (fig. 28). The photograph was likely used to publicize the variety acts Vaughn and her husband, W. A. Mestayer, performed on New York stages in the 1880s and 1890s. It is significant that Vaughn—like Apperson in Johnston's photograph—does not merely pose with but actually plays her banjo. Simultaneously sliding down with her thumb and plucking upwards with her index finger (and smiling, balancing herself on the faux fence), Vaughn plays the instrument with the sureness and poise of a professional.[33]

Like Apperson and Johnston, as well as Cassatt's protagonist in *Music*, Vaughn has little use for the flora below her at lower right. Armed with her banjo, she seeks rewards and merits attributes of a different, higher sort. It is equally remarkable that she holds the Electric model manufactured by the A. C. Fairbanks Company, which advertised itself as "makers of highest grade banjos." With twenty-two frets capable of three octaves, the so-called Electric banjo, "a thoroughly up-to-date instrument in every respect," promised to "mark a new era in the Banjo World."[34] The professional-grade instrument certainly finds its match in Vaughn's expert fingering and confident demeanor. If this modern banjo marked a new era, the instrument found its human equivalent in Vaughn, Hearst, Johnston, and other "new women."

There are certainly exceptions to the pairing of banjos and empowered women in late-nineteenth-century American art. Particularly remarkable here is H. Siddons Mowbray's painting *Fairy Music* (fig. 29). The piece was engraved in the illustrated art book *American Figure Painters* from 1886, where it was accompanied by lines from seventeenth-century English poet William Strode's "In Commendation of Music." Positing the "charming air" of "soft" music as the stuff of "wonder sweet," Strode's verse provides a romantic veil for the frank depiction of the female form. Where Cassatt and Johnston present the banjo as a sign of women's intellectual awakening via music, Mowbray's model—bare-chested and ensconced in flowers, including the floral motifs on her dress—engages the senses of touch and sight. In *Fairy Music*, the banjo joins the woman's gaze and fecund landscape in a sensorial appeal to the viewer. The subject's passivity and suggestion of sexual availability are also at odds with Grayson's painting and the photograph of Theresa Vaughn. In the latter pieces, the instrument signifies personal and professional achievement. *Fairy Music* returns the female subject, banjo in hand, to the conventional constrictions of Flora.

fig. 30
Bacon Banjo Company, promotional four-string banjo, 1926, photograph. Courtesy R. D. Montana.

fig. 31
Big Ben Banjo Band, LP cover for *Happy Banjos,* c. 1950s, Capitol Records 10062. Used by permission of the University of Missouri–Kansas City Libraries, Special Collections Department.

Embodying the Banjo in Twentieth-Century America

Mowbray's painting anticipates several ostensibly lighthearted but ultimately degrading come-ons in twentieth-century American visual culture. Few sexualizations of the instrument are as blatant as the Bacon Banjo Company's 1926 promotional photograph for an amateur banjo contest at the Pantages Theatre, in which women "play" the fingerboard of a gigantic four-string banjo, a phallus-like behemoth (fig. 30).[35] Continuing the trend, in the late 1950s the Big Ben Banjo Band emphasized the "happiness" of their LP *Happy Banjos* by coupling on the album cover a smiling banjo face with a young, attractive woman in a low-cut dress. She smiles, in turn, at the viewer as she positions the instrument's "head" adjacent to her face (fig. 31). In both cases the subjects evoke the possibility of sexual activity with the banjo by caressing the instrument.[36]

Figures 30 and 31 point to longstanding artistic and literary conventions equating banjos with the human form. A tradition dating to Aristotle's *De anima* compares the inner soul of the individual to the exterior body of a musical instrument. For modern audiences, this trope finds its way into the motions, exertions, and sheer physicality of performers as they play their instruments, as well as in the decorations of the instruments themselves.[37] Selected works by Thomas Hart Benton, Dox Thrash, and Aaron Douglas, however, let us go a step further in our assessment of what we might call the embodiment of the banjo. They each demonstrate the banjo's role in reclaiming a masculine or feminine self perceived to be at risk. Although they worked in disparate social circumstances, these artists each invested the instrument with allusions to sexual difference as well as the cultural consequences of asserting one's masculinity or femininity.

As many musicologists and folklorists have pointed out, there is little that is *not* gendered and sexualized in the twentieth-century bluegrass and early country music cultures in which banjos figured so prominently. This is certainly the case with a group of illustrations Thomas Hart Benton produced for the 1943 novel *Taps for Private Tussie,* a sentimental, Steinbeckesque narrative of Depression-era squalor by the Kentucky literary regionalist Jesse Stuart. An award-winning Book of the Month Club selection that sold more than a million copies, *Taps for Private Tussie* concerns the competing affections of George Tussie and his nephew, Mott Tussie, for Aunt Vittie, their relative through marriage. Mott and George enlist their banjo and fiddle, respectively, to entice the woman. Mott can hunt and make things more adeptly than George, but fails to "bring the music from his banjer that Uncle George could bring from his fiddle." "I'm a good trapper but I'm not a good lover," Mott confesses, adding, "my banjer won't come up to Uncle George's fiddle . . . take that fiddle away from him and I'd stand a chance with the woman we love."[38]

fig. 32
Thomas Hart Benton, untitled book illustra-
tion, 1943, 6⁷/₁₆ × 4 inches (image). In Jesse
Stuart, *Taps for Private Tussie* (New York:
E. P. Dutton, 1943), 201. The Pennsylvania
State University Libraries, University Park,
Pennsylvania. Art © T. H. Benton and
R. P. Benton Testamentary Trusts/UMB Bank
Trustee/Licensed by VAGA, New York.

Taps for Private Tussie is littered with puns on "instrument," a word that, in Benton's and Stuart's hands, oscillates between musical and sexual contexts. In perhaps his most finished drawing for the book—and one that was reproduced on the cover of *The New York Times Book Review*—Benton depicts Mott frenetically playing his banjo and singing for Vittie, as George leans on the mantel, holding his fiddle and waiting his turn (fig. 32). Throughout Stuart's text, the banjo is not only an identifying moniker; it is also a surrogate for Mott's deficient virility. Nowhere is this more clear than in Stuart's conclusion, in which the drunken Mott, having just killed two conniving cousins, returns home, finds George playing music for Vittie, and shoots the fiddle. "I've blowed that son of a bitch to smithereens," says Mott, who proclaims that "it'll never steal any more women."[39]

Benton's illustrations point to the banjo's symbolic potential in a masculine quest for domination that recurs throughout selected twentieth-century American art, music, and literature. That struggle is also given vivid, if ultimately ambivalent,

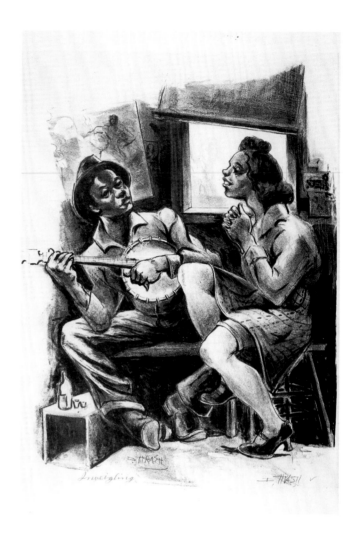

fig. 33
Dox Thrash, *Inveigling,* c. 1940–41, lithograph,
17⅛ × 12⅞ inches. U.S. General Services
Administration, Public Buildings Service,
Design Excellence and the Arts Program, on
deposit at The Free Library of Philadelphia,
Print and Picture Collection, 86.1699. Photo:
Will Brown.

form in Dox Thrash's lithograph *Inveigling* (c. 1940–41, fig. 33), a work whose title is defined by the *Oxford English Dictionary* as "To blind in mind or judgment; to beguile, deceive, cajole; to entice, lure, seduce." That the banjo is an agent of sexual entrapment is suggested in the figure of the woman at right, who raises her right leg so that it appears to touch the instrument. Her clasped hands evoke both prayer and enchantment, as if she is so taken by her suitor that she worships at his banjo-shrine.[40] Not unlike Thrash's print *Happy Journey* (1939–40, fig. 34), *Inveigling* certainly enlists the banjo to redress the very racism it has been used to enforce, yet the inclusion of the woman prompts us to consider the instrument as a different sort of social tool, one invested with sexual powers. Moreover, the performer's psychic absorption and musical control only bring to the fore the woman's banjo-induced emotional surge and perhaps loss of self-control.

Thrash's picture demands yet more attention on account of its mixture of race and sexuality. With the woman spellbound and exhilarated by her suitor's music,

the image evokes a modern trend in racially charged film and theater in which playing or simply possessing stringed instruments invariably leads to emotional quagmire and loss of bodily control. In Willis Richardson's play *The Broken Banjo*, published in Alain Locke's *Plays of Negro Life* (1927), the banjo connotes virility gone amok. Events come to a climax when the protagonist, Matt, inadvertently breaks his banjo while fighting his rival, Old Man Shelton. Throughout Richardson's text, the banjo takes on a life of its own, functioning as Matt's livelihood and, when broken, his inadvertently silenced partner. In explaining to his wife, Emma, that he killed Shelton, Matt alludes to how crazy the banjo made him: "Ah didn't mean to kill him. When he broke my banjo, Ah hit him harder than Ah thought." Only "moonshine whiskey," he concludes, rivals the banjo in driving him crazy.[41]

In *The Broken Banjo*, Matt may be strong enough to conquer and kill, but the destruction of his instrument renders him profoundly feeble. His state of emasculation is powerfully portrayed in Aaron Douglas's woodcut illustration for Richardson's text, which depicts the standing, writhing figure holding the pieces of the destroyed banjo in each hand, while the woman in whose defense he ruined his instrument stands beyond the doorway. Exposed slats in the upper reaches of the wall and a shattered glass window cropped at right join the banjo in evoking the "break." These elements, in turn, find their foil in the similarly flattened, angular form of Matt's body, whose awkward stance suggests anatomical stiffness and physiological obsolescence, as if his once-powerful physique, like the banjo itself, can no longer perform.

fig. 34
Dox Thrash, *Happy Journey*, 1939–40, carborundum relief etching, 9¹⁵/₁₆ × 7 inches. U.S. General Services Administration, Public Buildings Service, Design Excellence and the Arts Program, on deposit at The Free Library of Philadelphia, Print and Picture Collection, 86.1644. Photo: Will Brown.

Banjo Vernacular

When Matt breaks his banjo, he loses not only his musical livelihood and sexual symbolism but also his primary means of self-expression. Similarly, in *Taps for Private Tussie*, Mott appears to be an intelligent, sensitive character only when playing or talking about his banjo. In the world of the Tussies, sentiments with no other outlet for expression find a voice through the banjo. With the instrument connoting stasis and facilitating the passing of oral history, Stuart's and Benton's vernacular banjo imagery shares with more rarefied expressions (e.g., works by Tanner and Cassatt) an emphasis on generational bonds and unspoken but clearly understood communications. For Matt and Mott alike, the banjo functions as a discursive device—that is, a tool for reasoning and for communicating stories and exchanging ideas.

Selected contemporary artists, including painter, filmmaker, and musician Clare Rojas, have seized on the idea of the banjo as a discursive tool. Rojas's multimedia piece *J. M. P. H. A. M.* (2003, fig. 35) depicts the artist and her mother teaching each other to play the banjo.[42] Rojas's materials and framing devices approximate

fig. 35 *(left)*
Clare Rojas, *J. M. P. H. A. M.,* 2003, gouache,
latex, paper, and material, 16 × 8½ inches.
Collection of Judy Rojas.

fig. 36 *(right)*
Daniel K. Tennant, *A Marine's Life,* 2004,
gouache on museum board, 32 × 26 inches.
Courtesy Hammer Galleries, New York.

the surface texture and compositional properties of a family quilt, which seems
appropriate given the many late-nineteenth-century banjo pictures that incorpo-
rate the instrument as a vehicle for transmitting family history and tradition.

Under the pseudonym Peggy Honeywell, Rojas has released two CDs featuring
her singing, banjo picking, and guitar playing. In "Worried Man," a banjo song
from her 2004 CD *Faint Humms,* deliberate picking links the two dubbed voices,
much as the instrument compositionally unites the mirroring forms of artist and
mother in *J. M. P. H. A. M.* In the song's final refrain, Honeywell addresses the lis-
tener on the topics of authorship and the musical medium: "If anyone should ask
you who composed this song, say it was me, and I'll sing it all day long."[43] Rojas/
Honeywell employs the banjo in what one may call an act of witness, a documen-
tation of oneself.

Similarly locating value in the vernacular and enlisting the banjo on a journey
of remembrance is Daniel K. Tennant's *Marine's Life* (2004, fig. 36), a meticulously

linear *trompe-l'oeil* still life that recalls any number of late-nineteenth-century cabinet and rack pictures. Tennant's painting, however, also draws attention to the limits of the banjo's discursive potential. The work honors a friend of the artist, one who served in the Marines in 1968–69 but lost the use of his legs in 1975 after an accident that severed his spinal cord. Banjo playing has brought him emotional uplift and personal satisfaction since then. The military jacket, dog tags, sharpshooter badge, and Ruger Blackhawk .357 in Tennant's piece recall Marsden Hartley's canonical *Portrait of a German Officer* (1914, Metropolitan Museum of Art, New York).[44] The latter evokes the loss of Hartley's dear friend Karl von Freyburg in World War I, and it suggests that memories—which can be recalled but not relived via insignia and flags—are all that are left to one's survivors. Although Tennant's subject is in fact alive, one also detects absence here, with the regalia serving only decorative and commemorative purposes. In place of the Marine's body, the banjo literally hangs by a string, and it appears as cleansed as the neatly pressed jacket.

Yet in locating meaning in vernacular banjo imagery, several contemporary artists have taken an approach somewhat different from Tennant's diary-like *A Marine's Life* and have opted for more public engagement. A particularly notable "shared" usage of the banjo transpires in David Robbins's recent television pilot for the Sundance Channel, called *The Ice Cream Social* (2004, fig. 37). The program is one of several related productions organized by the artist over an eleven-year period in which he posited Baskin-Robbins ice cream parlors as the ultimate populist American space. In a novella of the same name, Robbins contends that the communal area, the frozen treats, and, most of all, the pink, white, and brown dots render the commercial establishment ideal for dispensing feel-good messages to television audiences.[45] The ice cream is a social glue for the "roomful of strangers, united by a single experience," as he puts it in the story. Throughout the Sundance pilot, a woman playing the banjo stands on a small oval stage, like an axel integrating the wheel of ice cream lickers. Asked about the musician, Robbins recently commented that she played no particular song, that she just provided ongoing "ambient sound." He further remarked that "ice cream and banjos are both longstanding American traditions," and in *The Ice Cream Social* it is indeed tempting to envision food and music alike as allegories of cultural connectedness.[46]

The banjo is also a discursive tool in Mary Hufford's *Dave Bailey Holding Russell Cox's Banjo with Crucifix Painted on Back* (1997, fig. 38), one of several photographs documenting a musical gathering and dinner party in Sundial, West Virginia. As director of the Center for Folklore and Ethnography at the University of Pennsylvania, Hufford has conducted extensive fieldwork in central Appalachia, where she became acquainted with Bailey and Cox, who were fellow guests at the soiree. Hufford was intrigued by the detailed rendering of the Crucifixion and the Crown of Thorns as well as the evocation of suffering. For her, the image suggested

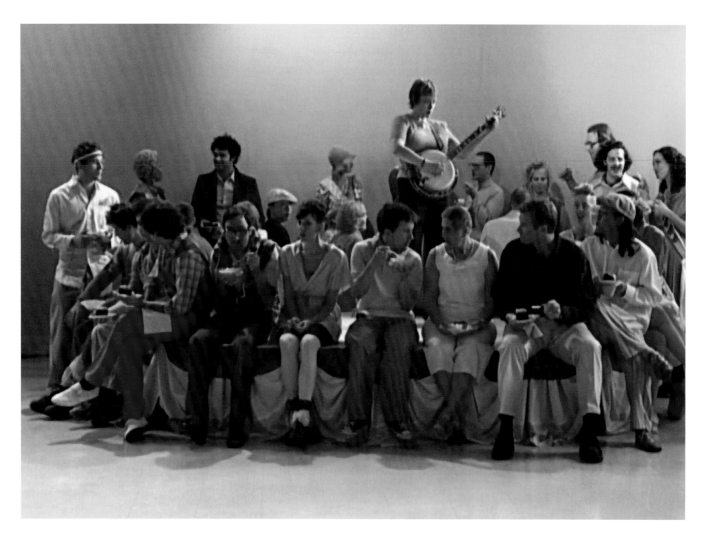

fig. 37
David Robbins, video still from *The Ice Cream Social,* 2003. Courtesy the artist and Feature, Inc., New York.

a pictorial version of a region-specific anguish that, typically, would be articulated verbally. Hufford's scholarship has surveyed the physical (i.e., landscape and bodily) toll of the corporate usurpation of native fructuary rights. In this context, the agonies of Christ—as drawn on the instrument—stand in as hope for survival in an otherwise dire context.[47]

Picturing the Vernacular

Perhaps more than any other twentieth-century American artist, Thomas Hart Benton explored the discursive and expressive potential of vernacular banjo imagery. Benton was a music aficionado, self-taught harmonica player, and avid folklorist, and he depicted the banjo in paintings, murals, drawings, and book illustrations. In many of these works the banjo is not the primary focus, but in each its symbolism is charged and its presence integral to the theme. This is the case

with one of his most important paintings, the mural *The Sources of Country Music* (1975, fig. 39), the last work Benton produced. Commissioned in 1973 by the Country Music Foundation (CMF) in Nashville, Tennessee, the large canvas was on the easel in his studio when he died on 31 January 1975, shortly after adding finishing touches to the piece.[48] As we will see, Benton played no small role in establishing visual conventions for the banjo. *The Sources of Country Music* and related works illuminate the symbolic baggage that the instrument continues to carry.

Beginning in the early 1930s, Benton had devoted a great deal of time to studying, collecting, and playing the folk music whose roots, he believed, were all too quickly being eclipsed by impure commercial derivatives. Before leaving New York City in 1935, Benton was something of a leading figure in the Greenwich Village music scene. He hosted musical gatherings frequently attended by performers, composers, and musicologists such as Carl Ruggles, Edward Robinson, and Charles Seeger. (Benton's harmonica band played at some of these events.) This activity came to a climax of sorts when Benton teamed up with his musician and composer friends to record five songs on a 78-rpm LP called *Saturday Evening at Tom Benton's*, released in 1942.[49]

As early as 1937, Benton saw the folk music with which he had grown up as endangered. In a now-famous passage in his autobiography, he predicted that "the old music cannot last much longer," adding, "I count it a great privilege to have heard it in the sad twang of mountain voices before it died." Benton, however, did his part to make the music last as long as possible, to preserve it for coming generations. In a career spanning several decades, he would collect the music of some 130 songs from his rural sojourns and musical evenings.[50]

In collecting, playing, recording, cataloguing, and painting music, Benton partook in a social process that the cultural historian J. M. Mancini has called "anthological modernism." Mancini applies this term to the activities of mid-twentieth-century musicians and folklorists who—like Harry Smith, editor of the 1952 multivolume LP *Anthology of American Folk Music*—sought to preserve in time a musical authenticity they believed was vanishing amid the commercial music and cultural conformity of Cold War America.[51] Like Smith with his recording studio and the folklorist John Lomax with his field tape recorder, the anthologists, Mancini points out, enlisted modern "technologies of containment" to register the sincerity and the nothing-held-back severity of earlier American musical traditions.

Benton's anthological modernism is probably nowhere more apparent than in *The Sources of Country Music*, and the downsized but critical figure of the banjoist plays an integral role here. As art historian Vivien Green Fryd has amply documented, Tex Ritter, Bill Ivey, and others at the CMF were most "anxious to express [their] commitment to tradition" by way of the large mural. The painting's emphasis on pre-1920s noncommercial themes and folksy origins was entirely consistent with its

fig. 38
Mary Hufford, *Dave Bailey Holding Russell Cox's Banjo with Crucifix Painted on Back*, 1997, color photograph. Courtesy the artist.

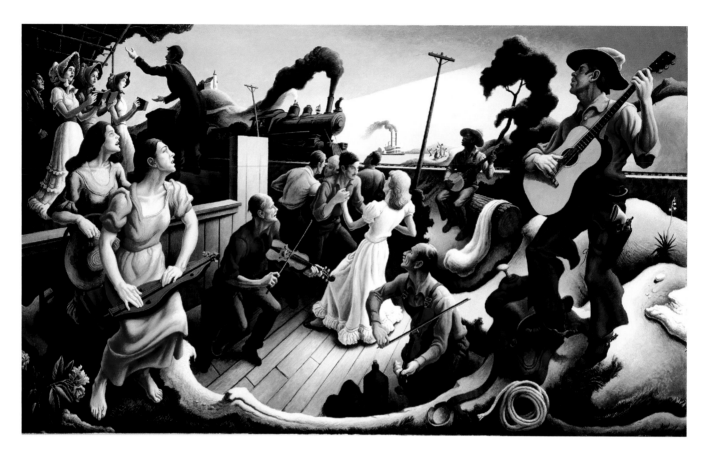

fig. 39
Thomas Hart Benton, *The Sources of Country Music*, 1975, acrylic on canvas, 72 × 120 inches. Courtesy of Country Music Hall of Fame® & Museum, Nashville, Tennessee. Art © T. H. Benton and R. P. Benton Testamentary Trusts/UMB Bank Trustee/Licensed by VAGA, New York.

patron's desire to recapture the flavor of the "old-fashioned" amid threats posed by the ascendancy of rock and roll and an overall waning of traditional country music.[52]

The placement of the banjoist in *Sources* bears directly upon its meaning, and Benton apparently thought carefully about the matter before assigning the African American musician his place upon the log just right of center. A stickler for folkloric accuracy, Benton inquired into the date at which Appalachian musicians had first embraced the five-string banjo, with Bill Ivey of the CMF informing the artist of particularities regarding the instrument's history and its role in early-twentieth-century African American blues.[53] The African American musician's dynamically counterpoised form parallels the slant of the telegraph pole (itself repeating the angles of the oncoming locomotive), and his body links the fore- and middle ground, beckoning our attention in spite of the other figures that loom larger. Here and elsewhere in Benton's musical imagery, the banjo motif takes on an axis-providing, mediating role. In the mural, the banjoist steadies the vortex of musicians and revivalists radiating about him. Although miniature in comparison to the monumental, bracketing form of the cowboy at right, the engrossed banjoist nonetheless sets the stage for what one art historian has described as the mural's "sense of stability amid explosive energy and movement."[54]

For the figure of the banjoist, Benton used as his model the "freckle-faced" Melvin Deaver, a presumably Anglo acquaintance of the artist's longtime friend Sammie Feeback. Benton further complemented his working process with a trip through the Ozarks, where, in search of authentic musical types, he sketched fiddlers, singers, and dancers. The same sort of anthropological fieldwork—driving along back roads in search of ideal subjects, interviewing individuals, transcribing their music—had supplied the central characters for several earlier paintings, including *The Ballad of the Jealous Lover of Green River Valley* (1934, Spencer Museum of Art, The University of Kansas), as well as two works with prominent banjo imagery, *Lord, Heal the Child* (1934, Collection of John Callison Jr., Kansas City, Missouri) and *"Pop" and the Boys* (1963, Nelson-Atkins Museum of Art, Kansas City, Missouri). *"Pop" and the Boys* and *Lord, Heal the Child* derive from Benton's long walks down country roads, during which he had attended "country dances and church singin's." He persuaded locals to teach him songs and to lend him their sheet music so he could copy it.[55]

The instrument's importance can be detected, at least in part, by the highly finished graphic studies of banjoists Benton produced for some of these paintings. He made the mixed-media drawing *Red* (1934, fig. 40), for example, in advance of *Lord, Heal the Child*. The banjoist Red was the leader of a "Holiness" band Benton encountered at a revival meeting during his sojourn through the Smoky Mountains in the summer of 1934. Understanding that the banjo provided a foundation in the rural religious rite, the artist depicted the musician's head and hands working together in an act of inspired concentration. Red surely made quite an impression on Benton, who described him as a "glorious banjo-smiting vagrant." Benton reproduced *Red* in his 1937 autobiography, *An Artist in America,* as a testament to his devotion to rural music and the folkways of which it is a part.[56]

The African American banjoist, church choir, cowboy, and fiddler were among the types initially approved by the CMF board overseeing the project. In noting the importance of trains in country music history and song lyrics, the board also requested that Benton add a locomotive, which appears in the final squared study for *The Sources of Country Music* (fig. 41) and the mural itself.[57] One of the most significant changes, however, between the latter images and a slightly earlier study concerned the banjoist and the very nature of his instrument. In the preliminary study from 1974 (fig. 42), hieratic scaling emphasizes the musician as a crucial character in the work. Seated at right, turning to the left with an open mouth (as if singing), he strums the instrument. Slightly smaller than the central singers, but equal to or larger in size than others in the composition, the banjoist figures prominently in this early conception of the mural, with the importance of the instrument indicated by its presence as well in the musical cornucopia depicted at lower right.

fig. 40
Thomas Hart Benton, *Red,* 1934, pen and black ink, brush and brown wash over graphite on off-white wove paper, 11⅞ × 8⅞ inches. Cooper-Hewitt, National Design Museum, Smithsonian Institution, New York. Gift of William J. Donald, 1953-102-5. Art © T. H. Benton and R. P. Benton Testamentary Trusts/UMB Bank Trustee/Licensed by VAGA, New York. Photo: Matt Flynn.†

In the squared study, though, the once sizeable banjoist is reduced in scale and relegated to the background, and the banjo still life is completely eliminated. Replacing the figure of the banjoist is an even larger rendition of a guitar-playing Tex Ritter. (The retired star of film westerns was a most active member in the CMF, and he may have been solely responsible for Benton's commission. He was, in the words of one particularly ardent fan, the "patron saint of Country Music.") When Ritter died in January 1974, in the midst of Benton's work on the project, the artist and Ivey agreed to memorialize him in the mural. Noting the figure's close resemblance to Ritter's early publicity photographs, Fryd observes that "by fore-grounding the cowboy . . . Benton emphasized country *western* music and its mythic cowboy associations." This is especially remarkable because in the preliminary study, the banjoist—abutting the cowboy and horse in the upper vignette—had similarly mediated past and present. Moreover, in photographs of such groups as Fiddlin' John Carson's band, The Binkley Brothers, and The Cumberland Ridge Runners taken in the 1920s and 1930s, shortly after the commercialization of country music, the banjoist stands at far right, as the performer did in Benton's preliminary study for *Sources*.[58] By removing the banjoist from the right side of the composition, the later conception for the mural deemphasizes the role of the banjo—and its Africanness—as a "source" of country music.

Sources is thus the site of some historical revisionism. Benton and Ivey knew well the African and minstrel roots of modern folk, country, and blues. In a 1975 brochure published for the unveiling of the mural, Ivey commented, "The black musician represents the impact of Afro-American culture upon country performance." For his part, Benton owned LPs by the African-inspired banjoists Moran Lee "Dock" Boggs and Pete Steele.[59] Yet by replacing the African American banjoist of the preliminary study for *Sources* with an Anglo American (playing the guitar, a European instrument) in the later study, Benton, intentionally or not, neutralized the profound racial dynamics underlying traditional folk music, effectively privileging white appropriations over black origins.

Earlier in his career, Benton had written that the locomotive was, broadly considered, a "symbol of change."[60] In this regard, the coupling of newfangled train and antiquated steamboat parallels that of Hollywood-modern Anglo guitarist and archaic African American banjoist. The ferocious locomotive repeats but mimics the smokestacks and forward motion of the miniscule steamboat; similarly, Tex Ritter's pose, gaze, and angle of instrument repeat those of the banjo player. In each case, the new law has replaced the old law, with the former compositionally dwarfing—as if quashing—the latter. The stinging irony, of course, is that in dwelling on the present, the CMF mural downplays the very past upon which its existence hinges. Indeed, the African instrument is an integral part of American musical traditions—upon which Ritter's cowboy-ness derives, at least in part—just as the chugging steamboat is as

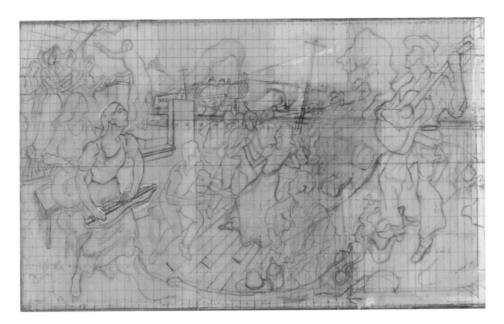

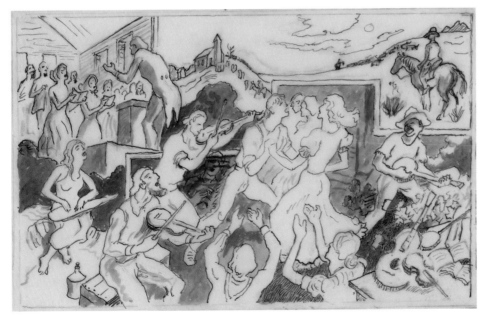

fig. 41
Thomas Hart Benton, squared study for the mural *The Sources of Country Music*, 1974–75, pencil and ink, 16 × 25 inches. Courtesy of Country Music Hall of Fame® & Museum, Nashville, Tennessee. Art © T. H. Benton and R. P. Benton Testamentary Trusts/UMB Bank Trustee/Licensed by VAGA, New York.

fig. 42
Thomas Hart Benton, preliminary study for *The Sources of Country Music*, 1974, ink, pencil, and sepia wash on paper, 7 × 12 inches. Courtesy of Country Music Hall of Fame® & Museum, Nashville, Tennessee. Art © T. H. Benton and R. P. Benton Testamentary Trusts/UMB Bank Trustee/Licensed by VAGA, New York.

vital as the barreling locomotive in the history of transportation. Benton, that is, edited his painted anthology in a manner that complemented the CMF's version of American music history. With these subtle but critical changes in the final study and mural, *The Sources of Country Music* underscores the expressive and manipulative potential of the banjo as an emblem of vernacular identity and folk authenticity. It should be noted, though, that for Benton and the CMF alike, "the disappearance of American folk music" stood for a larger problem: the ongoing effort, to borrow Mancini's words, "to formulate a meaningful response to modernity."[61]

The Sources of Country Music achieves just such a sleight of hand, with the banjo itself, ironically, serving as a metaphor for modernity. In searching for a model for his banjo player, Benton's friend Sammie Feeback apparently sought out Melvin Deaver because he owned a Sears, Roebuck banjo. Few icons could announce the modern era quite like this store-bought instrument. During the pre-Depression era, the arrival of railroads, department stores, Coca-Cola, and an increasingly sophisticated postal system helped transform citizens in the rural South and Appalachia into keenly active participants in a modern corporate economy of industry and exchange. As Mancini shows, such fiscal consciousness found its way into myriad contemporary country music lyrics, providing a refreshingly enlightened view of the inhabitants of these regions that contradicts timeworn stereotypes of poverty-stricken bumpkins. Thanks to Montgomery Ward and Sears, Roebuck stores and mail-order catalogues, inexpensive guitars, banjos, and other stringed instruments played important roles in this commodity culture.[62]

Benton, Boggs, and Beyond

Clearly, Benton was deeply invested in the production of early country music in both its recorded and visual forms. He appears to have had an equally strong impact as a collector and transcriber of folk music, which he made available to many companions. Among those to whom he lent music was the renowned musicologist and folklorist Charles Seeger, his colleague at the New School for Social Research in New York. At the 1931 unveiling of the artist's *America Today* mural at the New School, Seeger was captivated by Benton's harmonica-band performance and borrowed from him some recordings by the legendary banjo players Pete Steele and Dock Boggs (fig. 43).[63]

Though Benton surely could not have predicted it at the time, his loan of the Dock Boggs record to Seeger was crucial in the ongoing effort to preserve "the sad twang of mountain voices." Several scholars have commented that by introducing the musicologist to Boggs and bluegrass, Benton unwittingly inspired Seeger to switch his scholarly specialty from avant-garde modernism to American folk music. The musician and folklorist Mike Seeger, Charles's son, writes, "In 1927, almost by chance, [Boggs] . . . recorded commercially a few songs that attracted . . . attention. Somehow the Missouri artist Tom Benton got a copy of one of those 78 rpm records and played it for some of his fellow artist and musician friends (including my mother and father) at a party in New York scarcely five years later. Hearing Dock's 'Pretty Polly' became a major event in my musicologist parents' 'discovery' of truly American folk music." As founder of the New York Musicological Society and deputy director of the Federal Music Project of Roosevelt's Works Progress Administration (among other posts), Charles Seeger literally changed the

criteria by which modern audiences understand and assess vernacular music. Effectively opening Seeger's eyes and ears, Boggs affected folk music profoundly and in ways that are only now beginning to be fully understood. Boggs's career, art, and image further illuminate the banjo's vernacular symbolism in twentieth-century America.[64]

The western Virginia coal miner and moonshiner to whom Benton introduced Seeger had the voice of a visionary as well as a radically innovative banjo-playing style that he brought to a series of recordings in the late 1920s for Brunswick Records. (Because the instrument was associated with sin and philandering, Boggs's Pentecostal wife implored him to give up the banjo, which he did in 1934. He resumed playing much later, in the 1960s.) Boggs was out of the public eye until 1952, when Harry Smith included his songs "Sugar Baby" and "I Wish I Was a Mole in the Ground" on the *Anthology of American Folk Music*. Coinciding with the folk music revival, the Boggs rediscovery commenced in the 1960s, when Mike Seeger interviewed him and arranged for the sixtysomething musician to play at folk festivals.[65]

In the last quarter-century, as country and rock musicians have increasingly incorporated and popularized traditional bluegrass and folk styles, interest in Boggs has gained momentum. Several articles on the musician appeared in the late 1990s, including two important and widely read but sharply differing interpretations of Boggs as a musical and cultural icon: Greil Marcus's *Invisible Republic: Bob Dylan's Basement Tapes* (1997), and William Hogeland's essay in *The Atlantic*, "Corn Bread When I'm Hungry: Dock Boggs and Rock Criticism" (1998). Critic-journalist Marcus devoted two chapters of *Invisible Republic* to the banjoist, finding in him an archetype of what the author would call, elsewhere in his book, "the old, weird America." According to Marcus, in renditions like "Country Blues," Boggs's banjo is unpredictable, caught in a frenetic race with the lyrics, replete with ghostly presence and the mystery of old age:

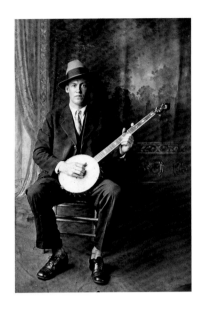

fig. 43
Dock Boggs, c. 1927, photograph. Collection of Mike Seeger. Courtesy Dock Boggs and Mike Seeger.

> The banjo . . . carr[ies] the storyteller not forward, but elsewhere. Small notes, blues notes weighted down with a kind of nihilistic autonomy . . . barely rise to meet descending vocal phrases, and they don't make it all the way up—rising, at first, as if to support what's being said, then dropping away as if the music, so much older than the words, has heard it all before. Here the banjo can seem to take over the song, racing across the heroic peaks and valleys its quickening pace has revealed, until a ragged word appears to meet it and turns its course. But always, the sound the banjo makes pulls away from the singer, discrediting him as a fact, his performance as an event: the sound is spectral, and for seconds at a time a specter is what it turns the singer into.

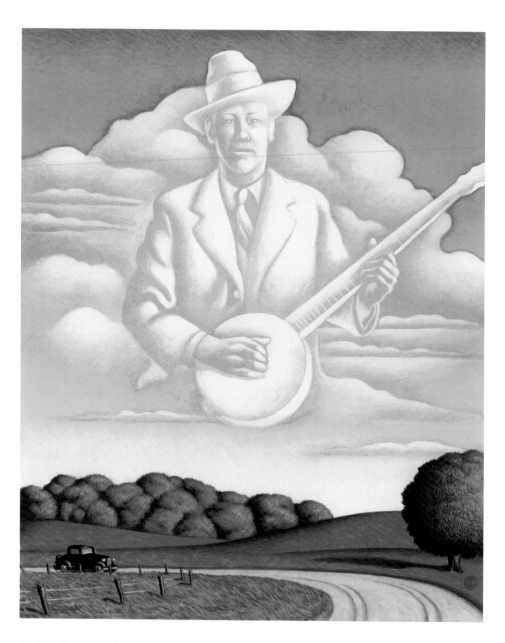

fig. 44
Steve Carver, *Corn Bread When I'm Hungry,*
1998, acrylics and alkyd oils on canvas, 17 × 14
inches. Courtesy the artist. © 1998 Steve
Carver.

Only a few months after the appearance of *Invisible Republic,* the cultural studies journal *Representations* published a slightly revised version of Marcus's comments on Boggs.[66]

Appearing in *The Atlantic* about a year after Marcus's essay, Hogeland's "Corn Bread When I'm Hungry" offered an alternative analysis of Boggs and his legacy. Hogeland directed his aim at the earlier essay, contending that "Marcus is so busy being spooked by Boggs' life that he fails to see clearly the musical background to Boggs' work," suggesting that the journalist interpreted the banjoist's contributions through a misleading and pigeonholing critical filter of "oddity." In place of

what he sees as Marcus's psychological determinism, Hogeland emphasized that Boggs's amplified chants arose from the need to shout in order to be heard in coal mines and mills, and that his nasal, at times atonal, sounds were consistent with a "modal" tradition extending to minstrelsy and African folk music. Yet here lay a significant difference between the two interpretations. Where Marcus emphasizes Boggs's early, seminal encounters with black blues as *the* source for his banjo style, Hogeland suggests that any African or African American strain we may perceive in Boggs is itself a hybrid, tempered by an equally apparent debt to the Scots-Irish and other European roots one finds in much Appalachian music.[67]

The Marcus-Hogeland debate (if it can be called that) was more than a disagreement over the extent to which Boggs's music engaged African themes and styles. At stake was less the music than the image of Dock Boggs, and, within that image, the symbolism of the banjo. Boggs's music, career, and likeness pose several questions. Is the banjo simple or surreal? Is it folk or fantastic? On the occasion of Hogeland's article, *The Atlantic* commissioned from artist-illustrator Steven Carver a fanciful image of Boggs, essentially the negative of a well-known image of the musician from the late 1920s (fig. 44). His white presence repeating the formal characteristics of the clouds from which he emerges, Boggs towers over a gently rolling landscape—one thinks of his native southwestern Virginia—inhabited by stylized trees and, in the middle distance, a Depression-era sedan on a one-lane dirt road. Hogeland's accompanying article stressed the banjoist's playful, cathartic, even "fun" nature. And in Carver's image, Boggs plays the part of Gulliveresque guardian over rural premodernity.

Surprisingly, however, Carver's benevolent banjoist, suspended above the countryside, also matches Marcus's description of the musician as a ghoulish, inescapable presence. (In one passage Marcus comments that "Boggs sang like a seer, standing outside of himself as the prophet of his own life, the angel of his own extinction.") In this respect, it is ironic that Hogeland's efforts to normalize Boggs, to bring him down to earth, would open with a surreal depiction of him floating above it. With the performer hovering about the landscape and yet naturalized by way of his realistic likeness, Carver's image of Boggs exemplifies the Janus-faced nature of banjo imagery that *Picturing the Banjo* reveals.[68]

NOTES

1. Among the most informative of these studies are *The Birth of the Banjo* (Katonah, N.Y.: Katonah Museum of Art, 2003); Cecelia Conway, *African Banjo Echoes in Appalachia: A Study of Folk Traditions* (Knoxville: University of Tennessee Press, 1995); Michael Theodore Coolen, "Senegambian Archetypes for the American Folk Banjo," *Western Folklore* 43 (April 1984): 117–32; Dena J. Epstein, "The Folk Banjo: A Documentary History," *Ethnomusicology* 19 (September 1975): 347–71; Philip F. Gura and James F. Bollman, *America's Instrument: The Banjo in the Nineteenth Century* (Chapel Hill: University of North Carolina Press, 1999); Karen S. Linn, *That Half-Barbaric Twang: The Banjo in American Popular Culture* (Urbana: University of Illinois Press, 1991); and Robert Lloyd Webb, ed., *Ring the Banjar! The Banjo in America from Folklore to Factory* (Cambridge, Mass.: MIT Museum, 1984). For a thoughtful art-historical exploration of the icon, see John Davis, "Eastman Johnson's *Negro Life at the South* and Urban Slavery in Washington, D.C.," *Art Bulletin* 80 (March 1998): 67–92.

2. See Epstein, "The Folk Banjo," and Gura and Bollman, *America's Instrument*, 11–73.

3. Gura and Bollman, *America's Instrument*, 19–25.

4. Robert Cantwell, *Bluegrass Breakdown: The Making of the Old Southern Sound* (Urbana: University of Illinois Press, 1984), 218–21. See also Rita Steblin, "The Gender Stereotyping of Musical Instruments in the Western Tradition," *Canadian University Music Review* 16, no. 1 (1995): 128–44.

5. I am grateful to Jim Bollman for helping me clarify my thoughts on the visual (vs. aural) introduction many persons apparently had to the instrument; Bollman, telephone interview with author, 23 September 2004. The very shape of the banjo may also account, in part, for its popularity in the visual arts and design (e.g., the banjo clock). Merging rudimentary, familiar forms—a line and a circle, a narrow rod and a cylinder about half the length of the rod—the banjo's design is reassuringly basic. The contrast of the banjo's white head with the typically darker fingerboard also adds to the aesthetic charge.

6. Peter Szego, interview with author, 27 September 2004, Hillsborough, N.J.

7. August P. Trovaioli and Roulhac B. Toledano, *William Aiken Walker: Southern Genre Painter* (Baton Rouge: Louisiana State University Press, 1972), 61.

8. See Paul J. Foley, *Willard's Patent Time Pieces: A History of the Weight-Driven Banjo Clock, 1800–1900* (Norwell, Mass.: Roxbury Village, 2002).

9. Charters's work is recorded on the Smithsonian's Inventory of American Sculpture (IAS), control no. KS000198. IAS is accessible online at www.siris.si.edu. The sculpture is located on the 100 block of North McLean Boulevard in Wichita. Other regions have also employed banjo motifs and insignia to help shoppers, tourists, and other popular audiences define a given locale. A well-known mass-marketed poster by Lexington, Kentucky artist Doug Prather, for example, enlists the banjo—along with a corncob pipe, a spray of tobacco leaves, and a University of Kentucky basketball jersey, among other icons—in its offset lithographic reification of the Bluegrass State. Other states, even markedly non-bluegrass ones, have been identified via the banjo emblem (including Texas, allegorically represented within a frame of banjo memorabilia). One can purchase the product at Pickett's Fine Art and Frame Shop, Seguin, Texas.

10. Timothy Corrigan Correll and Patrick Arthur Polk, *Muffler Men* (Jackson: University Press of Mississippi, 2000), 20. Clements's work is recorded on IAS, control no. CA001913.

11. For an illuminating comparison of these two formative conceptualizations of culture, see Marc Manganaro, *Culture, 1922: The Emergence of a Concept* (Princeton, N.J.: Princeton University Press, 2002), 2–6.

12. See Bruce Bastin, *Red River Blues: The Blues Tradition in the Southeast* (Urbana: University of Illinois Press, 1986); J. M. Mancini, "'Messin' with the Furniture Man': Early Country Music, Regional Culture, and the Search for an Anthological Modernism," *American Literary History* 16 (Summer 2004): 208–37; and David E. Whisnant, *All That Is Native & Fine: The Politics of Culture in an American Region* (Chapel Hill: University of North Carolina Press, 1983).

13. Bollman, interview. Late-nineteenth-century American banjos were frequently marketed to men and women by way of yellow and pink straps, respectively.

14. See Bill Hardwig, "Cocks, Balls, Bats, and Banjos: Masculinity and Competition in the Bluegrass Music of Bill Monroe," *Southern Quarterly* 39 (Summer 2001): 39, 40, 46; Barry O'Connell, "Dock Boggs, Musician and Coal Miner," *Appalachian Journal* 11 (Autumn–Winter 1983–84): 44–57; Richard A. Peterson, *Creating Country Music: Fabricating Authenticity* (Chicago: University of Chicago Press, 1997), 12–32.

15. Robert Cantwell has observed that "as banjo music loiters on the edges of western musical categories, so it has tended to linger where sexual, social, and political boundaries are most ambiguous." See Cantwell, *When We Were Good: The Folk Revival* (Cambridge, Mass.: Harvard University Press, 1996), 246–47.

16. Conway's *African Banjo Echoes* is a most persuasive documentation of the continuity of eighteenth-century African folk traditions through present-day banjo cultures.

17. On Hans Sloane's *Voyage,* I have relied on Kay Dian Kriz, "Curiosities, Commodities, and Transplanted Bodies in Hans Sloane's *Natural History of Jamaica," William and Mary Quarterly* 57 (January 2000): 35–78. See also Richard Cullen Rath, "African Music in Seventeenth-Century Jamaica: Cultural Transit and Transition," *William and Mary Quarterly* 50 (October 1993): 700–726.

18. Kriz, "Curiosities, Commodities," 37–46. The instrument marked 1 in Sloane's engraving is not African—it is an Indian *tanpura*—and is illustrated only for purposes of comparison. See also Rath, "African Music," 704. Sloane (xlviii–xlix) is quoted on 712 of Rath's article.

19. Rath, "African Music," 711. The widely read text was re-released in a second edition in 1814 and translated into Dutch, Italian, French, and several other languages. See Hugh Honour, *The Image of the Black in Western Art, IV: From the American Revolution to World War I* (Houston: The Menil Foundation, 1989), 86. See also Robert N. Essick, *William Blake: Printmaker* (Princeton, N.J.: Princeton University Press, 1980), 52, and Richard Price and Sally Price, introduction to *Stedman's Surinam: Life in an Eighteenth-Century Slave Society,* ed. Richard Price and Sally Price (Baltimore: The Johns Hopkins University Press, 1992), xxii, xxiv, xix–xx.

20. Price and Price, eds., *Stedman's Surinam,* xxxv, xxxix. For an inventory of the banjo-like instruments Stedman encountered—as well as reproductions of some of the surviving string and wind instruments, including the *banja,* now at the Rijksmuseum—see Price and Price, "John Gabriel Stedman's Collection of Eighteenth-Century Artifacts from Suriname," *Nieuwe West-Indische Gids* 53 (1979): 121–40.

21. Weighing economic issues against humanitarian concerns, Blake and Stedman were at best mitigated abolitionists (they opposed the British slave trade, but not slavery itself, and indeed may be seen as apologists for the practice). On the problematic dynamics of slavery in Blake, see David V. Erdman, "Blake's Vision of Slavery," *Journal of the Warburg and Courtauld Institutes* 15 (July 1952): 242–52; David Bindman, "Blake's Vision of Slavery Revisited," *The Huntington Library Quarterly* 58, no. 3–4 (1995): 373–82; and Anne K. Mellor, "Sex, Violence, and Slavery: Blake and Wollstonecraft," *The Huntington Library Quarterly* 58, no. 3–4 (1995): 345–70. Note, too, that several of the African women in Blake's seventeen etchings for Stedman maintain European body types; see Mellor's "Sex, Violence, and Slavery," 358.

22. For Jennings's painting, see Robert C. Smith, "*Liberty Displaying the Arts and Sciences:* A Philadelphia Allegory by Samuel Jennings," *Winterthur Portfolio* 2 (1965): 84–105, as well as Smith's "A Philadelphia Allegory," *Art Bulletin* 31 (December 1949): 323–26.

23. *Minutes of the Proceedings of the Library Company of Philadelphia,* 3:206–7, cited in R. Smith, "Philadelphia Allegory," 324. R. Smith, "*Liberty Displaying the Arts and Sciences,*" 90. The "backgrounding" of the instrument is in keeping with a thinning-out of native folkways and identifiably African influences that historians have discerned among the many freed slaves inhabiting late-eighteenth- and early-nineteenth-century Philadelphia. See Gary B. Nash, *Forging Freedom: The Formation of Philadelphia's Black Community, 1720–1840* (Cambridge, Mass.: Harvard University Press, 1988), and Julie Winch, *Philadelphia's Black Elite: Activism, Accommodation, and the Struggle for Autonomy, 1787–1848* (Philadelphia: Temple University Press, 1988).

24. *New Grove Dictionary of Music,* 2nd ed., s.v. "lyre." The African origins of the lyre complicate this interpretation and are beyond the scope of the present chapter. Notably, though, the ancient version of the instrument—which is played by modern Nilotic, Cushitic, Semitic, Nubian, and Bantu peoples—lacks the bridge, strings, and playing style of the classical lyre we see in Jennings's painting. It is an altogether different instrument, not sharing with the modern lyre the sorts of similarities we find between the modern banjo and its earlier antecedents. On the smaller version of the Jennings painting, with the British shield, see R. Smith, "*Liberty Displaying the Arts and Sciences,*" 93.

25. J. Kenneth Moore, "The African Roots of the Banjo," in *The Birth of the Banjo,* 18; Conway, *African Banjo Echoes,* 64–65.

26. Although Johnson's painting has taken various titles since its production—including *Life in the South, Negro Life at the South,* and *Old Kentucky Home: Negro Life at the South*—for the sake of clarity and

consistency it is here designated *Negro Life at the South,* in keeping with usage in modern scholarship. On the alternative title of *Old Kentucky Home,* see Davis, "Eastman Johnson's *Negro Life at the South,*" 70.

27. I am grateful to Jennifer Watts, curator of photographs at the Henry E. Huntington Library, San Marino, California, for her assistance in clarifying the Apperson-Hearst relationship; Watts, correspondence with author, 23 August 2004.

28. Frances Benjamin Johnston, "Some Homes Under the Administration: The Residence of Senator Hearst of California," *Demorest's Family Magazine* 26 (October 1890): 712–20. Elizabeth Edwards Harris, "Phoebe Apperson Hearst and the Changing Nature of 19th-Century Architectural Patronage" (Ph.D. diss., University of California, Los Angeles, 2002); Alexandra Nickliss, "Phoebe Apperson Hearst's 'Gospel of Wealth,' 1883–1901," *Pacific Historical Review* 71, no. 4 (2002): 575–605.

29. See Bettina Berch, *The Woman Behind the Lens: The Life and Work of Frances Benjamin Johnston, 1864–1952* (Charlottesville: University Press of Virginia, 2000), and Jennifer A. Watts, "Frances Benjamin Johnston: The Huntington Library Portrait Collection," *History of Photography* 19 (Autumn 1995): 252–62 (quotation on 252).

30. Watts, "Frances Benjamin Johnston," 258–59. Berch, *Woman Behind the Lens,* 32–36; Julie K. Brown, "Recovering Representations: U.S. Government Photographs at the World's Columbian Exposition, Chicago 1893," *Prologue* 29, no. 3 (1997): 218–31; Brandon Brame Fortune and Michelle Mead, "The Fine Art of Detection: An Introduction to the Catalogue of American Paintings and Sculptures Exhibited at the World's Columbian Exposition," in *Revisiting the White City: American Art at the 1893 World's Fair* (Washington, D.C.: National Museum

of American Art and National Portrait Gallery, Smithsonian Institution, 1993), 194–95, 302. Hearst may have lent not only Orrin Peck's painting *Love's Token* but also his portrait of her to the 1893 exhibition; see Fortune and Mead, "Fine Art of Detection," 197. Sally Webster, *Eve's Daughter*/Modern Woman: *A Mural by Mary Cassatt* (Urbana: University of Illinois Press, 2004), 67, 91–98.

31. In April 1851 the writer for the *Bulletin of the American Art-Union* instructed that the figure "is to be placed in a greenhouse; the lower part of the pedestal covered with moss, on which the drapery seems lightly resting." See also "American Sculpture," *New York Times,* 29 July 1852, sec. 1, p. 3. Both are cited in Lauretta Dimmick, "A Catalogue of the Portrait Busts and Ideal Works of Thomas Crawford (1813?–1857), American Sculptor in Rome" (Ph.D. diss., University of Pittsburgh, 1986), 449. See also Lorado Taft, *A Week at the Fair Illustrating the Exhibits and Wonders of the World's Columbian Exposition* (Chicago: Rand, McNally, 1893), 158, cited in Sylvia E. Crane, *White Silence: Greenough, Powers, and Crawford: American Sculptors in Nineteenth-Century Italy* (Coral Gables, Fla.: University of Miami Press, 1972), 353.

32. See Fortune and Mead, "Catalogue of American Paintings and Sculptures Exhibited at the World's Columbian Exposition," revised and updated, in *Revisiting the White City,* 250–51.

33. On Vaughn, see "The Everlasting Farce," *New York Times,* 17 January 1888, 5; "Theatrical Gossip," *New York Times,* 28 March 1892, 8; and "The Musical World," *Peterson's Magazine* 6 (November 1896): 8.

34. Advertisement for the A. C. Fairbanks Co., c. 1897, reproduced in Gura and Bollman, *America's Instrument,* 216; see 210–20 on Fairbanks's supremacy among late-nineteenth-century banjo manufacturers. As elegant as Vaughn's banjo is, even

more decorous is the Fairbanks No. 6, which would have cost about $70, in contrast to the present piece—a No. 2 banjo, priced at $30 (Bollman, interview). Bollman also points out that the banjo was not actually "electric." It was marketed with the fancy name in much the same way as dishwashers might have been dubbed "atomic" in the 1950s and 1960s as a sign of their power and effectiveness.

35. At left in the photograph is Ray "Montana" Coleman, a renowned banjo player on the Keith vaudeville circuit. One banjo historian notes that "the actresses are probably members of Madeline Berlo's Diving Beauties"; the only identified female figure is Grace Carlos, at lower left. Montana Coleman sponsored several such promotional contests—in which winners won a "fifty-dollar" Bacon banjo—that eventually became national in scope. See Webb, *Ring the Banjar,* 25.

36. With its salacious subject matter, the *Happy Banjos* record cover matches several c. 1950s–1960s banjo-less album illustrations depicting nude and provocatively posed female models. Musical acts resorting to this marketing included George Cates, the Johnnie Mann Singers, Dick Marris, and Mike Pacheco. The brainchild of British record producer (and hit-maker) Norrie Paramor, the Big Ben Banjo Band is discussed in Colin Larkin, ed., *The Encyclopedia of Popular Music,* 3rd ed. (New York: Muze UK, 1998), 5:4125–26. Numerous early- and mid-twentieth-century banjo owners depicted or reproduced sexually suggestive subject matter—scantily clad women, couples rolling in the hay—*on their* instruments. See, for example, the hand-limned c. 1920s instrument, manufactured by the National Banjo Company, illustrated at www.notecannons.com/banjo%2013.jpg.

37. Richard D. Leppert, *The Sight of Sound: Music, Representation, and the History of the Body* (Berkeley and Los Angeles:

University of California Press, 1993). See also Nancy van Deusen, "Recensiones," *Imago Musicae* 9–12 (1992–95): 290.

38. Hardwig, "Cocks, Balls, Bats," 46. Jesse Stuart, *Taps for Private Tussie*, illus. Thomas Benton (New York: E. P. Dutton, 1943), 206, 203. On Benton as an illustrator, see Vincent A. Keesee, "Regionalism: The Book Illustrations of Benton, Curry, and Wood" (Ph.D. diss., University of Georgia, 1972), especially 47–48, 101–6. *Taps* is indeed a satire, as Keesee and Henry Adams suggest, but I do not believe that it is "a humorous account of hillbilly life" (as Adams puts it). It is in fact a tale of family betrayal, incest, mistaken identity, and wretched poverty. See Adams, *Thomas Hart Benton: Drawing from Life* (New York: Abbeville Press, 1990), 165, and Keesee, "Regionalism," 101–3. On *Taps* as a bestseller, see Ben Crace, "'Livin' It Up While the Relief Lasts,'" *Kentucky English Bulletin* 51, no. 2–3 (2002): 24. The book won the 1943 Thomas Jefferson Southern Award; see Diana Trilling, untitled notice/review, *The Nation* 158 (22 January 1944): 105.

39. "The Tussies of Kentucky," *The New York Times Book Review*, 28 November 1943, front cover. Stuart, *Taps for Private Tussie*, 284.

40. Hardwig, "Cocks, Balls, Bats," 46. *Oxford English Dictionary*, 2nd ed., s.v. "inveigle." Kimberly Pinder, "'Racial Idiom' in the Works of Dox Thrash," in John W. Ittmann, *Dox Thrash: An African American Master Printmaker Rediscovered* (Philadelphia: Philadelphia Museum of Art, 2001), 70.

41. Willis Richardson, *The Broken Banjo*, in *Plays of Negro Life: A Source Book of Native American Drama*, ed. Alain Locke (1927; Westport, Conn.: Negro University Press, 1970), 312–13, 317, 318. Something of the inverse transpires in the 1940 film *Broken Strings* (Goldport Pictures, dir. Bernard B. Ray)—whose producers boasted of a "100 per cent all star colored cast"—in which the protagonist Arthur Williams's fingers are paralyzed in an accident, leaving him unable to play his violin. Its broken strings grant the movie's publicity poster a particularly pathetic aura. See also the banjo with broken strings in Peter Newell's illustration *Resourceful* in *Harper's Magazine* 121 (August 1910): 484.

42. Clare Rojas, correspondence with author, 28 July 2004. On Rojas, see *The Louis Comfort Tiffany Foundation: 2003 Awards in Painting, Sculpture, Printmaking, Photography, Video, and Craft Media* (New York: The Louis Comfort Tiffany Foundation, 2003), 54–55. The innovative work of the artist Margaret Kilgallen offers similar meditations on banjo iconography and, in particular, its discursive potential. See *Margaret Kilgallen: To Friend and Foe* (New York: Deitch Projects, 1999); *Margaret Kilgallen*, exhibition brochure (Los Angeles: UCLA Hammer Gallery, 2000); and Maria Porges, "Margaret Kilgallen," *Artforum* 35 (May 1997): 113–14.

43. Peggy Honeywell, "Worried Man," *Faint Humms: Pre-Dared Songs*, Galaxia (2004).

44. Daniel K. Tennant, "A Marine's Life," unpublished artist's statement, 2004.

45. Hans-Ulrich Obrist, "Good Humor Man," *Artforum* 42 (November 2004): 202–3. David Robbins, *The Ice Cream Social* (New York: Purple Books/Feature, 1998).

46. Robbins, *The Ice Cream Social*, 31, 38–39, 57–58. David Robbins, telephone interview with author, 9 November 2004.

47. Mary Hufford, telephone interview with author, 5 November 2004. See also Mary Hufford, ed., *Conserving Culture: A New Discourse on Heritage* (Urbana: University of Illinois Press, 1994), and her "American Ginseng and the Idea of the Commons," *Folklife Center News* 19 (Winter–Spring 1997): 3–18.

48. In a 1934 address to the John Reed Club, Benton commented, "Folk patterns . . . determine the direction and nature of everyday action and thought. . . . The culture of a people and the substance of their nationality are revealed by their actual behavior, by their way of life." Quoted in Archie Green, "Thomas Hart Benton's Folk Musicians," *JEMF Quarterly* 12 (Summer 1976): 75. Alan C. Buechner, "Thomas Hart Benton and American Folk Music," in *Thomas Hart Benton: Chronicler of America's Folk Heritage* (Annandale-on-Hudson, N.Y.: Edith C. Blum Art Institute, Milton and Sally Avery Art Center, Bard College Center, 1984), 74. For a photograph, taken shortly after the artist's death, of the recently finished work in Benton's studio, see Matthew Baigell, *Thomas Hart Benton* (New York: Harry N. Abrams, 1975), 158 (and see also 131).

49. Buechner, "Thomas Hart Benton," 73. See also Marilyn J. Ziffrin, *Carl Ruggles: Composer, Painter, Storyteller* (Urbana: University of Illinois Press, 1994), 141, 143. *Saturday Night at Tom Benton's*, Decca 23247-49.

50. Thomas Hart Benton, *An Artist in America* (New York: R. M. McBride, 1937), 114, as quoted in Vivien Green Fryd, "'The Sad Twang of Mountain Voices': Thomas Hart Benton's *Sources of Country Music*," *The South Atlantic Quarterly* 94 (Winter 1995): 327, and Green, "Thomas Hart Benton's Folk Musicians," 76. Buechner, "Thomas Hart Benton," 71.

51. Mancini, "Messin' with the Furniture Man," especially 222–24. Harry Smith, ed., *Anthology of American Folk Music*, Folkways Records FP 251–FP 253 (1952), re-released as Smithsonian Folkways/Sony Music Special Products SFW 40090 (1997).

52. See Fryd, "Sad Twang," 323, 302.

53. The most comprehensive and enlightening discussion of the mural is Fryd,

"Sad Twang." Also helpful are Green, "Thomas Hart Benton's Folk Musicians," 74–76, and Karal Ann Marling, *Tom Benton and His Drawings: A Biographical Essay and a Collection of His Sketches, Studies, and Mural Cartoons* (Columbia: University of Missouri Press, 1985), 1–12. On Benton mulling over the banjo figure, and his understandings of banjos and blues, see Marling, *Tom Benton*, 8, and Fryd, "Sad Twang," 306.

54. Fryd, "Sad Twang," 308.

55. Marling, *Tom Benton*, 5–7; Buechner, "Thomas Hart Benton," 71.

56. "[Red] sat with his banjo among a lot of other players, fiddlers, guitarists, and harmonica blowers. He was moved by the seriousness of the occasion and I could see his lips saying, 'Amen, amen'"; Benton, *An Artist in America* 3d rev. ed. (Columbia: University of Missouri Press, 1968), 103, 105–6. The illustration of *Red* is facing 117. See also Adams, *Thomas Hart Benton*, 123. A similar aura of musical engrossment pervades the drawing *"Pop" and the Boys* (1939; private collection), upon which he would base the 1963 oil painting with the same title. Dating from one of Benton's many sketching excursions through the Ozarks, the piece depicts a country music group led by Pop, the banjo player. Benton met the musicians at a cattle auction in Independence, Missouri. Believing that the "simplicity" heard in "churches hidden away in the depths of our mountains . . . is as genuinely music as any that may be heard in the churches of the great cities," Benton enlisted the banjo as an emblem of a cultural authenticity that, increasingly, one could find only by scouring the byways of rural America. See Adams, *Thomas Hart Benton*, 177, 179; Marling, *Tom Benton*, 10. Benton is quoted in Buechner, "Thomas Hart Benton," 75, 77. The drawing *"Pop" and the Boys* is reproduced in Adams, *Thomas Hart Benton*, 177.

57. Fryd, "Sad Twang," 307.

58. Ibid., 313, 315; Jim Cooper, "Tex Ritter in the Twilight Years," *JEMF Quarterly* 8 (Summer 1977): 79, cited in Fryd, "Sad Twang," 309. Fryd points out that Cooper was the president of the Tex Ritter Fan Club at the time he penned this article. See the photographs of the early country bands reproduced in Peterson, *Creating Country Music*, 21, 76, 77, 162. One finds some exceptions to this rule, including, of course, those instances when the lead performer (as in the case of Grandpa Jones) is a banjoist; see images G2.3, G2.4, and G4.1 in Peterson's *Creating Country Music*.

59. Bill Ivey, "The Making of the Sources of Country Music" (Nashville: Country Music Foundation, 1975). In this brochure, Ivey cites a letter in which Benton singled out, among his "sources," a "negro with banjo, maybe on the river below Memphis." I am grateful to Vivien Green Fryd for providing me with a copy of Ivey's brochure. *Reminiscences of an American Musicologist: Charles Seeger, Interviewed by Adelaide G. Tusler and Ann M. Briegleb* (Los Angeles: Oral History Program, University of California, Los Angeles, 1972), 469–70. See also Marling, *Tom Benton*, 8, and Fryd, "Sad Twang," 306. Fryd compared the banjoist of the final study and mural with images of, among others, the musician Huddie Ledbetter (a.k.a. Leadbelly). She notes that from Benton's early drawings to his later musings, the African American musician is transformed from an emblem of indolence and poverty to one of industry and employment. Ultimately, however, the banjoist occupies a compositionally and thematically constrained position. Fryd notes further that the banjoist's sobriety is especially pronounced in comparison with the dancing African Americans in the background, whose proximity to the steamboat only reinforces their archaic nature and obsolescence in a modern era; see "Sad Twang," 316–17, 322.

60. Benton, *Artist in America* (1937), 70–71; cited in Fryd, "Sad Twang," 322.

61. Mancini, "Messin' with the Furniture Man," 226. Early A&R—act and repertory—scouts had been attracted to the likes of Jimmie Rodgers and the Carter family because of their supposed ability to revise the sounds of folk authenticity in a manner that would be meaningful to contemporary audiences; see Peterson, *Creating Country Music*, 34, 41–46.

62. Marling, *Tom Benton*, 6–7, 9. I am paraphrasing Mancini's profound insights on the intersection of rural modernity and commodity culture in early country western music (see "Messin' with the Furniture Man," 215). On the subject of cheap guitars and other instruments' availability from Sears, Mancini cites the groundbreaking work of Bruce Bastin in *Red River Blues*, 14–18. See also Whisnant, *All That Is Native and Fine*, 97.

63. *Reminiscences of an American Musicologist*, 470. It would be difficult to overemphasize Benton's contributions to American music—he even devised a tablature notation system for harmonica tutorials. See Buechner, "Thomas Hart Benton," 71. Benton's *America Today* mural was painted in 1930 and is now part of the AXA Financial collection.

64. Mike Seeger, in Mike Seeger, Jon Pankake, Kinney Rorrer, and Willis Poyser, "Dock Boggs: Memories and Appreciations," *The Old-Time Herald* 6 (Winter 1998–99): 19. On the Benton–Charles Seeger relationship, see Robert Cantwell, *When We Were Good*, 95; Green, "Thomas Hart Benton's Folk Musicians," 85; Buechner, "Thomas Hart Benton," 73; David King Dunaway, "Unsung Songs of Protest: The Composers Collective of New York," *New York Folklore* 5 (Summer 1979): 6; and especially *Reminiscences of an American Musicologist*, 204–6, 222, 259–60, 469–70.

65. Greil Marcus, *Invisible Republic: Bob Dylan's Basement Tapes* (New York: Henry

Holt, 1997), 127–87. On the time-honored outsider's perspective on backcountry music as sin and vice, see Hardwig, "Cocks, Balls, Bats," 40.

66. See Marcus, *Invisible Republic,* 173–74, and his "Dock Boggs in Thomas Jefferson's Virginia," *Representations* 58 (Spring 1997): 1–23. Among the more substantial additions to the version of the Boggs essay in *Representations* are two references to Thomas Hart Benton. Aside from the Hogeland essay in *The Atlantic,* discussed below, other pieces on Boggs from the late 1990s include Seeger et al., "Dock Boggs," 19–24, 51, and Jack

Wright, "Only Remembered for What He Has Done—'Dock' Boggs," *The Old-Time Herald* 6 (Winter 1998–99): 24–28, 56.

67. William Hogeland, "Corn Bread When I'm Hungry: Dock Boggs and Rock Criticism," *The Atlantic* 282 (November 1998): 116-21. Repeating the terms of the Marcus-Hogeland debate, a writer in *The Old-Time Herald* (Winter 1998–1999) found Marcus's version of Boggs a mere "fiction," while an article in the *Herald*'s previous number upheld the critic's contention, arguing that the banjoist created "a music from some other place in time." Jon Pankake, in Seeger

et al., "Dock Boggs," 23; Wright, "Only Remembered for What He Has Done," 25.

68. Marcus, "Dock Boggs in Thomas Jefferson's Virginia," 3. We might reach a similar odd-yet-ordinary conclusion in assessing photographs of other early and mid-twentieth-century banjoists who camouflage the "old, weird America" with sympathetic expressions and reassuringly familiar gestures. See, for instance, John Cohen's photograph on the cover of the recording *Roscoe Holcomb,* 1964, Smithsonian Folkways Research Center.

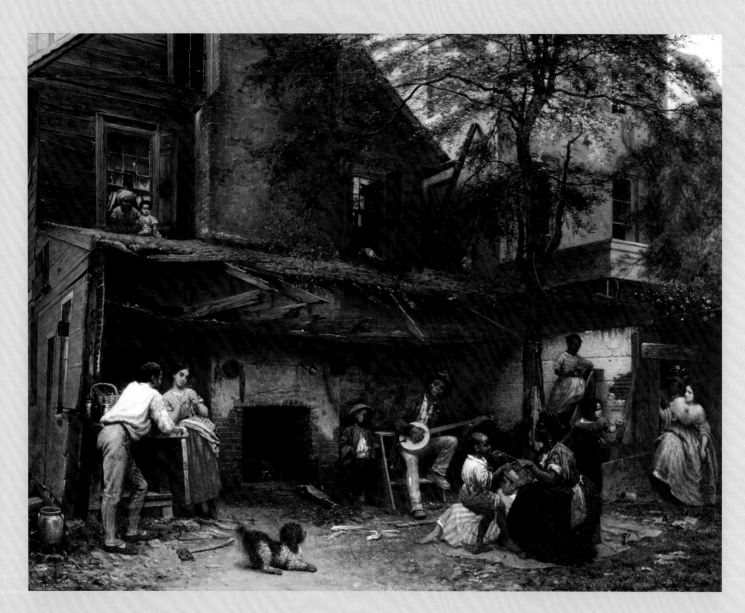

fig. 45
Eastman Johnson, *Old Kentucky Home—Life in the South* [or *Negro Life at the South*], 1859, oil on canvas, 36 × 45¼ inches. Collection of The New-York Historical Society, New York. On permanent loan from The New York Public Library, Stuart Collection, no. S-225.

JOHN DAVIS

2

A Change of Key: The Banjo During the Civil War and Reconstruction

THE STUDY OF nineteenth-century banjo iconography can sometimes be an exercise in frustration. The deeper one digs into period sources, the more the examples proliferate until the banjo's very ubiquity threatens to rob it of any specific meaning. We find the banjo and its related minstrel antics not only on the banks of the Mississippi, or at some dimly remembered "Old Kentucky Home," but also at the far-flung extremes of American cultural frontiers. Thus Willa Cather's hero, Father Latour, encounters "the Negro melodies of Stephen Foster" in 1850s Santa Fe in the novel *Death Comes for the Archbishop*. Listening one evening alongside a group of Mexican *rancheros*, Cather's bishop associates the sound of the "savage" banjo with "a kind of madness, the recklessness, the call of wild countries." Yet similar

entertainments penetrated the very heart of civilization, as at the annual dinner for students of Jean-Léon Gérôme's Parisian atelier at the École des Beaux-Arts, where a contemporary source reported that "a man from Providence, Rhode Island, has been known to sing a Negro song and dance a breakdown before the master's awful eye."[1]

Despite the disparity of these settings, the visual archive of the banjo has a tendency to replicate and feed on itself. Certain locations, attitudes, and characters repeatedly emerge in popular prints, photographs, and easel paintings. Reading the language of the banjo requires that viewers move beyond what is often the sameness of the type and discriminate finely between slight nuances of tone and intent. Often this involves considering the implied audience of a given image, for despite the performative directness and implicit aurality of scenes of banjo players and listeners, much that is significant within them—issues of race, community, and politics—ends up quietly coded for a limited circle of viewers.

Time is also an important factor. What the banjo implies in a late-eighteenth-century plantation scene must necessarily differ from a similar rendition executed after the eradication of slavery, as any diachronic survey of the material makes clear. No decade saw more change at the national level than that encompassing the Civil War and the early years of Reconstruction, so it is logical to ask how images and understandings of the banjo evolved (or failed to evolve) during these tempestuous years. Historians are still grappling with this period, trying to comprehend how our nation could have found itself in such a compromised situation. How could the injustices of slavery have been tolerated for as long as they were? And why, once the Civil War had ended, was it still so difficult for whites to move beyond the racist assumptions and stereotypes that had blighted public and private discourse for so many years?[2]

A critical image of the time was Eastman Johnson's *Negro Life at the South* (1859, fig. 45), the painting that launched the artist's career when it was first exhibited in New York in 1859, two years before war broke out. *Negro Life at the South* catalyzed a public debate about the morality of slavery at an explosive moment in American history, and in recent years scholars have explored the mixed ideological reception of the painting, the specifics of its setting in politically torn Washington, D.C., and its connections to abolitionist literature.[3] But perhaps the most obvious context in which to examine images like Johnson's racially charged painting is the world of American popular music. Looking at vernacular musical expression of the period means considering African American musical practices, to be sure, but it also means confronting the phenomenon of minstrel songs by white men, songs that falsely claimed to be based on an "authentic" culture—or what was presented as an authentic culture—created by blacks under slavery.[4]

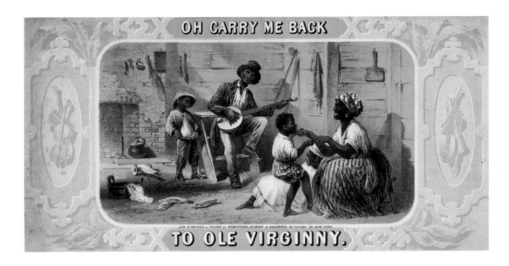

fig. 46
Oh Carry Me Back to Ole Virginny, 1859, color
lithograph, 13¹¹⁄₁₆ × 17¼ inches. Published by
Robertson, Seibert and Shearman, New York.
Library of Congress, Prints and Photographs
Division, Washington, D.C., LC-USZC4-2356.

Johnson's painting certainly engages popular musical culture through its sub-
ject matter, with the central banjo player inspiring a young child to try out a few
dance steps. It also evoked the world of sound, however, through the alternate
title—*Old Kentucky Home*—that almost immediately attached itself to the work.
This association invited comparison with the imagery of Foster's well-known song
"My Old Kentucky Home, Good Night," a sad tune with overtones of impending
death and nostalgia for the "uncomplicated" past, when slaves supposedly lived
untroubled lives on an idyllic plantation.[5] Specific vignettes, such as the man
courting the light-skinned woman at left, could be associated with another fre-
quent theme of minstrelsy: the male slave's love of a "yaller," or mulatto, girl and
the often tragic consequences of their attachment, which often resulted in separa-
tion or death. This scenario is described in such songs as "Mary Blane," "Lucy
Neale," "Will No Yaller Gal Marry Me?" and "The Yellow Rose of Texas." In music
and in art, the light-skinned female slave was an object of particular sentimental
interest for white audiences, who found her plight at the edge of the color line
unusually sympathetic. The narratives of these minstrel songs likely found their
way into Johnson's conception.

"Plantation tunes" are notoriously inconstant in their geographic allusions and
frequent changes of lyric. This open-ended adaptability made it easy to swap
images promiscuously to illustrate different song titles. In 1859, at the same
moment that Johnson's image became associated with Foster's "My Old Kentucky
Home," a chromolithograph of the central part of *Negro Life at the South* appeared
as a tobacco packing label with a caption taken from the title of a different minstrel
song (fig. 46).[6] This time, the selection is Charles White's "Carry Me Back to Old
Virginny"—originally published in the late 1840s as "The Floating Scow of Old
Virginia." Again, the song is supposedly sung by a slave longing for happier days

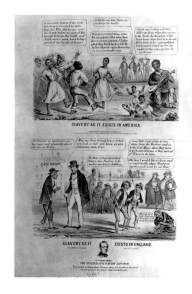

fig. 47
Slavery as It Exists in America/Slavery as It Exists in England, 1850, lithograph. Published by J. Haven, Boston. Library of Congress, Prints and Photographs Division, Washington, D.C., LC-USZ62-1285.

on the plantation. It ends with the line, "Oh, when I'm dead and gone to rest, / Lay the old banjo by my side."[7]

Some interesting things happen in this translation of the composition to the "Ole Virginny" tobacco label. The matriarch of the family adopts a wide minstrel grin and becomes clothed in the riant stripes and headscarf long associated with the mammy figure. Johnson's empty corn husks on the ground become actual ears of corn in the lithograph, their plumpness suggesting a condition of plenty. The original decrepit outdoor setting in the painting is transformed into a cozy interior space, with a working fireplace and andirons where Johnson had earlier painted a black hole. All of these changes conspire to leave an impression of comfort and gaiety, a happy condition made possible through the offices of the absent master. And this leads to the most significant change: the uneasy confrontation and visual exchange between the entering white woman and the black child, at the right in Johnson's painting, has been edited out in the print, as have the mulatto woman and her suitor at left. The minstrelized vignette is thus stripped of any potential friction and internal strife. The central group has now become an intact "nuclear" family, with two adults and three children—a more palatable presentation without Johnson's ambiguity of tone.

But the issues that arise here move beyond this single painting. The iconographic argot of minstrelsy clouded meanings and shifted interpretations of a number of similar works with racialized, musical thematics. Specifically, there is a traceable "visual genealogy" of Johnson's tableau that both predates *Negro Life at the South* and continues in the decade of the 1860s. This scene of the "banjo circle"— with a player, dancers, and listeners of both sexes and all ages—was employed to support an astonishing variety of political messages throughout the nineteenth century. In Johnson's case, the popular press began to transform the decaying urban structure surrounding his banjo player into the plantation "quarters" of this band of slaves, and their communal socializing and music making became evidence of untroubled lives lived under the protection of enlightened masters.

Such imagery was frequently harnessed directly to pro-South propaganda, as in a preposterous lithograph of 1850, *Slavery as It Exists in America/Slavery as It Exists in England,* showing carefree dancing and banjo playing while northern white visitors in the background comment on how they have been deceived by abolitionist exaggerations of the hard lives of slaves (fig. 47). Yet in keeping with the denotative elasticity of banjo imagery, much the same scene is found in what is probably the first antislavery painting by an American artist, Samuel Jennings's *Liberty Displaying the Arts and Sciences* (1792, fig. 48). Here, the slaves in the foreground adopt postures of worship and praise before the personification of Liberty, while in the background, a more vernacular musical celebration occurs, relatively free of the stigmatization that nineteenth-century exaggerations would later introduce.[8]

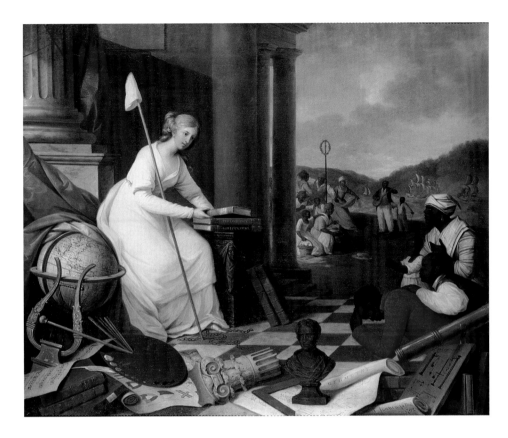

fig. 48
Samuel Jennings, *Liberty Displaying the Arts
and Sciences* [or *The Genius of America
Encouraging the Emancipation of the Blacks*],
1792, oil on canvas, 60¼ × 74 inches. The
Library Company of Philadelphia.

The gourd banjo, costume details, and Yoruba scarf dancing of *Liberty Display-
ing the Arts and Sciences* are remarkably similar to the contemporary watercolor
The Old Plantation (late eighteenth century; see fig. 97), which has been more
resistant to interpretation than Jennings's programmed allegory. Regardless of
whether the watercolor was conceived as a justification for slavery, it does establish
the canonical spatial landscape of the banjo circle, with the merrymaking taking
place in front of modest cabins and the distant Georgian manor house separated
from the slave zone by both a fence and a river. As historian Mark Smith has
shown, white southerners liked to hear "the faint tum-tum of the banjo" drifting
from the slave dwellings; they took it as a sign that all was well within the system.
One of the most effusive Confederate apologists, Patty Semple, wrote a postbellum
paean to the plantation where she grew up, remembering that "in the evening
came from the quarters the enticing sounds of the banjo and of 'pattin' Juba.'"
Wistfully, she regretted the passing of "the free, joyous spirit of a former time that
has gone from this representative old Kentucky home."[9]

The banjo obviously plays a prominent role in southern mythology, and in
Negro Life at the South, it is given a central position, essentially structuring the nar-
rative. The large, powerful hand of the player makes for an arresting silhouette
against the light-colored skin of the instrument's drum. From this pictorial node is

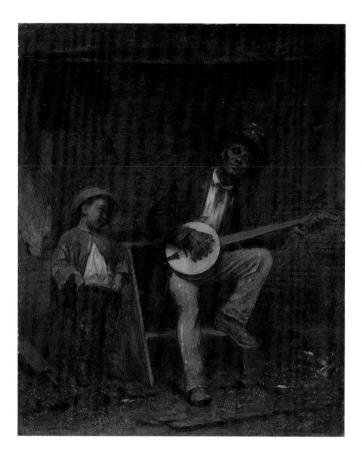

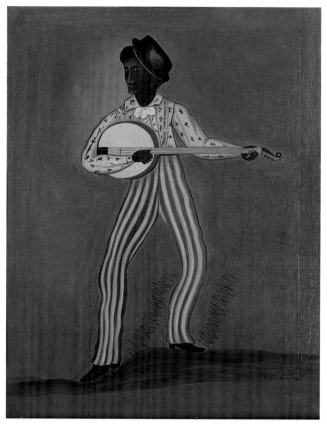

fig. 49 *(left)*
Eastman Johnson, *Confidence and Admiration* [study for *Negro Life at the South*], 1859, oil on canvas, 11¼ × 9⅛ inches (stretcher). Mead Art Museum, Amherst College, Amherst, Massachusetts. Museum purchase, AC 1958.48. Photo: Stephen Petegorsky.

fig. 50 *(right)*
D. Morrill, *Minstrel Banjo Player,* 1860, oil on canvas, 23⅞ × 19⅛ inches. Wadsworth Atheneum Museum of Art, Hartford, Connecticut. The Ella Gallup Sumner and Mary Catlin Sumner Collection Fund, 1942.630.

generated most of the rest of the painting's activity of listening, watching, and dancing. It is a remarkably accurate rendering of banjo play. The position of the man's fingers on the neck indicate that he is likely playing a D chord—assuming that this banjo, like the "banjars" of the slaves of Thomas Jefferson, was tuned to an open G, as that president reported was the custom. More important still is Johnson's documenting of the "clawhammer" playing style of the right hand, with bent fingers and thumb extended to the side. (*Confidence and Admiration* [1859, fig. 49], his smaller version of *Negro Life at the South,* also demonstrates the style.) This sharp, downward motion of the hand is the most ancient mode of banjo playing. The thumb strikes the drum head and then quickly picks the short chimer, or upper drone, string a fraction of a beat later, and the backs of the fingers sound the four longer strings below. Historians have noted the distinctly African sound that results, commencing with rhythm before melody, a percussive beat followed by high ringing sounds.[10]

Among antebellum depictions of banjo players, it is unusual to find this almost ethnographic attention to technique, surely a result of Johnson's study of an actual musician or model. One feels that the artist understands the tangible weight of the banjo, the balance that must be achieved between the body and the instrument to allow the hands sufficient freedom of movement. The inverse of this equilibrium is

poignantly demonstrated in his *Musical Instinct* (1860s, private collection), where a child struggles to master an overly large banjo of the type that characterized the minstrel decades of the 1840s and 1850s. Despite the figure's awkward attempt to manage a precarious situation, *Musical Instinct* nevertheless conveys a certain intimacy with the instrument, a moody sense of childhood discovery and potential. In a very different way, Johnson's little-known contemporary, D. Morrill, also marries figure and object by playing upon the rounded form and attenuated neck of the banjo to give his instrumentalist a serpentine, flowing delicacy of line that could accurately be described, musically and graphically, as lyrical (1860, fig. 50). Morrill's painting is likely based on a motif that appeared on several sheet music covers, including R. W. Smith's song "Alabama Joe" (1840, fig. 51). Admittedly, Morrill's flattened, undulant dandy is a far cry from Johnson's quiet, smoky forms, but they both eschew the most common minstrel stereotypes—bulging eyes, jutting hips, loose facial expressions, and elongated, flapping feet.[11]

Johnson's (and even Morrill's) measured treatment of banjo players stands in relief against a mocking minstrel tradition of outlandish postures and ludicrous gesticulations, where the instrument is essentially used as a prop that ridicules blacks and robs them of any semblance of intellect and sobriety. The banjo apparently made it easy for artists to slide into exaggeration. In fact, the universality of the language of minstrelsy probably made it difficult to *avoid* exaggeration. And even if the unusual dignity and poise of Johnson's banjoist signal the artist's attempt to subvert the prevailing stereotype, the reception of his painting as an Old Kentucky Home pushed it back in the opposite direction. Minstrelsy's emotional poles of feigned ebullience and nostalgia all too easily set the tone of such images, masking the genre's sharp-edged, violent implications. This trick was more difficult to bring off during the Civil War, however, when unprecedented death and destruction numbed audiences' usual responses.

We see these circumstances at work in a powerful and troubling painting by Winslow Homer called *Defiance: Inviting a Shot Before Petersburg* (1864, fig. 52). Homer depicts the barren killing fields of Tidewater Virginia from the Confederate point of view, where a southern soldier, frustrated by the stalemate of trench warfare, tempts his Union foes by leaping to the top of the earthworks, his body coiled in a fighting posture. The other soldiers are a passive set, crouching below the Union sight lines and barely visible in Homer's dark tones and summary brushwork. Disengaged from these men and seated above them on a nearby stump, however, is a banjo player, whose crude physiognomy blatantly invokes the burnt cork of blackface minstrelsy. Such buffoonery rarely makes its way into Homer's oil paintings (although caricature is not unknown in his drawings). And while banjo players were often on hand to entertain army and navy units on both sides of the conflict, here the parody of blackface seems unmistakably out of place against the grave realism of the rest of the painting.

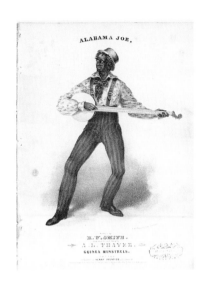

fig. 51
Benjamin W. Thayer (lithographer), *Alabama Joe*, 1840, lithograph, 13½ × 10 inches. Published by Henry Prentiss, Boston. Collection of James F. Bollman. Photo: Dana Salvo.

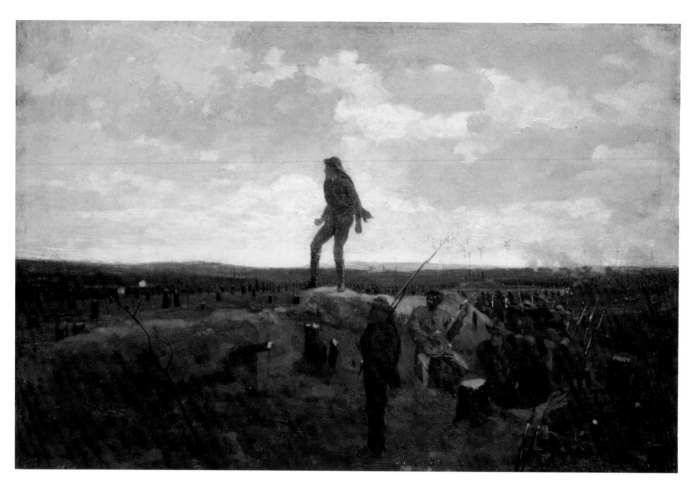

fig. 52
Winslow Homer, *Defiance: Inviting a Shot Before Petersburg,* 1864, oil on panel, 12 × 18 inches. Detroit Institute of Arts. Founders Society Purchase with funds from Dexter M. Ferry Jr. Photo © 1989 The Detroit Institute of Arts.

Homer's use of this demeaning icon must be intentional. Its presence in such a deathly landscape can be understood as an ironic indictment of the racist lies that undergirded the Confederate defense of slavery. The banjo player almost appears as a ghost haunting the trench, a spectral embodiment of the underlying origins of the war. The neck of his banjo rhymes suggestively with the shouldered weapon of the nearby sentry, who appears oblivious to his presence. The inert sentry's bayonet is no threat to any Union soldier—all safely on the other side of no-man's-land—but the banjo itself may be a more deadly implement. Its player knowingly looks up at the defiant soldier—and, beyond him, to the two puffs of smoke that signal his demise at the hands of Union sharpshooters. As Kirk Savage has written, "It requires only a little stretch of the imagination to see the rebel as dancing to the darky's tune—and dying for it."[12] The banjoist essentially functions as a Greek chorus, providing the macabre accompaniment to the hero's downfall. In this, he might be compared to the skeletal figure of Death occupying a similarly ominous position behind the lines in James Henry Beard's *Night Before the Battle* (1865, fig. 53), a painting contemporary with Homer's. Both works bring a certain fatalism

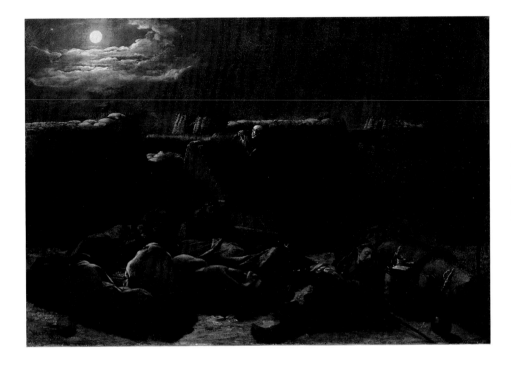

fig. 53
James Henry Beard, *The Night Before the
Battle,* 1865, oil on canvas, 30½ × 44½
inches. Memorial Art Gallery of the University
of Rochester, Rochester, New York. Gift of
Dr. Ronald M. Lawrence, 78.15.

and hopelessness to their subjects, but Beard—a veteran as well as an artist—uses
his skeleton to symbolize the effect of the war, whereas Homer's minstrel presents
the cause.

The same year in which Homer composed *Defiance,* David Gilmour Blythe
painted *Old Virginia Home,* which also connects the banjo to southern misfor-
tunes (fig. 54). An outsider figure from Pittsburgh, Blythe painted this work for a
local Sanitary Fair, at which it was sold for $30 to benefit the Union. But while
the artist ardently opposed the rebellion, he disliked abolitionists with equal
intensity and feared the day when blacks would get the vote.[13] This mixed bag of
political views resulted in atypical iconography in his *Old Virginia Home.* In con-
trast to most of the minstrelized visualizations of the South, the "old home" is
here thoroughly incinerated. The myth of the paradisal plantation is shattered by
the apocalyptic figures of war streaking through the sky. The former slave, drag-
ging his broken shackles as he leaves the South's ruins, can scarcely be imagined
to be approaching a rosy future, however. Blythe places a banjo in the man's
hand, as though he is unwilling to give up that token of his old life. The artist
seems to ask what this slinking freedman has left without the protective planta-
tion environment that formerly sheltered him. The figure turns and looks out
from the picture with tired eyes, forcing a certain complicity in the viewer. In
many ways, Blythe's canvas is a send-up of the Old Kentucky Home stereotype,
making the point that despite all the minstrel longing, you really couldn't go back
to the plantation.[14]

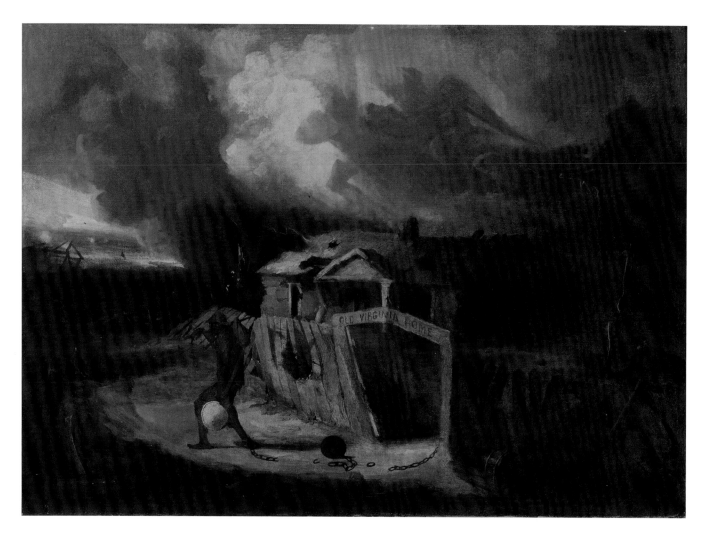

fig. 54
David Gilmour Blythe, *Old Virginia Home*,
1864, oil on canvas, 20¾ × 28¾ inches. The
Art Institute of Chicago. Ada Hertle Turnbull
Fund, 1979.55. Photo © The Art Institute of
Chicago.

This did not stop other artists from trying, as evidenced by the Düsseldorf-trained John Whetten Ehninger's *Old Kentucky Home,* with its banjo, violin, vine-covered cabin, mammy figure peeling apples, and angelic blond, blue-eyed child reminiscent of Little Eva from *Uncle Tom's Cabin* (1863, fig. 55). Interestingly, this generalized image (with its stock title) only seems to rise to a level of particularized detail in the figure of the banjo player, with his unusual, parti-colored patchwork jacket and his Windsor chair that has lost its back. Like Homer and Blythe, Ehninger executed his canvas in the midst of the Civil War. In postwar years, many similar print images would perpetuate the Old Kentucky Home iconography, but few of them would move beyond the stock graphic parameters that had already been established in the minstrel era.

One of the best known and most influential of these prints was Fanny Palmer's lithograph *Low Water in the Mississippi,* drawn for Currier and Ives—a firm not known for its support of abolition (1867, fig. 56). Taking a cue from *Negro Life at*

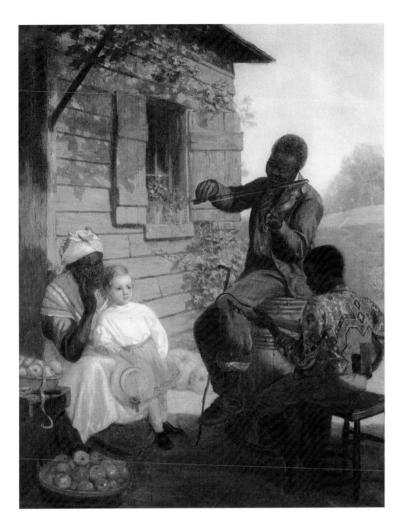

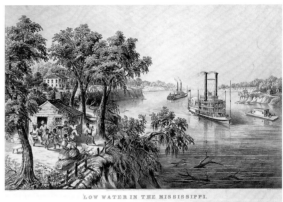

fig. 55 *(left)*
John Whetten Ehninger, *Old Kentucky Home,*
1863, oil on canvas, 15½ × 19 inches. © Shel-
burne Museum, Shelburne, Vermont, 27.1.7-
013. Photo: Ken Burris.

fig. 56 *(above)*
Fanny Palmer, *Low Water in the Mississippi,*
1867, lithograph. Published by Currier and
Ives, New York. Library of Congress, Prints and
Photographs Division, Washington, D.C., LC-
USZ62-12333.

the South, she reprises the banjo circle, with the familiar motif of the mother and
dandled baby. And again like Johnson, she makes a point of juxtaposing the pic-
turesque slave realm (rundown and a bit threatening with its unkempt brambles,
exposed roots, and river snags) with the clean, scoured grounds of the big house in
the background. John Michael Vlach has discussed the Palmer print as particularly
successful northern propaganda, designed to pacify the South and cement the
Union victory.[15]

Certainly it took hold of a number of artists' imaginations in the coming
decades. For example, in the original print, Palmer provides a visualization of a
standard minstrel story line, that of the actual or longed-for river passage of slaves,
either away from or back to their native plantation. The cover illustration on an
1880 version of the sheet music for a song entitled "On the Levee by the Riverside"
has an almost identical composition, with dancers, banjo player, and beckoning
steamboat. Even more interesting is the reuse of Palmer's banjo circle as vignettes

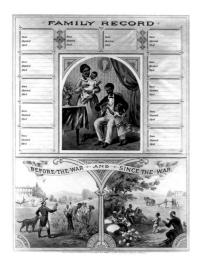

fig. 57
Family Record: Before the War and Since the War, c. 1880, chromolithograph. Published by Krebs Lithographing, Cincinnati. Photo courtesy John Davis.

in such post-Emancipation prints as George Cram's *Distinguished Colored Men* and Gaylord Watson's *From the Plantation to the Senate* (both 1883), ostensible images of African American pride.[16] These broadsides were marketed to the community of freed slaves, as was a chromolithograph entitled *Family Record: Before the War and Since the War* (c. 1880, fig. 57). At the center of this composition is an arched image of a respectable African American family, surrounded by blank boxes in which subsequent generations' names are to be inscribed. Below are two additional scenes representing their lives before and after the war, labeled "Slavery" and "Freedom." Astonishingly, the minstrelized banjo circle—with dancing child, baskets of cotton, and an Uncle Ned–type onlooker—was selected by the Cincinnati publisher as an inspiring emblem of the bright future of "Freedom."

It seems that even sympathetic white artists could end up appropriating the derogatory legacy of minstrelsy in their work. In this struggle between affirmation and stereotype, some of the most fascinating images to emerge in the wake of the Civil War are the paintings executed by the Swiss artist Frank Buchser, who visited the United States for six years beginning in 1866.[17] Shortly after his arrival, Buchser surprised art critics with a series of genre paintings of freed blacks residing in Washington, D.C., where he had opened a studio. These included the unusual *Volunteer's Return* (1867, Öffentliche Kunstsammlung Basel), which features a young African American soldier, gun in hand, recounting stories of the war to two admiring bootblacks. Such a depiction of a strong, confident, battle-tested black soldier was unheard of in American painting, and one critic who saw the composition of the three youths remarked that Buchser "portrays them in no spirit of ridicule, but with the most genuine sympathy and comprehension of them."[18]

Buchser, a headstrong maverick who arrived in the South in the early days of Reconstruction, was not averse to venturing into charged political territory. Two other paintings, *Art Student or Rising Taste* (1869, fig. 58) and *Black Youth Reading the Newspaper on a Barrel* (1870, fig. 59), engage issues vital to the future of freed blacks while exploring the range of meanings to be found in the banjo. In *Art Student,* a young bootblack finds himself in an artist's studio. (The paintings on the wall identify it as Buchser's.) During a period when blacks were not permitted to visit the exhibition halls of the National Academy of Design, and when the audience for fine art was simply understood to be homogeneous and white, this scenario packs a certain punch. It is true that one cannot discount an element of humor in the conception of the painting, capitalizing on the young man's presumed ignorance when brought face-to-face with Western artistic traditions. But the painting raises a more serious issue, too, one at the heart of much of the violence visited on freed slaves during Reconstruction and after. It would not have escaped an audience of the time that this young man is staring at a painting of a nude white woman, an act that, in real life, could easily have resulted in his death

fig. 58 *(left)*
Frank Buchser, *Art Student or Rising Taste,*
1869, oil on canvas, 38¹/₂ × 20⁵/₆ inches. Foun-
dation for Art, Culture, and History, Winterthur,
Switzerland. Photo courtesy Schweizerisches
Institut für Kunstwissenschaft, Zurich.

fig. 59 *(above)*
Frank Buchser, *Black Youth Reading the
Newspaper on a Barrel,* 1870, oil on canvas,
30¹/₄ × 25¹/₄ inches. Private collection, Switzer-
land. Photo courtesy Schweizerisches Institut
für Kunstwissenschaft, Zurich.

at the hands of white racists.[19] In this light, the painting becomes a kind of public
provocation.

How, then, to interpret the banjo hanging on the studio wall in the upper right
corner, especially at this comparatively early date (1866), before it had become a
common element of genteel decoration? Knowing Buchser's political views, its

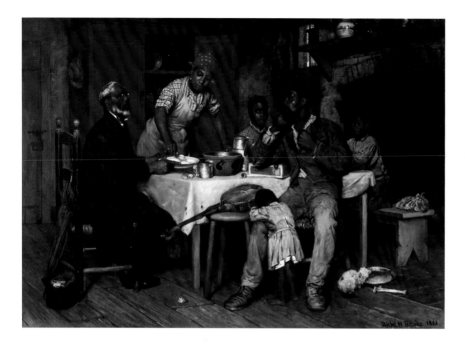

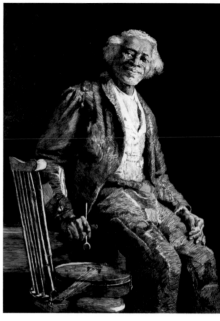

fig. 60 (left)
Richard Norris Brooke, *A Pastoral Visit,* 1881, oil on canvas, 47¾ × 65¾ inches. Corcoran Gallery of Art, Washington, D.C. Museum purchase, Gallery Fund, 81.8.

fig. 61 (right)
Dem Was Good Old Days (after Thomas Hovenden), 1885, etching on paper, 16⅝ × 12¼ inches. Collection of James F. Bollman. Photo: Dana Salvo.

inclusion could be seen as sympathetic to blacks, elevating this symbol of African-derived musical culture, and "exhibiting" it alongside the paintings of a white European. Yet the artist also seems aware of the negative connotations of the instrument. The banjo in *Art Student* is hung so that it overlaps a Buchser sketch entitled *Cowering Black Youth,*[20] and the bootblack has turned his back on that passive representation, as well as on the banjo, in order to test a new boundary. Similarly, in *Black Youth Reading the Newspaper,* the banjo is pointedly left to one side on the floor, neglected in favor of the active cultivation of literacy and knowledge of public affairs. It has become a still-life element, still pregnant with meaning but treated as a mute icon, much like the untouched banjos in the foregrounds of such later paintings as Richard Norris Brooke's *Pastoral Visit* (1881, fig. 60) and Thomas Hovenden's relic-like *Dem Was Good Old Times* (see figs. 61, 78), both of which would be reproduced and widely disseminated.

Buchser's original title for *Black Youth Reading the Newspaper* was *Eppur si Muove,* Galileo's famous words whispered as an affirmation in the face of institutional ignorance and intolerance.[21] When a *New York Daily Tribune* critic saw this painting and similar African American genre paintings by the artist, he made the connection to the feelings of truth and possibility that some Americans associated with Reconstruction:

> Buchser's Negro paintings are progressive. He seems to have been impressed at first with the grotesque or the merely picturesque in Negro character, but he was not slow to penetrate to the poetical, and to do

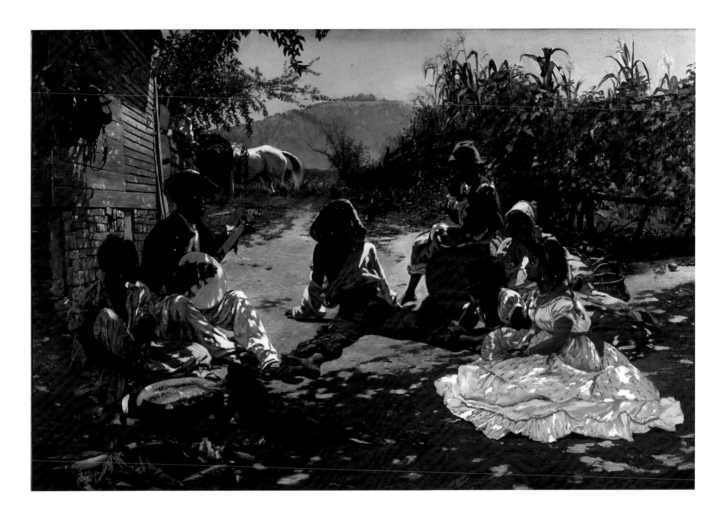

justice to the sympathetic nature and grave earnestness underlying that levity which Slavery superinduced upon cheerfulness. . . . He has discerned the ambition, the hope, and the aspiration that mark the great transition which the Negro race in this country is now undergoing—a transition, perhaps, the most rapid, gigantic, and beneficent which the history of the human race has yet witnessed. . . . One sees a full realization of the truth that "knowledge is power" and a necessary adjunct of freedom.[22]

fig. 62
Frank Buchser, *The Song of Mary Blane,* 1870, oil on canvas, 40¾ × 60⅝ inches. Kunstmuseum Solothurn, Solothurn, Switzerland. Gift of the Gottfried Keller Foundation.

Among all his American works, Buchser considered his masterpiece to be the large *Song of Mary Blane* (1870, fig. 62), his most direct connection to the American vernacular musical tradition. *The Song of Mary Blane* proved to be a contentious project for the artist, one that he actually began composing before *Art Student* and *Black Youth Reading the Newspaper* but subsequently took four years to complete. His initial impediment was the decidedly chilly welcome he received in Wood-

[*The Artist whilst engaged in painting his grand representation of Southern life.*]

OUR ART GALLERY—No. 3,

fig. 63
[*The Artist whilst engaged in painting his grand representation of Southern life*], woodcut illustration from the *Shenandoah Herald,* 15 August 1867, 3. Photo courtesy John Davis.

fig. 64
Woodcut illustration from "Our Art Gallery—No. 3," *Shenandoah Herald,* 12 September 1867, 4. Photo courtesy John Davis.

stock, Virginia, a small village in the Shenandoah Valley where he hoped to make studies for his canvas in August 1867. The acerbic local paper, the *Shenandoah Herald,* announced "the appearance of a very mysterious personage—a veritable live artist, who is now engaged in executing his *chief d'ouvrie*—which brilliant composition is composed of a beautiful and artistic grooping of some half dozen tender *enfants* of the African persuasion."[23] Given the clear participation of *Mary Blane* in the plantation mythology of the Old South, it is perhaps surprising that Woodstock's residents met the artist and his project with suspicion.

The town, however, was chafing under Reconstruction, and its citizens believed, as the *Herald* put it, that Buchser "was probably sent to gather caricatures, &c, and intended by so falsely representing the negro in dirt and rags, to give fresh color to the puritanical radical howl and cry for confiscation and division of spoils."[24] The artist had arrived at a singularly inopportune moment. Five months earlier, Congress had passed the first Reconstruction Act, declaring martial law in Virginia and giving blacks the right to vote. Shortly thereafter, the first Republican party convention took place in Richmond, where there was talk of confiscating slaveholders' land. (Such state gatherings were called "Bones and Banjo conventions" because of the perception of black dominance by newly enfranchised voters.)[25] It certainly did not help that Buchser was traveling at the time with his mistress, an unmarried mixed-race woman. The result was an attack on the artist and a widespread belief that he had come to produce pro-black and anti-South visual propaganda.

The opening gambit in the newspaper's campaign was a woodcut depicting Buchser before his *Mary Blane* composition, a wildly gesticulating black figure cruelly speared to the top of his easel for easy study (fig. 63). But this loose-limbed stereotype and the suggestion of violence were only the beginning. Buchser became conflated (thanks, in part, to a mocking letter he sent to the editor) with the hated military officers and Republican judges who were attempting to restructure the state's political apparatus, and in subsequent weeks the *Shenandoah Herald* fought back visually. Inaugurating a new feature entitled "Our Art Gallery," the editors began to run crude woodcuts of dancing minstrel figures, which the newspaper's editorials wove into denunciations of Buchser, abolitionists, carpetbaggers, reforming jurists, and anyone else who threatened the old order (fig. 64).[26] The sentimental imagery of what would become *The Song of Mary Blane* was apparently not broad enough for their purposes. Instead, they turned to the pure visual doggerel of minstrelsy.

The *Herald*'s woodcuts employ a noisy, unruly graphic language that suggests a frightening lack of control. (Ingeniously, they also implicate Buchser by making the artist the subject of caricature himself.) *Mary Blane,* on the other hand, is meditative in tone, with the six listeners thoughtfully regarding the singing banjoist, who is accompanied by a young harmonica player at right. If anything is jarring, it

is the hot, intense color scheme, which American viewers saw as European and strangely unfamiliar.[27] But the "calm" is also broken by the insertion of certain repugnant stereotypes quite familiar to Americans, such as the naked, watermelon-eating child in the foreground. This imagery, along with the implied narrative of the work, makes it a difficult picture to interpret.

The title of the painting comes from yet another minstrel song, this one a first-person account of a male slave lamenting the kidnapping of his beloved wife, Mary. The "Mary Blane" song, which exists in at least five versions, was written by a white man in the 1840s—probably by F. C. German of the Ethiopian Serenaders.[28] Yet in keeping with the false authenticity of the minstrel movement, it was put forward as a black folk song, "overheard," as the conceit would have it, by a white listener on the plantation. This, indeed, is the premise of Buchser's painting. We are that listener—or, rather, that viewer. His conception replicates the minstrel lie that we are glimpsing a "true" moment, when a culturally indigenous song of sadness is performed within the closed circle of the black community, rather than a white fantasy that puts alien words in the mouths of its constructed subjects. When it was exhibited in New York and Boston, writers viewed the painting through the lens of the song. Some even identified the young mulatto woman at right as Mary Blane herself—a "neatly dressed quadroon," presumably pre-kidnapping—as if Buchser had undertaken an illustration of the tune's lyric.[29]

This lyric complicates any interpretation of *The Song of Mary Blane.* A study of nineteenth-century sheet music discloses that most versions of the Mary Blane song ridiculously attribute the kidnapping either to Native Americans or, even less plausibly, to African Americans, who, we are to believe, tarred and feathered Mary Blane—anyone but the white folks who wrote and were the primary audience for the song. Only one rare version, called "The New Mary Blane," placed blame on whites for her disappearance. Thus, the majority of the musical source material fell squarely into the minstrel tradition of exonerating slaveholders of responsibility for any misfortune that might befall blacks. Yet some viewers in the North were hungry for a kind of representation that might redeem the banjo circle iconography and reflect the new assumptions of Reconstruction. Critics repeatedly discussed *The Song of Mary Blane* as an unusually honest visual document and even a kind of *cri de coeur* against the unjust treatment of blacks: "The picture as a whole is highly poetic and has withal a deeper meaning, for the ballad is a simple but pathetic recital of one of the typical wrongs of the slave code, and one cannot help feeling that the singer is an eloquent preacher of freedom stirring in the heart such sentiments as sometimes endure through a life-time, giving purpose and direction to powers, which would else have remained latent."[30]

Most of all, Buchser's painting was hailed as a sign of change, as a dual embodiment of a past that had rarely been on view in the North and a future in the South that was still uncertain. One "friend" of the artist wrote,

The events of the last few years have not only obliterated the landmarks of the past in political and social life, but have developed almost a new era in Art, furnishing subjects which have hitherto been regarded as unworthy of artistic delineation, or only employed in Art by the caricaturist. The results of the war and emancipation of the Negro race exhibit their effects on the political and social structure of those States in which the institution of slavery had existed, and brought prominently into view the characteristics of that race. . . . Buchser has not been slow to discover the mine of picturesque wealth that has lain so long unworked.

Another suggested ominously, "Such a picture as 'Mary Blaine' will gain a historical value if the predictions that the Negro race is to become extinct in the United States shall be verified." Still others reiterated the view of Buchser's work as simple, picturesque Americana: "Negro Melodies are at last asserting their proper place in the sentimental art of the period. Thackeray used to cry over them, Nilsson sings them, and at last a great Swiss painter dips his brush into their fresh inspiration."[31]

Buchser was convinced that *The Song of Mary Blane* was "a masterwork of the first sort," as he wrote in his diary on 7 February 1871.[32] Yet only two months later, without a buyer in sight, he had decided to return to Europe and send the canvas on tour there. Politics, he maintained, had soured the reception of his painting:

Mary Blane is going to London at once. I will [not] venture on this any further exhibition in this country without the propre engineering of the press, the exhibition of it would only injure its reputation, particularly if I take the powerful lobby in consideration which was at work against it here. I think however this lobby will soon broken and better times will follow.[33]

Whether Buchser is referring to anti-Reconstruction forces or to a more parochial resistance within the art world is unclear. In his mind, though, the painting was clearly provocative, and it is undeniably imbued with a certain psychological intensity.

It is striking how reminiscent all this is of Johnson's *Negro Life at the South.* There are the obvious similarities in subject: the banjo circle, the light-skinned woman, the possibility of romance, the focus on black community and group identity. And each image, whether intentionally or not, became conflated with a song that, depending on the viewer, materially colored its meaning. The two paintings skirt the edges of visual and aural stereotype; they engage with a vernacular tradition while remaining distinct from it. They effect a kind of semiotic flicker,

calling into question the minstrel tradition from which they derive but also begetting more pure and virulent versions of the type. Twelve years apart, they bracket the period of the war and early Reconstruction, with all its social changes and shifts in meaning of racial imagery. But Buchser's complaint reminds us of one great difference between them. Johnson's painting was a singular success with the American public, whereas the reception of *The Song of Mary Blane* left its creator disappointed and defeated.

The postwar complexities posed problems that Johnson chose not to deal with and that made Buchser's pursuit of his subject an inherently contradictory enterprise. As one of Buchser's most trenchant critics wrote, "It is his success in effecting this essentially difficult conjunction—this faithful adherence to two antithetic realities whose coexistence is the special mark of the exceptional circumstances under which the Negro is now found—it is this which gives his works their chief historical value. . . . It is a feature of art which must make its way to popular appreciation in the face of very strong prejudices."[34] On which side of those strong prejudices should we place *The Song of Mary Blane,* though? Whatever Buchser's intentions, his odd, even naïve painting was received by many as familiar and picturesque, the same "characteristic" banjo and watermelon imagery that hundreds of plantation songs had naturalized. But in the era of transition that was Reconstruction, what was needed was a break from the past, a disruption of the powerful shaping ideology of nostalgia. A writer in the *New York World* summed up the "change of key" that had become the painter's new reality:

> The truth is the old plantation is gone, and with it the jocund days of darkeydom. Once the minstrels caught somewhat of the wild pathos, and reproduced the animal levity which amused us, but they have grown too big for that without having reached to any excellence above it. The plantation utterance has been stifled, or, under new conditions, is harsh, defiant, and crazed: there is no longer anything to delineate; the thing has been worn to shreds, and wiped away by a political change.[35]

NOTES

1. Willa Cather, *Death Comes for the Archbishop* (1927), in *Later Novels* (New York: Library of America, 1990), 384, 388; Richard Whiteing, "The American Student at the Beaux-Arts," *Century Magazine* 23 (December 1881): 263.

2. Some standout studies include Eric Foner, *Reconstruction: America's Unfinished Revolution, 1863–1877* (New York: Harper and Row, 1988); Kirk Savage, *Standing Soldiers, Kneeling Slaves: Race, War, and Monument in Nineteenth-Century America* (Princeton, N.J.: Princeton University Press, 1997); and David W. Blight, *Race and Reunion: The Civil War in American Memory* (Cambridge, Mass.: Harvard University Press, 2001).

3. For current scholarship on this intriguing painting, see John Davis, "Eastman Johnson's *Negro Life at the South* and Urban Slavery in Washington, D.C.," *Art Bulletin* 80 (March 1998): 67–92, and Patricia Hills, "Painting Race: Eastman Johnson's Pictures of Slaves, Ex-Slaves, and Freedmen," in Teresa A. Carbone and Patricia Hills, *Eastman Johnson: Painting America* (Brooklyn: Brooklyn Museum of Art in association with Rizzoli International Publications, 1999), 126–31.

4. Among other studies of the vast topic of music from the period, see Sam Dennison, *Scandalize My Name: Black Imagery in American Popular Music* (New York: Garland, 1982), which takes particular care in analyzing song texts.

5. The immense popularity of "My Old Kentucky Home" is chronicled in Ken Emerson, *Doo-dah!: Stephen Foster and the Rise of American Popular Culture* (New York: Simon and Schuster, 1997).

6. The use of the Johnson image to sell tobacco, when considered alongside the fact that the first two owners of *Negro Life at the South* were New York's most powerful cotton and sugar merchants, respectively, ties it intimately to the three principal cash crops of the slave economy—a remarkable nexus of political, cultural, and economic vectors. Hills, "Painting Race," first discussed this lithograph (130–31).

7. It is worth noting that Johnson's painting is consistently identified with border states. This is also true of many minstrel songs and singing groups, where the regions of Kentucky, Virginia, and Tennessee are repeatedly used to evoke a certain liminal territory pulled in two directions—close to the possibility of freedom, but also ready to provide a quick and easy retreat into the myths and spaces of southern plantation life.

8. The painting was intended for the Library Company of Philadelphia, the directors of which specifically asked the artist to place "in the distant back Ground a Groupe of Negroes sitting on the Earth, or in some attitude expressive of Ease & Joy." Jennings elected to include the banjo. Quoted in Robert C. Smith, "*Liberty Displaying the Arts and Sciences:* A Philadelphia Allegory by Samuel Jennings," *Winterthur Portfolio* 2 (1965): 89.

9. M. R. Ailenroc, quoted in Mark M. Smith, *Listening to Nineteenth-Century America* (Chapel Hill: University of North Carolina Press, 2001), 36; Patty B. Semple, "An Old Kentucky Home," *Atlantic Monthly* 60 (July 1887): 39, 43.

10. The rhythmic clawhammer technique contrasts greatly with the more continuous, up-picking style that has since come to be associated with bluegrass music. See Karen S. Linn, *That Half-Barbaric Twang: The Banjo in American Popular Culture* (Urbana: University of Illinois Press, 1991), 17. I owe these observations on Johnson's depiction of banjo playing to the keen eye of John Michael Vlach. Jefferson's mention of the "banjar" comes in his *Notes on the State of Virginia* (1781; rpt., Boston: Bedford/St. Martin's, 2002), 177. On shifts in banjo tuning, see Philip F. Gura and James F. Bollman, *America's Instrument: The Banjo in the Nineteenth Century* (Chapel Hill: University of North Carolina Press, 1999), 51.

11. Johnson's painting *Musical Instinct* is reproduced in *American Drawings, Paintings and Sculpture,* auction catalogue (New York: Sotheby's, 5 December 1996), lot 79.

12. Savage, *Standing Soldiers,* 173. See also Patricia Hills's catalogue essay on the painting in *American Paintings in the Detroit Institute of Arts, Volume II: Works by Artists Born 1816–1847* (New York: Hudson Hills Press, 1997), 116–19. It may be relevant that Homer is known to have played the banjo, opening the possibility of his identification with the instrumentalist in *Defiance.*

13. On Blythe, and this painting in particular, see Bruce Chambers, *The World of David Gilmour Blythe* (Washington, D.C.: National Collection of Fine Arts, 1981), 94–97, and Andrew Walker, ed., *Terrain of Freedom: American Art and the Civil War, Museum Studies* (Art Institute of Chicago) 27, no. 1 (2001): 21.

14. The plantation in ruins was a standard postwar icon in both the North and the South. An example is Henry Mosler's dramatic painting *The Lost Cause* (1869, private

collection), painted in Cincinnati for a
southern audience and later chromolitho-
graphed. The canvas depicts a dejected Con-
federate soldier returning to an abandoned,
tumbledown home. Mosler was a student
of James Beard and, like Homer, a Civil
War correspondent and draftsman. See Bar-
bara C. Gilbert, *Henry Mosler Rediscovered: A
Nineteenth-Century American-Jewish Artist*
(Los Angeles: Skirball Museum, 1995).

15. John Michael Vlach, *The Planter's
Prospect: Privilege and Slavery in Plantation
Paintings* (Chapel Hill: University of North
Carolina Press, 2002), chap. 5.

16. The prints by Cram and Watson are
illustrated in ibid., 129, 130.

17. Buchser had been commissioned by a
group of Swiss patriots to execute a painting
for the Parliament in Bern commemorating
the restoration of the Union and the defeat
of slavery. The principal literature on the artist
includes H. Lüdeke, *Frank Buchsers
Amerikanische Sendung, 1866–1871* (Basel: Hol-
bein-Verlag, 1941); Gottfried Wälchli, *Frank
Buchser, 1828–1890, Leben und Werk* (Zürich:
Orell Füssli Verlag, 1941); Frank Buchser, *Mein
Leben und Streben in Amerika*, ed. Gottfried
Wälchli (Zürich: Orell Füssli Verlag, 1942);
Frank Buchser in Amerika, 1866–1871 (Biberist:
Schlösschen Vorder-Bleichenberg, 1975);
Hugh Honour, *The Image of the Black in West-
ern Art*, IV (Houston: The Menil Foundation,
1989), pt. 1, pp. 240–44; Roman Hollenstein et
al., *Frank Buchser, 1828–1890* (Solothurn,
Switzerland: Kunstmuseum Solothurn, 1990);
and William U. Eiland et al., *Frank Buchser: A
Swiss Artist in America, 1866–1871* (Athens:
Georgia Museum of Art, 1996).

18. The quotation is from "Art in Wash-
ington," *New York Evening Post*, 27 February
1867. Still, Buchser fell into stereotype in his
diary when he referred to the painting as
"Sambo's return from the war" (Buchser,
Mein Leben und Streben, 44). Foner, *Recon-
struction*, 80, 120, confirms the importance of
returning black troops ("apostles of black
equality") in local communities. See also

"The Artists and the African," *New York
Evening Post*, 2 May 1867.

19. Blight, *Race and Reunion*, 120, notes
that the years 1868–71 were particularly vio-
lent, with thousands of blacks terrorized and
murdered by the Ku Klux Klan. On the
National Academy's exclusionary policy, see
"National Academy of Design," *Watson's
Weekly Art Journal* (17 June 1865), 116. See
also Rudolph P. Byrd, "American Images for
Circulation: The Black Portraiture of Frank
Buchser," in Eiland et al., *Frank Buchser*, 48.

20. *Kauernder schwarzer Junge*, c. 1869,
Öffentliche Kunstsammlung Basel.

21. See Paul Müller, "Junger Schwarzer,
auf einem Fass Zeitung lesend," in Hollen-
stein et al., *Frank Buchser, 1828–1890*, 160.

22. "The Negro in Art—Buchser's Paint-
ings," *New York Daily Tribune*, 20 January 1870.

23. "Artistic Mysteries," *Shenandoah
Herald*, 15 August 1867 (original emphasis
and spelling).

24. "Our Teuton Defended," *Shenan-
doah Herald*, 5 September 1867.

25. Foner, *Reconstruction*, 304, 317. On
the specific situation in Virginia and the
Shenandoah Valley, see Jack P. Maddex Jr.,
*The Virginia Conservatives, 1867–1879: A
Study in Reconstruction Politics* (Chapel Hill:
University of North Carolina Press, 1970),
and Gordon B. McKinney, *Southern Moun-
tain Republicans, 1865–1900: Politics and the
Appalachian Community* (Chapel Hill: Uni-
versity of North Carolina Press, 1978).

26. In the *Shenandoah Herald*, see "Our
Art Gallery," 29 August 1867; "Our Art
Gallery, No. 2," 5 September 1867; and "The
Original 'Jim Crow,'" 12 September 1867. See
also "Art," *New York Evening Post*, 22 August
1867. Buchser's diary reveals that he was no
friend of the Woodstock Confederates, refer-
ring to them as "die ignoramus-Rebellen."
While in Virginia, he socialized with Union
officers, calling them "meine nördlichen Fre-
unde, die Carpet-baggers." The county
court—as well as a sympathetic Republican

newspaper, the *Winchester Journal*—
supported the artist in this contretemps
and sanctioned the *Shenandoah Herald*. See
Buchser, *Mein Leben und Streben*, 49, 52, 72,
117. On local politics, see "Shenandoah
Republican Convention," *Winchester Journal*,
4 October 1867.

27. One critic wrote of "a Frankensteinism
in the coloring" of another of the artist's paint-
ings of blacks ("A New Artist in Washington,"
Daily National Intelligencer, 8 August 1866).
Lüdeke rather ahistorically and troublingly dis-
cusses the "peculiar" color scheme—"a strange
dissonance of pinks and light greens and deep
blues"—as "a kind of pictorial precursor of the
modern jazz, typifying the mentality of the
race." H. Lüdeke, "Frank Buchser: A Forgotten
Chapter of American Art," *Art in America* 35
(July 1947): 194.

28. On "Mary Blane" and its versions,
see Dennison, *Scandalize My Name*, 110–12,
and Lüdeke, *Frank Buchsers Amerikanische
Sendung*, 103–4, 124–25. ("Blane" is subject to
various spellings in the period literature.)

29. "Buchser's Picture of Mary Blaine,"
New York Evening Post, 27 April 1871. Interest-
ingly, the painting was exhibited in New York
at Tiffany's new jewelry store on Union Square.

30. "The Negro in Art—Buchser's
Paintings."

31. "An Artist Worth Knowing," *New
York Evening Mail*, 31 March 1871; "Art
Notes," *New York Herald*, 10 April 1871;
"Negro Melodies," *Boston Daily Evening
Transcript*, 3 February 1873.

32. Buchser, *Mein Leben und Streben*, 87
("'Mary Blane' ist vollendet und ein Meister-
werk erster Sorte").

33. Buchser to Louis Prang, 28 April 1871
(original English spelling and wording), quoted
in Wälchli, *Frank Buchser, 1828–1890*, 154.

34. "The Negro in Art—Buchser's
Paintings."

35. "Modern Minstrelsy," *New York
World*, 18 February 1868.

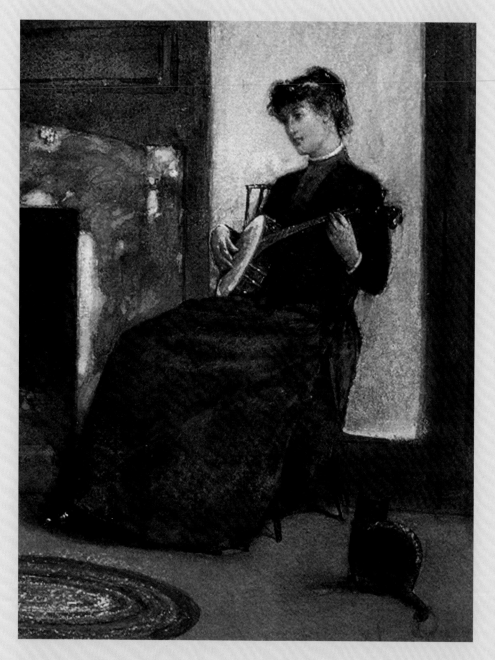

Childe Hassam, *A Familiar Tune*, c. 1880s,
watercolor on board, 15 × 21¼ inches (detail
of fig. 74). Florence Griswold Museum, Old
Lyme, Connecticut. Gift of The Hartford Steam
Boiler Inspection and Insurance Company,
2002.1.65.

Whiteface: Art, Women, and the Banjo in Late-Nineteenth-Century America

SARAH BURNS

BEFORE THE BANJO, middle-class feminine music making in the United States was sedate and mannerly. The raucous banjo was confined to the minstrel stage. Woodwinds, brass, percussion, and members of the violin family were, for the most part, the domain of male performers. Women, consigned to the domestic realm, had to make do with the three instruments designated supremely feminine: harp, piano, and guitar. The latter two became particular staples in the literature and performance of parlor music, through which young women and matrons alike could display skill, grace, cultivation, and sentiment. Home music was supposed to be soothing and sweet—a prescription best filled by the "soft, delicate, plucked string sounds" of the guitar or the piano's tender, romantic chords. Musical practice and

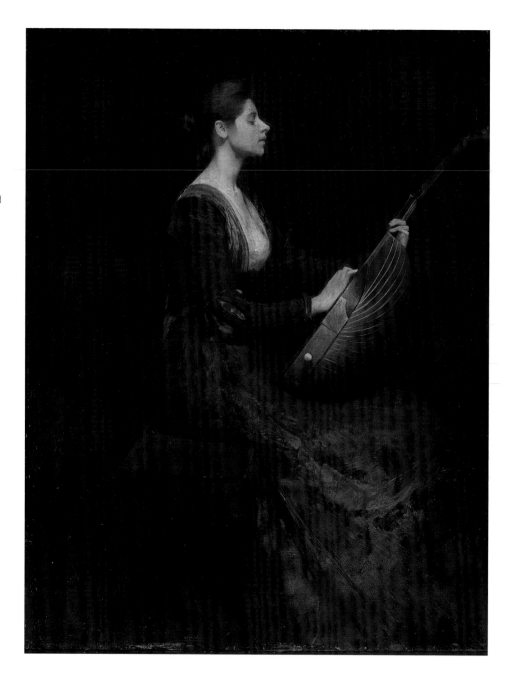

fig. 65
Thomas Wilmer Dewing, *Lady with a Lute*,
1886, oil on wood, 20 × 15⅝ inches. National
Gallery of Art, Washington, D.C. Gift of Dr. and
Mrs. Walter Timme, 1978.60.1. Image © 2004
Board of Trustees, National Gallery of Art,
Washington, D.C. Photo: Bob Grove.

performance, moreover, permitted the expression of emotion otherwise suppressed beneath the veneer of self-restraint demanded by middle-class decorum.[1]

In nineteenth-century American painting and graphic arts, women—as custodians of culture—frequently appeared playing or at least posing with guitars or other guitar-like instruments, as well as harps and pianos. The critic Clarence Cook found that guitars and harps lent themselves to "the movements of grace and beauty" of the human form. Such instruments, moreover, were by long tradition

fig. 67
Frances Benjamin Johnston, ["Miss Apperson"
playing banjo beside statue of "Flora" in niche
of Sen. George Hearst's residence, Washing-
ton, D.C.], c. 1895, platinum print. Library of
Congress, Prints and Photographs Division,
Washington, D.C., LC-USZ62-63501.

receiving vociferous applause for their "clever dialect work and their funny songs." Socialites connected with Brooklyn's Memorial Hospital for Women and Children emulated Lotta Crabtree when they planned a fund-raising minstrel show for which they would "'black up' in the most approved minstrel style and crack minstrel jokes, sing minstrel songs, and play minstrel banjos and tambourines."[9]

The instrument also figured as a prop in aesthetic interiors. One newspaper column, for example, detailed the daily life of a society lady, pampered and surrounded by luxuries. After being dressed by her loving black mammy, she passed into her morning room, a "beautiful, cozy apartment full of bric-a-brac and objects of art, an upright piano open in one corner, with a banjo, the latest craze, tilting its flat sphere against one leg." If the writer saw any irony in juxtaposing the archetypal African instrument with a black domestic servant in this opulent upper-crust interior, he or she did not let on. In Washington, a debutante hosted a cotillion for which the band was hidden behind a "large wire screen" on which were arranged the favors for the ladies: "Banjos, tied with ribbons, to be hung across the shoulders, feather aigrettes in all colors for the hair, and small ivory toilet boxes with mirrors set in the top."[10]

In the process of translation from its African roots and minstrel-show connections, the banjo itself underwent a dramatic metamorphosis. Manufacturers, stage performers, and parlor musicians aestheticized, modernized, feminized, and trivialized it. In the process, they also whitewashed it, for all that some female entertainers and even society ladies performed in blackface. Its connotations were, and remained, complex. It signified modern femininity and modern leisure, yet at the same time maintained an undertone of blackness, wildness, instinct—all attributes ascribed to the instrument in its premodern, African, and plantation past.

Frances Benjamin Johnston's photograph, ["'Miss Apperson' playing banjo beside statue of 'Flora' in niche of Sen. George Hearst's residence, Washington, D.C."] (c. 1895, fig. 67), showcases old and new models of femininity: it pairs the young banjo-strumming socialite with Leopoldo Ansiglioni's symbolic figure of Spring, a dancing nymph swathed in diaphanous drapery. Johnston (1864–1952) was a leading documentary and portrait photographer on the Washington scene in the late nineteenth century. Known as the "photographer of the American Court," in the 1890s she produced portraits of administration leaders and their families (as well as a series of White House interiors published in 1893). Johnston, an independent career woman, moved between the world of official Washington and her own more bohemian circle of fellow artists, writers, and free spirits.[11] Two of Johnston's self-portraits from the 1890s, now in the Library of Congress, suggest her double nature. In one, she poses ladylike in a plumed hat and fur cape; in the other, she sits mannishly before the hearth in her studio, her legs crossed, petticoats and stockings on display, a cigarette in one hand and a beer stein in the other.

fig. 66

Photographs of Miss Mary C. Browne and Miss Rachel E. F. Morton, reproduced in *College Girls* (Chicago: George Seton Thompson [?], c. early 1910s [?]). Records of the Redpath Chautauqua Bureau, Special Collections Department, University of Iowa Libraries, Iowa City, Iowa.

Shop. But the perennial attraction lay in seeing "Miss Lotta" dance the breakdown and sing comic songs to the accompaniment of her own banjo, which she played "like a prize negro minstrel." Crabtree's sprightly persona belied the hardheaded business sense that enabled her to retire from the stage in 1891 with a fortune estimated at two million dollars. On that fortune she capitalized handsomely, making "shrewd investments" in real estate and buying race horses "with which she won large stakes at harness races." Never married, in later life she made her home in her own Boston hotel, the Brewster, where she died at the age of 77.[5]

Although Lotta Crabtree fit the established mold of the stage actress as a marginal and occasionally maverick figure, she also transcended it. An independent agent, she crafted her kittenish public image, managed her own money, and identified herself as a fully contemporary career woman. She was a vice president of the Professional Women's Association in New York, and she made a bid (albeit an unsuccessful one) for election to the Sorosis Club, an emphatically feminist organization established for professional women by the journalist Jane Croly in 1868.[6]

In Crabtree's hands, the banjo symbolized this new feminine modernity at a time when women's roles, under the pressures of increasingly urgent activism for suffrage, education, and careers, were violently in flux. She paved the way for even more modern performers such as Theresa Vaughn, whom we see posing c. 1895 with her equally up-to-date banjo, the Fairbanks Electric No. 2 (see fig. 28).[7] Modernity was also the keynote of the banjo clubs that proliferated in both men's and women's colleges toward the end of the century. In that context, women's banjo clubs and banjo performances were of particular note. (A few institutions of higher learning had admitted women earlier in the century, but most of the women's colleges did not open their doors until after the Civil War.) In a photograph from the turn-of-the-century publication *College Girls,* the Misses Morton and Browne, sporting frilly dresses and stylish Gibson Girl pompadours, pose with their banjos (fig. 66). Performers in a college concert series, they specialized in southern songs. The songs themselves were archaisms, harking back to mythic antebellum plantation days. They were performed, however, by that most modern type of middle-class young womanhood—the female college student. The banjo even figured in a marriage dispute between a prominent Westchester County lawyer and his wife, who put up a spirited resistance to patriarchal rule. Countering the allegation of cruel treatment, the husband in his defense stated that among his wife's faults were "gin drinking, banjo playing, and singing popular songs."[8]

The banjo was ubiquitous among the late-nineteenth-century New York elite as well. Some women, such as the Misses Pickett, played at tea parties and other gatherings to earn a living. (Members of an "old New-York family," they were in "reduced circumstances" and had decided to support themselves by becoming "parlor banjoists.") The Misses Leech, another banjo duo, often entertained at society functions,

associated with love and romance. Late-nineteenth-century painters who sub-
scribed to the ideals of art for art's sake often used guitars or lutes to echo the mel-
lifluous curves of their models. Thomas Wilmer Dewing, for example, twinned
slender, seductive female figures with such props, as in *Lady with a Lute* (1886,
fig. 65), in which the swelling profile of the instrument amplifies the curve of the
model's breast.[2]

How—if at all—did the banjo fit into such patterns of representation when it
began to appear in conjunction with white, middle-class female players and per-
formers over the last two decades of the nineteenth century? Long associated with
the low, the primitive, and the crude, the banjo drew the scorn of what one propo-
nent called "those highbrow violinists and pianists." Graceless, shaped like a frying
pan, incompatible with the graceful female form, it was not a likely candidate for
the parlor or romance. Yet in the last two decades of the nineteenth century, the
banjo enjoyed what historian Karen Linn describes as a process of "elevation,"
through which that once-degraded instrument was enthusiastically received into
middle- and even upper-class parlors, strummed with zeal by legions of female
amateurs and professionals, and commercially produced in a great range of styles,
from plain to lavish.[3]

Banjo manufacturers and publicists, notably Philadelphia's S. S. Stewart,
played crucial roles in popularizing the instrument through vigorous advertising
that touted the banjo's new gentility. Physical modifications also made it more
acceptable in polite company. Frets facilitated the execution of harmonically based
music, as opposed to the earlier "rhythmic and monophonic" style that was char-
acteristic of minstrelsy. That, along with the introduction of an up-picking guitar-
style technique (instead of the downward-picking banjo, or stroke, style), enabled
the performance of genteel and sentimental parlor music originally written for the
guitar. Finally, the publication of notated banjo music beginning in the early 1880s
helped ignite a society fad that spread beyond the parlor to college clubs, camps,
and other venues of middle-class leisure in the last two decades of the century. As
one "eminent instructor" put it, "Once . . . the banjo was considered a barbarous
instrument, to be classed with the kettle-drum and the tom-tom. . . . Nowadays
the development of musical taste has brought about an appreciation of the higher
possibilities of the banjo. . . . It is quite easy to learn and serves admirably to
accompany singing in the parlor."[4]

Female entertainers, most notably Lotta Crabtree (1847–1924), also helped vault
the banjo to unprecedented heights of popularity among women. Crabtree started
out in blackface, playing the banjo and performing a Topsy act on the stages of San
Francisco and in the mining camps of California and Nevada with her theatrical
family. In 1863 she established herself as a popular sensation in New York, where
she played various roles, including Little Nell in Charles Dickens's *Old Curiosity*

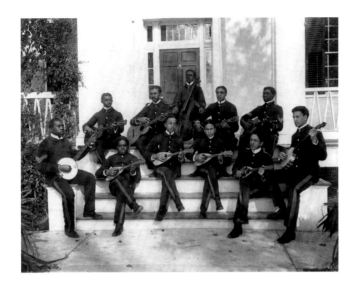

fig. 68
Frances Benjamin Johnston, ["Hampton Insti-
tute, Hampton, Va., ca. 1898—11 students in
uniform playing guitars, banjos, mandolins,
and cello"], 1899 or 1900, photographic print.
Library of Congress, Prints and Photographs
Division, Washington, D.C., LC-USZ62-62377.

The Hearst mansion, at 1400 New Hampshire Avenue, was the grand show-
place of the new senator from California. Johnston photographed it for *Demorest's
Family Magazine* in 1890, depicting room after cavernous room appointed with
stiff, elaborately tasteful décor. Like many wealthy Gilded Age matrons, the sena-
tor's wife, Phoebe Apperson Hearst (originally a Missouri schoolteacher), was an
avid international traveler and collector whose taste endowed the huge fortune of
her miner-turned-politician husband with social and cultural cachet. Within the
splendid halls at 1400 New Hampshire, Mrs. Hearst staged charity entertainments,
concerts, and musicales. She also found room in her life for "bevies of girls," whom
she sponsored, educated, pampered, and spoiled—including her niece Ann Dru-
cilla Apperson (b. 1878), almost certainly the banjo player in Johnston's picture.[12]

Theatrically framed by plush drapes, Miss Apperson strikes a playful, jaunty
pose in counterpoint to the demure goddess on her pedestal. The marble figure
hovers lightly, veiled and clad in swirling fabric, scattering spring blossoms. A
symbolic virgin in her flower, she embodies Victorian notions of pure, perfect
maidenhood. Ann Apperson's antics, by contrast, have an almost bohemian dash.
Blithely ignoring the posy Flora holds out to her, the fashionable miss props one
knee on a spindly neo-classical chair and energetically plucks her banjo, elbows
out, as if playing a minstrel breakdown for Flora's dancing feet. Miss Apperson is
no icon of girlish innocence: she personifies bold, contemporary young woman-
hood, insouciantly picking the strings of an instrument only recently elevated from
its lowly beginnings. In that ornately aristocratic corner, the banjo strikes an
incongruous note, much as Miss Apperson's up-to-date modishness and casual
stance mock Flora's chaste and timeless ideality.

Yet the banjo, in Johnston's work as in the culture at large, also led a double life
of sorts. In 1899, on commission, Johnston took a large number of photographs

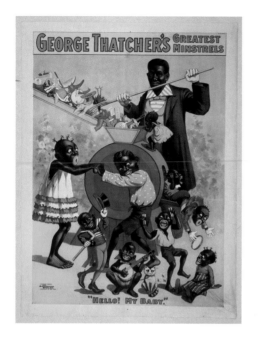

fig. 69 *(left)*
George Thatcher's Greatest Minstrels, 1899, color lithograph, 39³⁄₄ × 29⁷⁄₈ inches. Published by Strobridge Lithographic, New York. Library of Congress, Prints and Photographs Division, Washington, D.C., LC-USZC2-1772.

fig. 70 *(right)*
Charles S. Reinhart, *A Reminiscence of the White Sulphur Springs* (detail), wood engraving, 8¹¹⁄₁₆ × 13⁷⁄₁₆ inches. Published in *Harper's Weekly* 32 (4 August 1888): 576. The Pennsylvania State University Libraries, University Park, Pennsylvania.

documenting student life and racial progress at the Hampton Institute in Virginia. Founded during Reconstruction for the education and technical training of southern blacks and Native Americans, the Institute used Johnston's photographs for publicity and fund-raising. The images show students, male and female, learning useful skills in classrooms and workshops. One shows a group of young, neatly uniformed black musicians posing with their instruments: two banjos, four mandolins, four guitars, and a lone cello (fig. 68). The banjo players frame the rest like bookends. Their quasi-military dress symbolizes the values of order and discipline that the Hampton Institute sought to instill in its students. The Hampton musicians are grimly serious, as if to distance themselves from the taint of the African American's detestable popular image in the widely circulated "coon songs" of the 1890s. But their instruments inexorably evoke the ubiquitous image of "the plantation negro, with his curious talk, his childish interest in trifles, and his omnipresent banjo."[13] Indeed, in the very same year as Johnston's photograph, the Strobridge Lithographic Company published the song "Hello! My Baby" (fig. 69). On the cover are several demeaning caricatures, among them a little banjo-picking boy, squatting and leering with enormous lips.

Publicists and performers made a concerted effort to "elevate" the banjo, but many white entertainers as well as society amateurs indulged in their own style of musical caricature. They played and sang so-called plantation melodies, most of them by way of blackface minstrelsy. The songs often featured a grotesquely phonetic spelling of dialect: "Gwuffum hyah, strangah, / Pass dat cabin doh!"[14] We do not know, of course, what Miss Apperson might be playing, or pretending to play,

as she capers under Flora's veiled gaze. Chances are, however, that it is a plantation melody like those so often favored by socialites at their tea parties and fund-raisers. But the connotations of the plantation song were not all so innocent as the image of the "childish" slave might suggest.

Despite its "ascent" in the world, plantation music, rooted in what were perceived to be "strange, barbaric" African worlds of magic and primitive ritual, carried a sexual charge, however muffled by convention and decorum. For that reason, presumably, it was one of the therapies a New York doctor reportedly recommended to nervous women. A "rattling darkey melody briskly played on the banjo" would invigorate their flagging spirits and enable them, if only briefly, to escape the world of "civilized" discipline and self-restraint into some Dionysian frenzy. A short story published in 1903 played quite salaciously on such connotations. The heroine describes herself as one who can play the banjo "like the devil," her instrument a moody and capricious "witch"—sometimes sulky and mournful, at other times a "brawling roisterer," crude and shrill, and at still others boundlessly wild and rowdy. The banjo comes to her as the impromptu gift of a darkly handsome and mysterious "dare-devil drunk" encountered in Arizona, "playing his soul and all his future away to a greedy, infatuated, hatefully beautiful, sickeningly shoddy half-breed woman." His strident music is "like all the imps of hell let loose," and his face "crowded and jostled with all the badness and all the goodness you had ever dreamed of." After years of separation and erotic yearning, the two meet again and are happily joined. Throughout the story, the banjo unambiguously functions as metaphor for untrammeled passion and libidinal energy.[15]

Cleaned up, something of that same libidinal energy can be sensed in an article describing a young couple's honeymoon at White Sulphur Springs in West Virginia. In the illustration by Charles Reinhart (1888, fig. 70), the new bride sways in a hammock, strumming a banjo, while her handsome husband, ardently gazing, sips mint juleps. The text describes the moment: "The Lady does not sing. . . . What she does is with slow moving fingers to draw a few harmonious chords from her banjo, and she keeps time with the rhythmic balancing of her hammock. It is a low, sweet murmur of sound." On the table by her side are a bottle of wine and a melon, suggestively cut open. Slow moving fingers, sweet murmurs, rhythm, phallic bottle, slit fruit: all contribute to the erotic insinuations of the scene.[16] The painter H. Siddons Mowbray made explicit what Reinhart only tactfully implied. In *Fairy Music* (see fig. 29), a bare-breasted model looks out and smiles enticingly while strumming the large banjo on her lap.

Miss Apperson's modernity, then, is complicated by the banjo's innuendos of blackness and sexuality, all the more piquant when juxtaposed with the virginal innocence symbolized by the statue of Flora. Miss Apperson is not in blackface. But something about her banjo hints at the phallic suggestiveness of its deploy-

fig. 71
Mary Cassatt, reproduction of *Art, Music, Dancing* from right panel of *Modern Woman* mural, 1893, at World's Columbian Exposition, Chicago, 1¹¹/₁₆ × 7½ inches (image). Photograph in Maud Howe Elliott, *Art and Handicraft in the Woman's Building of the World's Columbian Exposition, Chicago, 1893* (New York: Goupil, 1893), 35. Special Collections Library, The Pennsylvania State University Libraries, University Park, Pennsylvania.

ment on the antebellum minstrel stage.[17] It is, of course, filtered through (and disguised by) layers of history, class, and gender. We might see Miss Apperson's performance, in her own "natural" whiteface, as a whitewash: a kind of inversion or impersonation through which she can, if only temporarily, appropriate some stereotypical notion of black identity involving vague intimations of orgiastic abandon. In that this role-playing challenges older Victorian ideals of chaste maidenhood, it is also the subversive sign of her modernity.

A different sort of modernity was on Mary Cassatt's mind when she produced several variations on the banjo theme in the early 1890s. Commissioned to paint a mural allegorizing "modern woman" for the Woman's Building at the Columbian Exposition in 1893, Cassatt decided to use appropriately contemporary symbolism for her fully up-to-date young women, seen pursuing fame, plucking the fruits of knowledge, and mastering the arts (fig. 71). As she described it to Bertha Palmer, president of the Exposition's Board of Lady Managers, the latter panel of the *Modern Woman* mural would represent "the Arts, Music (nothing of St. Cecelia) Dancing & all treated in the most modern way." For Cassatt, this modernity entailed replacing St. Cecelia and her organ with a young woman playing a banjo to accompany another doing a skirt dance. As Sally Webster has revealed, the skirt dance in the 1890s represented the most modern alternative to traditional dance forms, such as ballet. Flamboyantly performed by the American Loïe Fuller at the 1889 Exposition Universelle in Paris, it featured high kicks and voluminous, swirling draperies. Like banjo music, it owed little or nothing to classical forms; its roots lay in popular music halls. It was wildly popular in the late 1880s and the

1890s.[18] In choosing to represent the skirt dance and the banjo, Cassatt emphatically aligned herself with the most contemporary modes of femininity.

Webster writes that the skirt dance and the banjo in Cassatt's mural also indicate that the artist "was very conscious of her American audience." The artist always maintained close contact with her family, and her two young American nieces may have been her conduit into current fads and fashions. Yet like the novelist Henry James, Cassatt was also intensely ambivalent about the United States and its culture, and she lived in France as a permanent expatriate. As a young art student, she had attended opera performances rather than the disreputable music halls or cabarets frequented by her male colleagues. On one occasion (albeit as a grumpy *grande dame* of art), Cassatt announced to an American art student who had made a pilgrimage to see her idol, "So, you're an American? I don't like Americans. I've been in France too long." Were the banjo player and skirt dancer in the *Modern Woman* mural ever so slyly tongue-in-cheek regarding modern America and its raw, young popular culture? Was the artist simply intent on modernizing worn-out, traditional iconography? Or did she select the banjo specifically because it had come to be seen as an authentically American instrument?[19]

Whatever the case, she found the banjo theme sufficiently interesting to explore it in a group of prints and pastels representing a dark-haired woman demonstrating a chord to a younger girl (perhaps a little sister), who peeks over the elder's shoulder, their cheeks almost touching (see figs. 72, 73, 27). Here again, as in the Chicago mural, Cassatt modernized an old theme—in this case, her own earlier work, such as the 1872 *Mandolin Player* (private collection) or the 1869 *Young Woman Wearing a Ruff* (present location unknown), in which the subject also plucks the strings of a mandolin. Those paintings represented women in peasant or antiquated dress, playing picturesque instruments. Cassatt's teacher and pupil, by contrast, are utterly up-to-date. They appear to be middle class. The older girl sports a fashionable dress with huge puffed sleeves (not unlike Miss Apperson's) and a high collar. Like the women reaching for the fruits of knowledge in the center panel of her *Modern Woman* mural, these two need no patriarchal authority. They share and transmit knowledge on their own, independent of men.[20]

Cassatt's *Banjo Lesson* prints and pastels have a dark double in Henry Ossawa Tanner's exactly contemporary painting, *The Banjo Lesson,* which the African American artist completed in Philadelphia in 1893 (see fig. 112). Raised in that city and trained at the Pennsylvania Academy of the Fine Arts, Tanner had recently returned from Paris. In painting *The Banjo Lesson,* he embarked on what would be a brief exploration of African American themes before going back to Paris and making biblical subjects the basis of his life's work. The settling is a humble interior, where an elderly, white-bearded black man teaches a young boy, perhaps his grandson, to play a tune. The boy, barefoot, stands between the old man's knees,

and their cheeks (like those of Cassatt's young women) almost touch. Like Cassatt's figures, too, they are solemn and intent on the task at hand. In Tanner's painting, the youngster, helped by his mentor, awkwardly fingers a chord and plucks the strings.

The genesis of the idea may have come from Highlands, North Carolina, where Tanner traveled in the summer of 1889 and encountered a small African American community living in primitive rustic conditions. No work has survived from that trip; when Tanner took up the subject of rustic black music making four years later, he posed models in his Philadelphia studio. His aim in painting *The Banjo Lesson* was, as he put it, to "represent the serious, pathetic side" of black life with sympathy and appreciation. In Albert Boime's view, *The Banjo Lesson* is a thoroughgoing subversion of the "banjo-picking Negro," while Judith Wilson argues that it reified the ideology of racial uplift, self-help, and self-esteem promulgated by the African Methodist Episcopal (A.M.E.) Church. Regardless of Tanner's specific agenda, *The Banjo Lesson* is an intimate, sentimental scene without (as many have noted) a trace of caricature. Rather, the painting extols and celebrates the dignity of black American culture and the vitality of its traditions, taught by one generation to the next.[21]

Cassatt's *Banjo Lesson* pictures are as white as Tanner's is black. In them, she performs an act of appropriation that is, simultaneously, an act of erasure, one that literally expunged the "black" tradition and connotations of the banjo and replaced them with "white." Tanner's *Banjo Lesson* was exhibited at the Salon in Paris in May 1894. It may have been the painting now in the Hampton Institute, but the artist also produced another version now known only through the wood engraving published in *Harper's Young People* in 1893 (see fig. 90). In that version, the old man and the boy are cheek to cheek, both gazing down at the boy's hand moving tentatively over the strings. In Cassatt's composition, the older girl plays the instrument, but here too both are cheek to cheek, looking with equal concentration at the teacher's hand on the fingerboard. Might Cassatt have seen Tanner's painting at the Salon? We know, of course, that she had taken up the banjo theme on her own when designing the mural for the Chicago fair. But might Tanner's painting have rekindled her interest? We can only speculate. Still, Tanner's imagery and Cassatt's are uncannily close, the one a dark mirror of the other.[22]

Tanner's dark players haunt Cassatt's image, much as the banjo players in Johnston's Hampton Institute photograph haunt the image of Miss Apperson playing her impertinent tune under the blindingly white statue of Flora. In only one of Cassatt's images do the two worlds appear to collide. In the third and next-to-last state of the drypoint and aquatint, Cassatt no doubt sought aesthetic effect as she tried out different versions of the print (see fig. 72). Yet her experimentation rendered the models' flesh tones in such a uniform light brown shade that, were it

fig. 72
Mary Cassatt, *The Banjo Lesson* (iii/iv), 1894, drypoint and aquatint, 11¾ × 9½ inches. The Philadelphia Museum of Art. Purchased with Joseph E. Temple Fund, 1949, 1949-89-17.

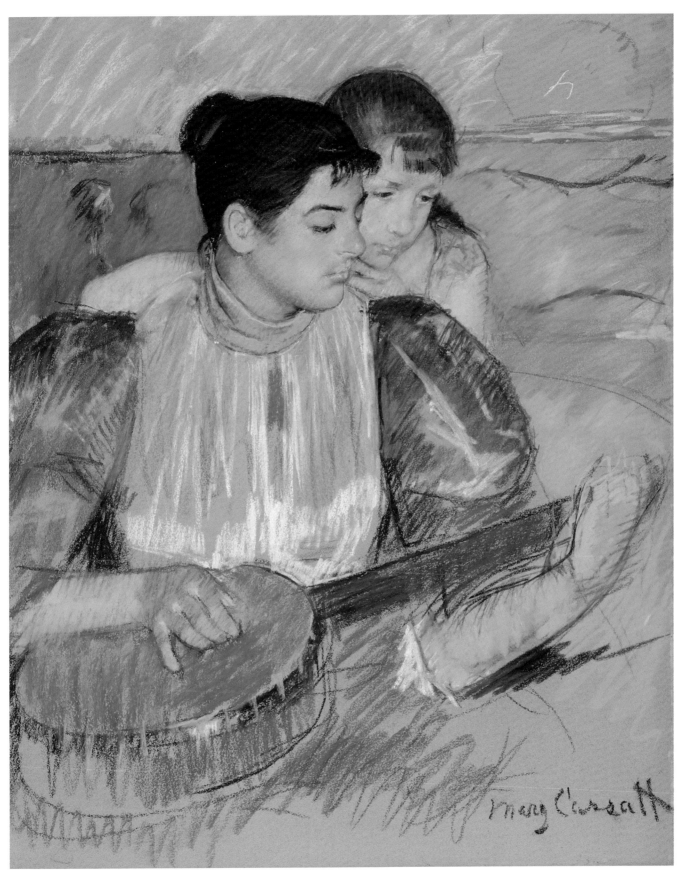

fig. 73

Mary Cassatt, *The Banjo Lesson,* 1894, pastel on paper, 28 × 22½ inches. Virginia Museum of Fine Arts, Richmond. The Adolph D. and Wilkins C. Williams Fund. Photo: Katherine Wetzel, © Virginia Museum of Fine Arts.

fig. 74
Childe Hassam, *A Familiar Tune,* c. 1880s,
watercolor on board, 15 × 21¼ inches. Flo-
rence Griswold Museum, Old Lyme, Connecti-
cut. Gift of The Hartford Steam Boiler Inspec-
tion Company, 2002.1.65.

not for their Caucasian features, they might "pass" as black. The darkening of her
middle-class subjects' complexions (however fortuitous) gives us a momentary
consciousness of what the "elevation" of the banjo involved: the neutralization,
domestication, and gentrification of the banjo's racial past. In that respect, Cas-
satt's *Banjo Lesson* is as thoroughgoing a whitewash as Miss Apperson's perform-
ance. Perhaps it was no accident that Boston manufacturer A. C. Fairbanks's most
wildly popular banjo, introduced in 1901, was named the "Whyte Laydie."[23]

More so even than Cassatt's images, Childe Hassam's early watercolor *A Famil-
iar Tune* (c. 1880s, fig. 74) not only domesticated and whitened the banjo but also
endowed it with utterly fictitious Yankee roots. The setting is an early New Eng-
land interior furnished with rag rugs, Windsor chairs, a slant-front desk, and artis-
tic touches, such as the portfolios leaning against the desk and the vase of white
flowers sitting on top of it. Above the brick fireplace, the chimneypiece is paneled
in dark wood; within the glowing hearth is an iron crane for suspending pots, sug-

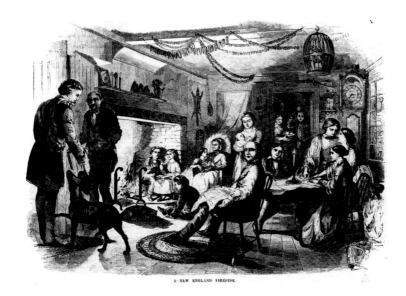

A NEW ENGLAND FIRESIDE.

fig. 75
Asa Coolidge Warren, *A New England Fire-
side*, 1855, wood engraving reproduced in *Bal-
lou's Pictorial* 8 (10 March 1855): 145. Photo
courtesy Sarah Burns.

gesting that the room originally functioned as a kitchen. To the right of the hearth, a pretty young woman in black wears a meditative expression as she sits in a Windsor chair and plucks the strings of the banjo in her lap. A black cat crouches nearby, and across the room her two black kittens tumble about. In its exaltation of the commonplace and its mood of domestic peace, *A Familiar Tune* resonates with the "spirit of the Dutchmen," as Hassam characterized his youthful work.[24]

From a very young age Hassam cultivated an interest in New England antiquities. A true Yankee who could (with pride) trace his family tree back many generations, he was born in the old town of Dorchester, Massachusetts, where his father, a cutlery merchant, had a barn full of old furniture and ancient junk. As a fledging artist, Hassam worked in book and magazine illustration and immersed himself in the antiquities and landscapes of Gloucester, Nantucket, Sudbury, and other time-worn Massachusetts towns. He developed a colorful, decidedly French-inflected Impressionist style in maturity, yet so strong and deep were his associations with New England that admirers persisted in characterizing him as a Puritan. Among his favorite writers were Ralph Waldo Emerson and Henry David Thoreau. Many of Hassam's later paintings, such as *In the Old House* (1914, private collection), celebrated the beauty of Colonial interiors graced with Windsor chairs and Federal-era carving. *A Familiar Tune* is a very early (and pre-Impressionist) essay along those same lines.[25]

Except for the banjo, the iconography of *A Familiar Tune* comes straight out of the Colonial Revival, which had been gathering momentum since the 1876 Centennial in Philadelphia. Spurred by nostalgia and multiple anxieties about demographic change after the Civil War, the Colonial Revival sought strength and authenticity in the material culture of early New England. In his influential guide,

The House Beautiful, tastemaker and critic Clarence Cook (like Hassam, a native of Dorchester) praised the special quality of old American furniture: "in going back to its use, in collecting it, and saving it from dishonor, and putting it in safe-keeping, we are bringing ourselves a little nearer in spirit to the old time."[26]

More than any other room, the New England kitchen's Windsor chairs, rag rugs, blazing hearth, and basking cats embodied those frugal, sturdy, ancestral values. In Asa Coolidge Warren's wood-engraved illustration *A New England Fireside* (1855, fig. 75), for example, all of those components are present, lending a sense of cozy domestic warmth to the family scene. Windsor chairs and capacious fireplaces appear again and again in Eastman Johnson's popular paintings of Nantucket interiors, relics of a better, bygone age. In the 1880s, Hassam himself had two rod-back Windsor chairs like those in *A Familiar Tune* in his Boston studio. The slant-front desk in Hassam's painting also connotes ancestral rectitude: the Puritan elder William Brewster had brought such a writing desk over on the *Mayflower.* A venerable heirloom, it was now in the possession of a descendant in Lyme, Connecticut, where Hassam would later produce so many paeans to old New England.[27]

Only the banjo strikes a glaringly incongruous note in Hassam's interior, suffused with references to the New England past. What does it mean? The title of the painting prompts us to think of the "familiar" as something handed down, like the antique desk and chairs. But we might ask if this Colonial kitchen is what it appears to be. The puffy white bouquet and the portfolios suggest, rather, an artist's studio, where an eclectic array of furnishings and accessories create what was then styled as "art atmosphere." Antiquarian painters, in particular, filled their studios with period props that could then be incorporated into historicizing genre scenes. One of Hassam's contemporaries, Frank D. Millet, had a summer studio in Bridgewater, Massachusetts, where he installed, intact, a kitchen "taken bodily from a house in the neighborhood built in 1695." While Hassam's interior in *A Familiar Tune* is not his own Boston studio, in its gathering of well-crafted artifacts tastefully arranged, it suggests an artistic sensibility at work, not merely that of the nostalgia-driven antiquarian.[28]

In that context, the banjo is not so inconsistent as it might at first appear. It could be part of a painter's studio paraphernalia. Boston artist William Morris Hunt kept a banjo with other instruments in his studio and on some occasions, "merry and light-hearted," he would take it up, "play a little, sing a French song, joke a great deal, and tell stories."[29] In Philadelphia, Thomas Eakins or one of his close associates had a banjo; it appears, most anachronistically, in a photograph of Blanche Gilroy (c. 1885, fig. 76), reclining in classical costume, the banjo propped at her feet. In *Cowboy Singing* (1888, fig. 77), Eakins portrayed his student Franklin Schenck sitting in a Windsor chair, accompanying himself on a banjo (perhaps the same one we see in the Blanche Gilroy image) and dressed up in a fringed buckskin

outfit Eakins had brought back from the Dakotas in 1887. The banjo—with its savor of otherness, of the social fringe—was a seamless fit in the bohemian atmosphere of the studio.

Windsor chairs and banjos, indeed, often kept company. Like Hassam's model and Eakins's cowboy, the Philadelphia painter Thomas Hovenden's black banjo players also posed with Windsor chairs. In *Dem Was Good Ole Times* (1882, fig. 78), a grizzled old black man smokes his pipe, banjo deposited on the seat of a fan-back Windsor, seen in profile to the right; in the painting *I's So Happy!* (1885, fig. 79), known today only by a print after the work, the fan-back chair is behind the same model, who now faces front, banjo in play. Like his contemporaries, Hovenden collected antiques to use in staging his rustic New England or southern genre scenes. Well-crafted and authentically American, or at least nativized, the Windsor chair and the banjo were emblematic of bygone days, north and south. Hovenden elided any harsh reference to the historical reality of slavery, leaving little but melancholy sweetness.[30] His paintings, like Hassam's, also obscure the fact that by the 1880s, banjos—far from being lovingly handcrafted—were being turned out by the thousands in factories and marketed aggressively through mass-market newspapers and magazines.

In Hassam's *Familiar Tune*, the banjo has undergone a thoroughgoing metamorphosis. Aestheticized and turned Yankee, it signifies homey, innocuous, arty

fig. 76
Thomas Eakins, *Blanche Gilroy in Classical Costume, Reclining, with Banjo,* c. 1885, albumen print, 2⁷/₈ × 4⁹/₁₆ inches. Courtesy the Pennsylvania Academy of the Fine Arts, Philadelphia. Charles Bregler's Thomas Eakins Collection. Purchased with the partial support of the Pew Memorial Trust, 1985.68.2.250.

fig. 77
Thomas Eakins, *Cowboy Singing*, 1888, oil on
canvas, 24 × 20 inches. The Philadelphia
Museum of Art. Gift of Mrs. Thomas Eakins
and Miss Mary Adeline Williams, 1929, 1929-
184-22. Photo: Graydon Wood.

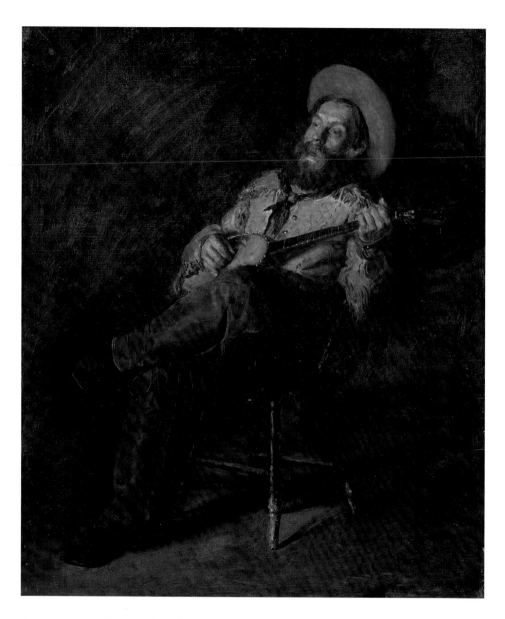

domesticity. Whatever is primitive or wild has been displaced onto the black cat
and kittens—small dark bundles of instinct (domesticated "familiars," perhaps)
safely contained in this old-fashioned yet tastefully calculated interior. While the
cats may also refer obliquely to the sexuality of the young woman, that, too, seems
securely bottled up. Despite her modish dress, she is as antimodern as Miss Apper-
son, breaking out of the Victorian box, is flagrantly contemporary. Here, too, the
artist's gender may tell. Whereas both Johnston and Cassatt were themselves
decidedly modern women, photographing and painting women as modern as they
were, Hassam, a young but fairly conventional man, persistently depicted women
in their domestic and ornamental capacity.

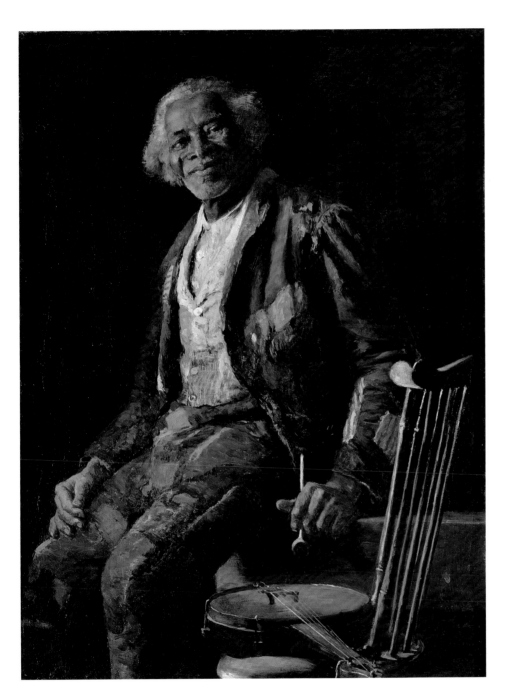

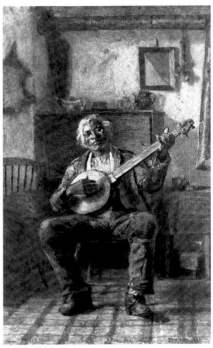

fig. 78 (left)
Thomas Hovenden, *Dem Was Good Ole Times,* 1882, oil on canvas, 16⅛ × 12⅛ inches. Chrysler Museum of Art, Norfolk, Virginia. Museum purchase with funds provided by the Chrysler Museum Landmark Communication Art Trust; an anonymous donor; Mr. and Mrs. Richard M. Waitzer; Mr. and Mrs. Richard F. Barry III; and the Museum's Accession Fund, 92.49.1.

fig. 79 (above)
Willy Miller, *I's So Happy!* (after a lost painting by Thomas Hovenden), 1885, engraving, 8⅞ × 5¹¹⁄₁₆ inches. Collection of James F. Bollman. Photo: Dana Salvo.

In the 1880s and 1890s, the banjo in the hands of middle-class Euro-American women was a floating signifier connoting a multiplicity of often contradictory meanings. It led a double life, its dark past haunting its daylight present. It was primitive and refined, wild and domesticated. It was modern yet antimodern, southern yet northern. It was white and yet it was always also black, however thick the whitewash. For every banjo-strumming socialite, every genteel feminine banjo lesson, every nostalgic tune, there were dark doubles. Euro-American women who took up the banjo proclaimed their modernity and independence. At the same time, they also aligned themselves, if only symbolically, with an oppressed and dis-enfranchised race with which (as second-class citizens in patriarchal society) they had more in common than they may have known. In the late nineteenth century, the banjo was the hidden link that joined them. Only in the twentieth century would both groups put aside their banjos as they embarked on the long journey toward full citizenship.

NOTES

1. Rita Steblin, "The Gender Stereotyping of Musical Instruments in the Western Tradition," *Canadian University Music Review* 16, no. 1 (1995): 139. For background on women and music in nineteenth-century America, I have relied on a number of invaluable sources, including Julia Eklund Koza, "Music and the Feminine Sphere: Images of Women as Musicians in *Godey's Lady's Book*, 1830–1877," *The Musical Quarterly* 75 (Summer 1991): 103–29; John Louis Salsini, "The Guitar and the Ideal of Femininity in Nineteenth-Century America" (M.A. thesis, University of Minnesota, 1990); Judith Tick, "Passed Away Is the Piano Girl: Changes in American Musical Life, 1870–1900," in *Women Making Music: The Western Art Tradition, 1150–1950*, ed. Jane Bowers and Judith Tick (Urbana: University of Illinois Press, 1986), 325–48; Lynn Hizer-Jenkins, "Instruments and Gender in Nineteenth-Century Music Making," *NACWPI Journal* 44 (Spring 1996): 4–12; and Jeffrey Kallberg, "The Harmony of the Tea Table: Gender and Ideology in the Piano Nocturne," *Representations* 39 (Summer 1992): 102–33. In the later nineteenth century, the rigidly gendered distinctions between "male" and "female" instruments began to break down as more and more women took up the violin, cello, or flute.

2. Clarence Cook, "Home and Society, Some Old-Fashioned Things Worth Reviving," *Scribner's Monthly* 22, no. 1 (1881): 148. Cook, however, considered the piano an awkward and decidedly unpicturesque object in painting. On the iconography of music in American art, see *The Art of Music: American Paintings and Musical Instruments, 1770–1910* (Clinton, N.Y.: Hamilton College, Fred L. Emerson Gallery, 1984). Also see Ronald G. Pisano, *Idle Hours: Americans at Leisure, 1865–1914* (Boston: Little, Brown, 1988), 33–34.

3. Thomas J. Armstrong, "A Forty-Year Banjo War," *The Crescendo* 8 (August 1915): 20; Karen S. Linn, *That Half-Barbaric Twang: The Banjo in American Popular Culture* (Urbana: University of Illinois Press, 1991), 5–39. Much of the background I sketch here is taken from Linn's invaluable study. Also indispensable is Philip F. Gura and James F. Bollman, *America's Instrument: The Banjo in the Nineteenth Century* (Chapel Hill: University of North Carolina Press, 1999).

4. Linn, *That Half-Barbaric Twang*, 16–18; "The Evolution of the Banjo," *New York Times*, 5 November 1883, 5. On Stewart's role in gentrifying and popularizing the banjo, see Gura and Bollman, *America's Instrument*, 137–90.

5. "Amusements: Wallack's Theatre," *New York Times*, 30 July 1867, 5; "Lotta Crabtree, Actress, Is Dead," *New York Times*, 26 September 1924, 21. Biographies of Crabtree include Constance Rourke, *Troupers of the Gold Coast, or The Ride of Lotta Crabtree* (New York: Harcourt, Brace, 1928); Phyllis Wynn Jackson, *Golden Footlights: The Merry-Making Career of Lotta Crabtree* (New York: Holiday House, 1949); and David Dempsey with Raymond P. Baldwin, *The Triumphs and Trials of Lotta Crabtree* (New York: William Morrow, 1968).

6. Information on Crabtree's club memberships comes from "Lotta Doesn't Care a Snap," *New York Times*, 19 May 1893, 2. According to this article, only seven votes (out of more than two hundred) prevented Crabtree's election to the Sorosis, the issue being the nominee's stage career, which at least some persisted in viewing as morally questionable.

7. On the popularity of the Fairbanks Electric model, see Gura and Bollman, *America's Instrument*, 212–17. Despite its name, the Electric was an acoustic instrument, though it had a vibrant tone because of a new rim design.

8. "M'Cahill's Domestic Woes," *New York Times*, 19 July 1892, 5.

9. "The Social World," *New York Times*, 22 June 1894, 2; "The Liederkranz's Anniversary," *New York Times*, 12 January 1896; "Society Women as Minstrels," *New York Times*, 19 December 1893, 12.

10. "A Society Lady's Routine," *New York Times*, 17 January 1886, 2; "In Washington Society," *New York Times*, 14 January 1892, 4.

11. Bettina Berch, *The Woman Behind the Lens: The Life and Work of Frances Benjamin Johnston, 1864–1952* (Charlottesville: University Press of Virginia, 2000), 30. Berch's study gives a useful overview of Johnston's career. Also see Pete Daniel and Raymond Smock, *A Talent for Detail: The Photographs of Miss Frances Benjamin Johnston, 1889–1910* (New York: Harmony Books, 1974), and Jennifer Watts, "Frances Benjamin Johnston: The Huntington Library Portrait Collection," *History of Photography* 19 (Fall 1995): 252–62.

12. Phoebe Apperson Hearst was the mother of the notorious newspaper mogul William Randolph Hearst. See Winifred Black Bonfils, *The Life and Personality of Phoebe Apperson Hearst* ([1928]; rpt., San Simeon, Calif.: Friends of Hearst Castle, 1991); on her relations with young women and her niece Ann, whom she raised like her own daughter, see especially 31 and 134–35. I thank Jennifer Watts for her help in identifying "Miss Apperson." Johnston's photographs of the mansion appeared in Frances Benjamin Johnston, "Some Homes Under the Administration: The Residence of Senator Hearst of California," *Demorest's Family Magazine* 26 (October 1890): 712–20.

13. Kilham, "Sketches in Color," *Putnam's Magazine* 15 (February 1870): 206. On Johnston's Hampton photographs, see James Guimond, *American Photography and the American Dream* (Chapel Hill: University of North Carolina Press, 1991), 23–53. Interestingly, the Native American orchestra at the Hampton Institute posed with "classical" instruments, including violins, trumpets, and a clarinet.

14. Translation: "Go away from here, stranger. / Pass that cabin door!" Taken from Henry Tyrrell, "The Evolution of a Dialect Poem: When de Honeyshuck's in Bloom," *Bric-a-Brac: Century Popular Quarterly* 40 (May 1890): 160. On the divergent directions of late-nineteenth-century banjo music, see Linn, *That Half-Barbaric Twang*, 18–23, 48–49.

15. "The Evolution of the Banjo"; "The Music Cure Is the Latest," *Philadelphia Press*, 24 May 1896, quoted in Linn, *That Half-Barbaric Twang*, 41. For a vivid sense of the banjo's associations with the orgiastic and the wild, see George Washington Cable, "Creole Slave Songs," *Century Illustrated Magazine* 31 (April 1886): 820, which describes a voodoo ritual accompanied by a "hideous combination of banjo and violin"

to which participants dance in a delirious frenzy. Jean D. Hallowell, "The Girl with the Banjo," *Lippincott's Monthly Magazine* 72 (July–December 1903): 594–603.

16. "A Reminiscence of the White Sulphur Springs," *Harper's Weekly* 32 (4 August 1888): 575. Linn discusses the illustration as "a picture of upper-class privilege, with a hint of feminine decadence" (*That Half-Barbaric Twang*, 30).

17. Eric Lott, *Love and Theft: Blackface Minstrelsy and the American Working Class* (New York: Oxford University Press, 1993), 117. I borrow Lott's model in suggesting that Miss Apperson's performance is an act of cultural thievery and transvestitism.

18. Mary Cassatt, letter to Bertha Honore Palmer, 11 October 1892, in Nancy Mowll Mathews, ed., *Cassatt and Her Circle: Selected Letters* (New York: Abbeville, 1984), 238. See Sally Webster, *Eve's Daughter/Modern Woman: A Mural by Mary Cassatt* (Urbana: University of Illinois Press, 2004), 91–98, for an absorbing discussion of the skirt dance and the banjo-playing theme in Cassatt's mural.

19. Webster, *Eve's Daughter*, 96; Anna Thorne, "My Afternoon with Mary Cassatt," *School Arts* (May 1960): 11, quoted in Nancy Mowll Mathews, *Mary Cassatt: A Life* (1994; new ed., New Haven, Conn.: Yale University Press, 1998), 271.

20. On the prints, see Nancy Mowell Matthews and Barbara Stern Shapiro, *Mary Cassatt: The Color Prints* (New York: Harry N. Abrams in association with Williams College Museum of Art, 1989), 48–49, 164.

21. Tanner quoted in Dewey F. Mosby, *Henry Ossawa Tanner* (Philadelphia: Philadelphia Museum of Art; New York: Rizzoli International Publications, 1991), 116; Albert Boime, "Henry Ossawa Tanner's Subversion

of Genre," *Art Bulletin* 75 (September 1993): 423; Judith Wilson, "Lifting 'The Veil': Henry O. Tanner's *The Banjo Lesson* and *The Thankful Poor*," *Contributions in Black Studies* 9–10 (1990–92): 31–54. Notably, *The Banjo Lesson* in 1894 went to the Hampton Institute, where Frances Benjamin Johnston would photograph the student banjo players in their quasi-military uniforms five years later.

22. See Mosby, *Henry Ossawa Tanner*, 120–22, on the problem of pinning down the evidence that the Hampton *Banjo Lesson* actually was exhibited at the Paris Salon. On the lost *Banjo Player*, see Eileen Southern and Josephine Wright, *Images: Iconography of Music in African-American Culture* (New York: Garland, 2000), 27. I am indebted to Leo Mazow for directing my attention to this source through his "From Sonic to Social: Noise, Quiet, and Nineteenth-Century American Banjo Imagery," paper delivered at the College Art Association Annual Meeting, Seattle, 2004, 13n23. The supposition that Cassatt saw Tanner's *Banjo Lesson* in Paris is speculative. The painting was hung high, and she would have had to be looking actively to notice and study it.

23. On the Whyte Laydie, see Gura and Bollman, *America's Instrument*, 219–20.

24. Hassam quoted in Adeline Adams, *Childe Hassam* (New York: American Academy of Arts and Letters, 1938), 75.

25. On Hassam, see Ulrich W. Hiesinger, *Childe Hassam: American Impressionist* (New York: Prestel, 1994); Warren Adelson, Jay E. Cantor, and William H. Gerdts, *Childe Hassam: Impressionist* (New York: Abbeville, 1999); and H. Barbara Weinberg, *Childe Hassam: American Impressionist* (New Haven, Conn.: Yale University Press for Metropolitan Museum of Art, New York, 2004), especially Elizabeth Broun, "Hassam's Pride in His Ancestry," 285–94. For a typical assessment

of Hassam as a native son, see Israel White, "Childe Hassam—A Puritan," *International Studio* 45, no. 178 (December 1911): xxix–xxxvi. Hassam began to use the distinguishing crescent before his signature about 1883; the watercolor likely dates from that time, c. 1883–85, when he produced a large body of watercolors dealing with New England themes.

26. Clarence Cook, *The House Beautiful: Essays on Beds and Tables, Stools and Candlesticks* (New York: Scribner, Armstrong, 1878), 188–89.

27. Useful studies of the cult and the material culture of the Colonial Revival include Alan Axelrod, ed., *The Colonial Revival in America* (New York: W. W. Norton for The Henry Francis du Pont Winterthur Museum, 1985); Elizabeth Stillinger, *The Antiquers* (New York: Alfred A. Knopf, 1980); and William H. Truettner and Roger B. Stein, eds., *Picturing Old New England: Image and Memory* (New Haven, Conn.: Yale University Press for the National Museum of American Art, Smithsonian Institution, 1999). On the Brewster desk, see Martha J. Lamb, "Lyme," *Harper's New Monthly Magazine* 52 (February 1876): 321. For a photograph of Hassam's studio, replete with Windsor chair, see Hiesinger, *Childe Hassam*, 17.

28. Lizzie W. Champney, "The Summer Haunts of American Artists," *Century Magazine* 30 (October 1885): 856. On "art atmosphere," see Sarah Burns, "The Price of Beauty: Art, Commerce, and the Late Nineteenth-Century American Studio Interior," in *American Iconology: New Approaches to Nineteenth-Century Art and Literature*, ed. David C. Miller (New Haven, Conn.: Yale University Press, 1993), 209–38.

29. Henry C. Angell, "Records of W. M. Hunt," *Atlantic Monthly* 45 (April 1880): 562.

30. On Hovenden, see Anne Gregory Terhune et al., *Thomas Hovenden: American Painter of Hearth and Homeland* (Philadelphia: Woodmere Art Museum, 1995).

fig. 80
William Sidney Mount, *The Banjo Player*, 1856,
oil on canvas, 35¾ × 28¾ inches. The Long
Island Museum of American Art, History &
Carriages, Stony Brook, New York. Gift of
Mr. and Mrs. Ward Melville, 1955.

From Sonic to Social: Noise, Quiet, and Nineteenth-Century American Banjo Imagery

LEO G. MAZOW

AS WE HAVE SEEN, the banjo is one of the most common symbols in American art—yet as a symbol, it remains malleable, unfixed. Art historians have taken important strides in demonstrating how banjo imagery works as an agent of racial difference in canonical pieces by Eastman Johnson, Henry Ossawa Tanner, Thomas Eakins, William Sidney Mount, and other nineteenth-century American artists. But what of the aural dimensions of those representations? This essay does not seek still other iconographies for the banjo. Rather, I hope to interpret that symbolism within economies of sound. I will suggest that their aural evocations of noise controlled and redirected allowed banjos to function as makeshift motifs of social tranquility for post–Civil War American artists and audiences alike.

fig. 81
Jean-Baptiste Adolphe Lafosse, *The Banjo Player* (after William Sidney Mount), 1857, hand-colored lithograph, 25 × 20 inches. Collection of Peter Szego. Photo courtesy Peter Szego.

Following the examples of the Atlantic studies scholars Charles Piot and Paul Gilroy, we may consider the banjo as one among so many cultural symbols that were de-Africanized in the international slave trade.[1] I begin here with a brief history of the instrument's African roots, the very heritage that the banjo "hushed." I will then consider aural suppression as a subject in late-nineteenth-century banjo pictures and conclude with the suggestion that the imagery of sonic suppression finds an analogue in the symbolism of various tamed animals. It is tempting to join several previous observers who have interpreted—and correctly, I would argue—the racially charged *visual* symbolism of Tanner's *Banjo Lesson* (see fig. 112) and other pictures in terms of self-culture, intellect, and pedagogy. Paradoxically, though, when we temper those readings with sonic considerations, a far more ambivalent picture emerges, suggesting, at times, a silenced and even disempowered racial type.

The banjo descends from the African *bandore*—a hollowed gourd, wrapped in pelt, through which a stick strung with catgut is inserted. The *bandore* is likely depicted in the 1720s illustration by the British physician-explorer Sir Hans Sloane (see fig. 22). Its calabash cousin, the *molo*, we see in the late-eighteenth-century watercolor *The Old Plantation* (see fig. 97).[2] Dana Epstein's seminal article, "The Folk Banjo: A Documentary History" (1975), later expanded in her *Sinful Tunes and Spirituals* (1977), offers documentation of several early banjos and banjo-related instruments in British North America. Of the many American and European travelers cited by Epstein, an inordinately high percentage invoked what they understood to be the harsh sounds and uncivilized nature of the *bandore* so as to differentiate it from other instruments. A visitor to Jamaica in c. 1740 commented on the *bandore*'s "horrid noise," while the Englishman Nicholas Creswell, who visited Maryland in 1774, was not even comfortable calling it a musical instrument. Although the English traveler Thomas Fairfax, who visited Richmond in 1799, found the banjo conducive to "an agreeable serenade," he could nonetheless conclude that "its wild notes of melody seem to correspond with the state of Civilization of the Country where this species of music originated." A visitor to the West Indies in 1796 wrote that the instrument was "devoid of all softness and harmony," while Benjamin Latrobe, twenty years later, simply noted the banjo's "incredible noise." John Pendleton Kennedy's 1832 novel *Swallow Barn* deemed the "banjoe" a "rude instrument." A French visitor to Louisiana the following year commented that it sounded like a "plaintive melody from another hemisphere." Late-nineteenth-century accounts differ little, if at all, from the first known report of the African *bandore*, dating to 1621, which stressed that the instrument was "very unapt to yeeld a sweete or musicall sound."[3]

Most nineteenth-century banjo pictures, however—such as William Sidney Mount's *The Banjo Player* (1856, figs. 80, 81)—depict not the *bandore* but a

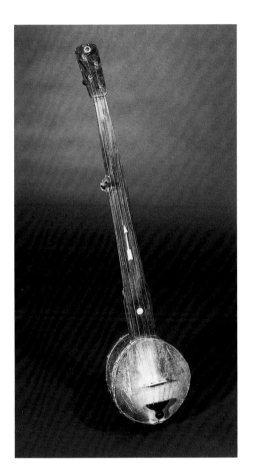

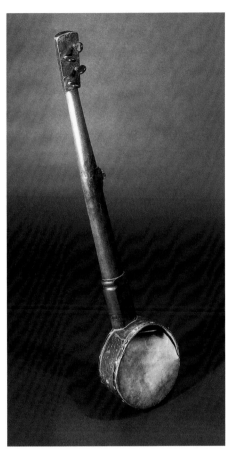

fig. 82 *(left)*
D. P. Diuguid, Lexington, Virginia, tackhead banjo (front), c. 1840, 38 × 8½ inches. Collection of Roddy and Sally Moore. Photo courtesy Peter Szego.

fig. 83 *(right)*
D. P. Diuguid, Lexington, Virginia, tackhead banjo (back), c. 1840, 38 × 8½ inches. Collection of Roddy and Sally Moore. Photo courtesy Peter Szego.

mass-manufactured, pre-fitted wood-and-metal instrument, a tonally modulated, "improved" version of its West African gourd ancestor. Accounting at least in part for this change, performers in minstrel troupes (usually white men "corking" their faces in imitation of African slaves) played tambourines, bones, and banjos beginning in the 1840s. Folklorist Cecelia Conway observes, however, that the latter instrument was "the most complex, tangible, specifically African-American element in minstrelsy." This wildly popular form of entertainment created market demand for easily and inexpensively produced banjos.[4] With large-scale production, the "sweete" sound sought by early observers was gained, but a good bit of the African heritage was lost.

In the space of just a few decades, a new, improved *bandore* appeared, called a banjo—itself a Westernized nomenclature. Some early tackhead banjos, with skin on both sides of the rim, retained some of the look of the gourd instrument (figs. 82, 83). Increasingly, however, skilled craftsmen in shops and factories produced banjos following the model of William Boucher of Baltimore, whose six-bracket, one-sided, scalloped-rim instrument set an industry standard (figs. 84, 85). This is the prototype used by many later nineteenth-century banjo manufac-

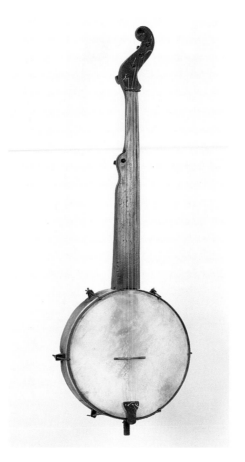
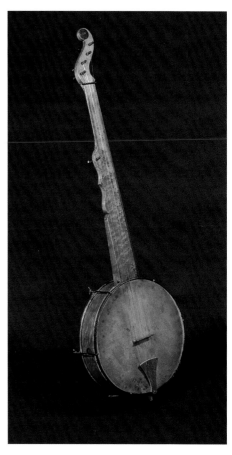

fig. 84 *(left)*
William Boucher, banjo, c. late 1840s or 1850s,
36 × 12 inches. Collection of James F. Bollman.

fig. 85 *(right)*
William Boucher, banjo, c. late 1840s or 1850s,
40½ × 13 inches. Collection of Peter Szego.
Photo courtesy Peter Szego.

turers, and we find it in pictures by Eakins, Tanner, and Mount. (Mount's musician, notably, plays a Boucher banjo.)[5]

Missing, however, was the gourd, which had provided the sound chamber and much of the "horrid noise" of the African instrument. The gourd had been the basis of the musical apparatus brought over in the international slave trade and, to some extent, a symbol of what was lost in the transplantation of Africans into North America. In addition to its several other practical uses—for instance, as a boat oar or food container—it was a percussion device. Many plantations eventually outlawed gourds because they facilitated communication and secret codes, useful for insurrection and rebellion.[6] In streamlining the banjo, then, manufacturers redirected its sonic properties and cultural meanings. Less noisy meant less African, more orderly, less "another hemisphere." But the missing gourd is only one of the problems with which we must reckon in exploring the socialization of the instrument's acoustic projections.

Also figuring in this discussion is the presumably softened and "sweete," melodious, plucking sound of the Americanized nineteenth-century banjo. In South Carolina, a law prohibiting slaves from performing *any* music considered loud and

boisterous had been on the books since the so-called Act of 1740. North Carolina passed a similar law in 1794. In the antebellum and Civil War eras, antislavery proponents took special aim at legislation concerning auditory and musical restraint. Yet as late as 1845, the Hotchkiss Codification, an amendment to the Georgia Statute Law, upheld a similar set of prohibitions against playing loud music. These statutes rendered it illegal for slaves to "beat drums, blow horns, or other loud instruments."[7] Because the stringed instrument was commonly reputed to be incapable of producing anywhere near the dynamic range and decibel levels of African percussion and hybrid reeds, banjo playing may well have emerged as a tonally subdued alternative to loud, disruptive music.

We might question, however, just how loud—literally, how many decibels—the banjo and *bandore* had been before and after Boucher and other early banjo makers. Was the *bandore* really so cacophonous and disruptive in the first place? Could at least some of the many observers Epstein quotes have been projecting their own fears of disorder and cultural difference onto the musical forms they encountered? In her insightful review of Epstein's travelers and other commentators, Conway suggests that these early accounts actually demonstrate "the changing abilities of the documentors to understand and appreciate the new cultural forms and contributions that the blacks brought with them from Africa."[8] Regardless of the actual acoustic projections, it seems likely that, as the cliché goes, individuals heard what they wanted to hear. Epstein's *dramatis personae* (and later observers as well) apparently did not know exactly what they were listening for, and they tended to call anything foreign to them "noise."

In any case, banjos—offering a contrast with at least the *perception* of unregulated noise—carry highly charged meanings within northern and southern soundscapes. Undue clamor on southern plantations frequently elicited a master's ire and resulted in severe punishment. By the Civil War, as Mark Smith has demonstrated, Confederate politicians and orators would enlist quietude as a sign of pastoral nostalgia and social calm. Conversely, in northern homes and factories, the din of productivity connoted efficiency and honesty, with southern quietude signifying not tranquility but laziness.[9]

It is difficult to divorce the ubiquitous banjo picture from these racially charged nineteenth-century debates about noise, quiet, chaos, and containment. Consider, for example, *The Banjo Man,* which posits the African American banjoist as a producer of mirthful music, but no longer an embodiment of it (c. 1815, fig. 86). His stasis and deportment suggest a tamed down—and perhaps wishful—version of contemporary performance. In mimicking the pronounced physicality of southern African American banjoists, minstrel troupes frequently used a banjo with a knob or handle on its heel so they could throw and catch the instrument with relative ease and agility. The seated banjo man, in contrast, prepares for no

such acrobatics. The English actress Frances Ann "Fanny" Kemble, who toured
and eventually settled in Georgia in the 1830s, recorded a performance of a Jim
Crow song and suggested the dynamic, corporeal, action-packed nature of early
banjo performances. She was impressed with "the feats of a certain enthusiastic
banjo player, who seemed . . . to thump his instrument with every part of his body
at once," denying the rules of "decorous gravity." Moreover, the banjo had long
been coupled with group dance, a physical means by which to summon spirits. Yet

in *The Banjo Man,* the man's animation and banjo playing only facilitate the movements of others.[10]

That the unanimated body represents sound hushed is also suggested much later in an 1881 sheet-music illustration for the song "The Banjo Now Hangs Silent on the Door." The inert figure on the cover does not dance or perform (fig. 87). Rather, slumped over in his chair, supporting his head in a time-honored melancholic pose, the elderly African American male matches the instrument at left in his obsolescence; neither is now capable of producing sound. In different ways, the musicians in both *The Banjo Man* and "The Banjo Now Hangs Silent on the Door" have tamed their passions and redirected the projections of the new syncretized instrument. Both images suggest pictorial strategies for quietude. Orators, clergymen, and politicians on both sides of the Mason-Dixon line seemed to stress not quiet—that is, complete silence—but rather *quietude,* the hushing of as many bodily mechanisms as possible.[11]

Although escaping the grotesque caricature of works like Mount's 1830 painting *Rustic Dance After a Sleigh Ride* (fig. 88), "The Banjo Now Hangs Silent on the Door" proclaims a similar message: the black musician's skills are valuable only insofar as they provide lively, orderly entertainment for white audiences. The latter print exemplifies the visual typecasting of the freed slave, who, in the decades following Emancipation, turns melancholic without an audience for which to perform—and somehow saddened now that the days of chattel slavery and legislated condescension are past. The new, improved, gourdless banjo facilitated submissive quietude, a far cry from the "racket" described by earlier observers and outlawed in several states.

More problematic are the many canonical late-nineteenth-century oil paintings depicting the musically engrossed African American banjoist. Scholars have interpreted Tanner's *Banjo Lesson* not as a voice quelled but rather as a post-Reconstruction expression of pedagogy, spirituality, intellectual engagement, and familial continuity. One historian goes so far as to argue that the work "subverts" contemporary racist genre pictures.[12] In contrast to paintings like Mount's *Rustic Dance* and Currier and Ives's *Old Barn Floor* (1868, fig. 89), in which music is yet another arena in which to assert racial hegemony, the individuals in the Tanner work enact self-performance and self-culture, much as they do in Eakins's *Negro Boy Dancing* studies (see fig. 99). The subject is elevated to a rational, thinking being, a master of the instrument's manual and mental complexities.

Certainly, by any accounting, these representations are more racially sensitive—more humane—than the messages relayed by Currier and Ives and elsewhere in print culture. But they are not unmediated "visual transcriptions of cultural exchanges," as one scholar calls them. Corresponding with Tanner's own privileged upbringing within the A.M.E. Church, *The Banjo Lesson* tempers cul-

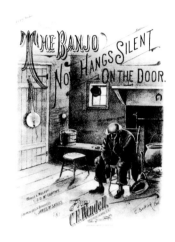

fig. 87
C. Selkirk, cover engraving for "The Banjo Now Hangs Silent on the Door," 1881, 10½ × 6¾ inches. Sheet music published by C. E. Wendell, Albany, New York. Library of Congress, Music Division, Washington, D.C., Dig. ID sm1876 08293.

fig. 88 *(right)*
William Sidney Mount, *Rustic Dance After a Sleigh Ride,* 1830, oil on canvas, 22⅛ × 27⅛ inches. Museum of Fine Arts, Boston. Bequest of Martha C. Karolik for the M. and M. Karolik Collection of American Paintings, 1815–1865, 48.458. Photo © Museum of Fine Arts, Boston.

fig. 89 *(below)*
The Old Barn Floor, 1868, lithograph, 17¾ × 23⅞ inches. Published by Currier and Ives, New York. Library of Congress, Prints and Photographs Division, Washington, D.C., LC-USZ62-12333.

THE OLD BARN FLOOR

tural expression with class-conscious modes of deportment, as Judith Wilson has observed. In the decades following the Civil War, the A.M.E. Church promoted European values with which to tone down and to remove the cacophony from native modes of music, dance, and worship.[13]

Tanner's painting complements the A.M.E. mission through several formal devices that create, in turn, an appeal to the aural. The "hushed" lighting implies a hushed sound, with the halo-like illumination over the figures' heads suggesting the muted solemnity of a religious altarpiece. Wilson points out that *The Banjo Lesson* was a sort of test piece, one with which Tanner "demonstrated his control of a range of technical skills."[14] Similarly, through a convergence of head and hand, the figures in *The Banjo Lesson* control their music, elevating it from the "horrid noise" of the *bandore* and removing it from the clamor and wildness shunned within Tanner's conservative family politics.

Still, it should be emphasized that northern presses and such periodicals as the *Independent, Harpers Weekly,* and *Century Magazine* perpetuated the mythology of the noisy, shouting, out-of-control African American well into the 1880s and 1890s. Particularly illuminating is William Ludwell Sheppard's engraving *The Shucking,* which appeared in *Century Magazine* in 1881 and depicted a seeming fury of African Americans exclaiming and wildly singing as corn husks fly about the rural scene. Even social reformer Jeffrey Richardson Brackett's groundbreaking text of 1889, *The Negro in Maryland,* insisted that the cakewalk dance invariably resulted in raucous "noise and disorder." Unlike that dance, or African-inspired drumming, the banjo was supposedly a soothing agent.[15]

The Banjo Lesson, then, matches an emerging etiquette of sonic restraint, with the instrument offering an arena in which to demonstrate one's civility. A print after a related Tanner painting, now lost, appeared in an article by Ruth M. Stuart for *Harper's Young People* in 1893 with the title *Dis Heah's a Fus'-Class Thing ter Work Off Bad Tempers Wid,* and it underscores the banjo's supposed role in calming oneself down. (The story and accompanying image after Tanner were reprinted three years later in *Solomon Crow's Christmas Pockets and Other Tales,* by the same author [fig. 90].) The text accompanies an interchange between little Tim and his grandfather, Uncle Tim (the phonetic proximity to "Uncle Tom" surely intentional). Uncle Tim advocates banjo playing as a way to ward off anger-driven impulsiveness. If a "mule temper" should "take a-holt" of little Tim's feet and make him kick wildly, he need only "teck hol' o' dis ole banjo des as quick as you feel de badness rise up in you, *an' play,* ... an' ef you feel it in yo' han', des run fur de banjo an' play de sweetes' chune you know, an' fus' thing you know all yo' madness'll be gone."[16]

The elder Tim suggests dancing as an activity that, when coupled with banjo playing, is sure to soothe one's nerves—a mood suggested in the print by the muted lighting, warm embrace, and rapt attention. The engraving depicts grandfather and grandson in a private moment of concentration, each caring for the other

fig. 90
Dis Heah's a Fus'-Class Thing ter Work Off Bad Tempers Wid (after Henry Ossawa Tanner), c. 1893, engraving, 5⅝ × 3½ inches. In Ruth McEnery Stuart, *Solomon Crow's Christmas Pockets and Other Tales* (1896; Freeport, N.Y.: Books for Libraries Press, 1969), frontispiece. The Pennsylvania State University Libraries, University Park, Pennsylvania.

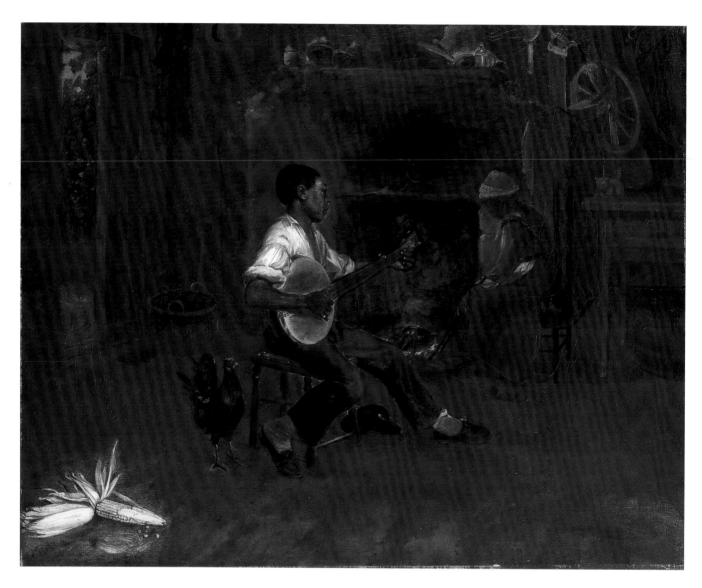

fig. 91
George Fuller, *The Banjo Player*, 1876, oil on canvas, 17 × 21 inches. Collection of Peter Szego. Photo courtesy Peter Szego.

and for their jointly produced sounds. They seem to understand the role of "sweet tunes" in thwarting "madness" and facilitating quietude.

We find a similar appeal to halcyon hush in George Fuller's *The Banjo Player* of 1876 (fig. 91). The hen, glowing corn, banjoist, and man tending the fire beckon our attention. The banjoist's pivoted head suggests intellectual absorption, and, along with the motionless animal, evokes the muting or perhaps silencing of the sounds one might expect to hear in such a scenario. Moreover, Fuller's *Banjo Player* is one of several works in which animals join the banjo to hint at the domestication of human beings as well.[17]

The manner in which these animals enter the mix, however, is remarkable. Several pictures point to the aural implications of the grouping of banjo, animal, and

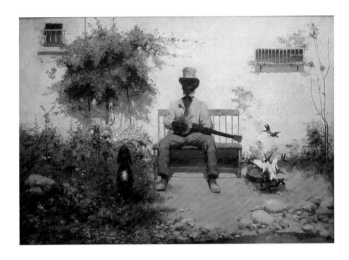

fig. 92
The Sunny South, c. 1889, oil on canvas,
28 × 39 inches. Morris Museum of Art,
Augusta, Georgia, 1990.124.

African American. The trio enforces the coupling of sonic with social harmony. Birds and frogs figure prominently in this visual tradition. (By comparison, in representations of Anglo banjo-playing subjects, the banjoists are typically paired with house pets. In Childe Hassam's c. 1880s watercolor *A Familiar Tune,* for example, cats facilitate the soft mood of musical meditation [see fig. 74].) Yet even when domesticated pets are coupled with African American banjoists, as in *The Sunny South* (c. 1889, fig. 92), something quite different transpires: the musician mimics a well-behaved animal. In *The Sunny South,* the dog, at left, repeats the man's static, frontal pose. The banjo literally points to the sweetly chirping birds, suggesting a melodious tune in keeping with the sun-drenched, picturesque setting.

Throughout nineteenth-century minstrelsy, the black body was often cast as an unrestrained animal, too wild for its own good.[18] Several late-nineteenth- and early-twentieth-century images suggest a similar analogy, matching cacophonous birds with African American banjoists in need of de-amplification. In the 1899 sheet-music illustration for "Dusky Dinah," woman and rooster share a precariously extending tree branch, with the caption suggesting that both figures will have difficulty "keep[ing] still" (fig. 93). Dinah, however, soothes herself and the clamorous bird with the de-Africanized instrument. Here, animal husbandry provides a stark metaphor for the domestication of a human being.

Few prints or paintings, however, can match the odious pairing of hen and human in the sheet music illustration for "Sam Will Oblige" (1905, fig. 94), in which the minstrel in blackface parallels the machinations of the cavalcade of cakewalk-dancing birds. The bound sheaves of wheat in the background suggest the themes of control and containment.[19] The sheet music informs us that during his "rendition," Sam interjects, "Shut da doah an' keep out dat perfume ob fried chicken, or It'll extinguish ma music."[20] Even the scent of fried foods, we are told, can threaten the orderly, sonorous setting. The rooster lends to the musically enforced hierarchy:

fig. 93
Cover image for "Dusky Dinah, an Original Cake-Walk and Patrol," by Dan J. Sullivan, 1899. Sheet music published by Chas. Shackford, Boston. Rare Book, Manuscript, and Special Collections Library, Duke University, Durham, North Carolina.

the banjo tames the race and its attendant sounds, just as the farmer redirects the energies of the animals.

Even more frequently than birds, frogs join the banjo in the reshaping of noise into quietude. In an 1876 poem, the Anglo-American poet-essayist Bayard Taylor lamented the "sorrowful noise" of the "chirp[ing]," "cry[ing]" frog. Late-nineteenth-century African American writers such as Paul Laurence Dunbar and Daniel Webster Davis occasionally coupled frog and banjo to suggest what Dunbar called

fig. 94
Cover image for "Sam Will Oblige," by Sam
and Alamanda Jackson, 1905. Sheet music
published by Edwin S. Brill, New York. Rare
Book, Manuscript, and Special Collections
Library, Duke University, Durham, North
Carolina.

"nature's harmony."[21] On the sheet-music cover for "We'll Raise de Roof Tonight"
(1884, fig. 95), the frog at lower right counterbalances the banjo at left and acts as a
repoussoir figure, leading us into the dusky, moonlit landscape. There's going to be
a raucous party at the house, the lyrics tell us, adding, "We'll shout dar, we'll sing
dar . . . I'se telling you de troof . . . we gwine to raise de roof." For now, however,
the frog joins the softly played banjo, and the roof appears intact.

In a poem of six years later, Dunbar evokes similar nocturnal quietude,
admonishing his true love, "Hush up, honey, tek my han'," and listen to the

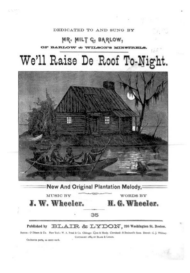

fig. 95
Cover image for "We'll Raise de Roof Tonight,"
by J. W. and Hawthorne G. Wheeler, 1884.
Sheet music published by Blair and Lydon,
Boston. Rare Book, Manuscript, and Special
Collections Library, Duke University, Durham,
North Carolina.

Rivah whisperin' "howdy do,"
Ez it pass you by—
Moon a-lookin' down at you,
Winkin' on de sly.
Frogs a-croakin' f'om de pon'

These visual and verbal examples point to the measures taken by poet and painter alike in suggesting not utter silence, not quiet, but quietude—a suppression of bodily functions that would have, in the previous generation, disturbed the master's relative peace and tranquility if not quelled. As Dunbar's lines suggest, well into the post-Emancipation era, the sweetly croaking frog joined the banjo in creating the myth of aural control. (Northern audiences, for their part, had long equated the audible but unobtrusive din of industry as an emblem of republican efficiency, and surely they too would have read racial stability in this sheet-music cover printed in Boston.)[22]

Late-nineteenth- and early-twentieth-century advertisers apparently understood well the banjo's role in quieting frog-like malaise. "Frog in Your Throat?"—a Philadelphia apothecary shop display from c. 1900—exemplifies this tendency (fig. 96). Like the melodious instrument, the lozenge promises to clear your raspy voice, to tame that frog in your throat, to ameliorate that sonic discord.

Even without the depiction of an African American individual (as in "Frog in Your Throat?"), it is difficult to dissociate groupings of animals and banjos from a racially charged environment. Renditions of "Jim Crow," one of the earliest and most famous banjo songs in minstrelsy, had long emphasized the "compliant, responsive, obedient, cheerful, well-behaved slave, who was happy to jump Jim Crow," to move his body at the whim and entertainment of his audience. Such a gesture bears uncanny fidelity to the experiences of slaves. (Frederick Douglass, during his tenure at a Baltimore shipyard, was literally treated like an animal—ordered to run, fetch, stay, and move, often simultaneously.)[23] Joined with frogs, dogs, and other animals, banjos evoke silent service and coercive calm.

Given this context, it is useful to return to the painting *The Old Plantation,* the eighteenth-century watercolor now at Colonial Williamsburg and probably the earliest surviving American banjo painting (fig. 97). A comparison of *The Old Plantation* with a nineteenth-century copy of the work held by the Mint Museum of Art in Charlotte, North Carolina (fig. 98) is particularly helpful in explaining the shift from the sonic use of the *bandore* to the socializing function of the banjo.[24] (With a frog prominently portrayed in the foreground, the painting also exemplifies the increasingly encountered triad of banjo, animal, and human.) Among other changes, the seated drummer at right in the Williamsburg version has moved to the other side in the copy, replacing the earlier watercolor's depiction of the

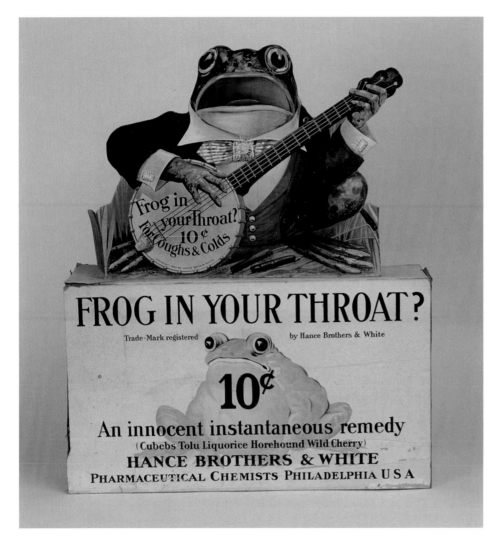

fig. 96
"Frog in Your Throat?" apothecary shop dis-
play, c. 1900, lithograph on cardboard, 25 × 21
× 6 inches. Collection of James F. Bollman.
Photo courtesy Don Eaton.

man with his hands descending upon the woman's breasts. (Even the cleavage of
the standing woman at right is toned down in the Mint version.) The sound of
music replaces—and perhaps curbs—human passions in the copy.

The *bandore,* not the banjo, is still present in the later picture. And the subject
in the center foreground remains the same, except that he has traded rod for fab-
ric, joining his female counterpart in the scarf dance. Where the earlier picture
portrays the so-called broom-jumping practice of a Congolese marriage ceremony,
the later watercolor dares a frog to do the jumping. The sonic order of banjo and
drum—and frog—provides the social foundation of a marriage rite.[25]

Perhaps the less sexualized Mint picture implies a new sense of seriousness. Art
historians have argued essentially the same thing about canonical banjo pictures
by Eakins, Johnson, and Tanner. Indeed, in Eakins's *Negro Boy Dancing* studies
from about 1877 (fig. 99) and Johnson's 1859 *Confidence and Admiration* (see

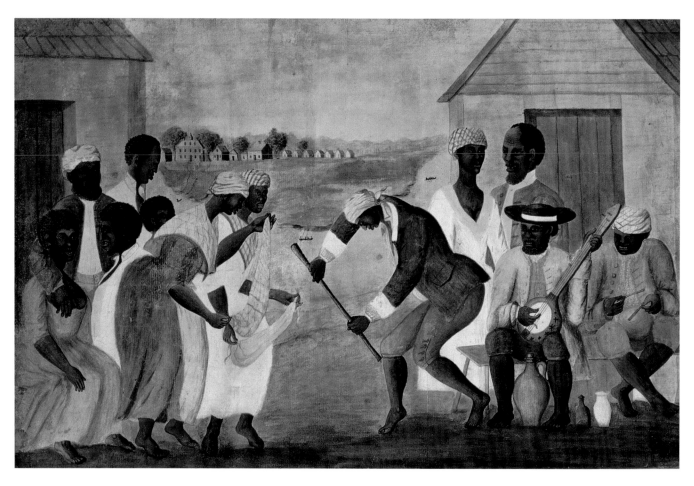

fig. 97 *(above)*
The Old Plantation, late eighteenth century,
watercolor, 11 × 18 inches. Abby Aldrich Rocke-
feller Folk Art Museum, Colonial Williamsburg
Foundation, Williamsburg, Virginia.

fig. 98 *(right)*
Plantation Scene, possibly nineteenth century,
watercolor on laid paper, 11⅜ × 16⅜ inches.
Mint Museum of Art, Charlotte, North Car-
olina. Gift of Mr. and Mrs. Donald Upchurch,
1985.83.1.

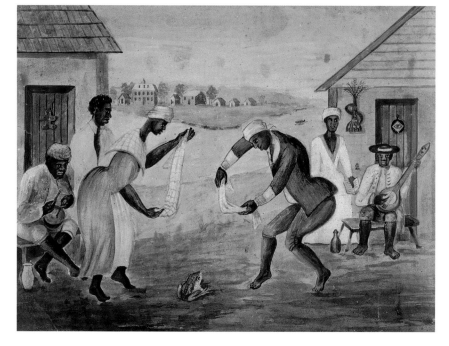

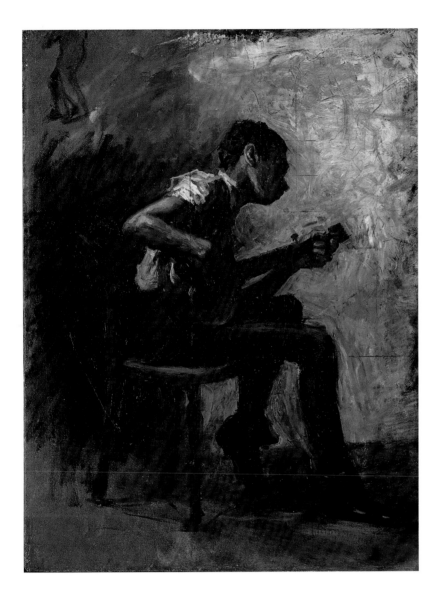

fig. 99
Thomas Eakins, *Study for "Negro Boy Dancing": The Banjo Player,* probably 1877, oil on canvas mounted on paperboard, 19½ × 14¹⁵⁄₁₆ inches. National Gallery of Art, Washington, D.C. Collection of Mr. and Mrs. Paul Mellon. © 2004 Board of Trustees, National Gallery of Art.

fig. 49) we find intellectual absorption replacing the racial typecasting of Mount's *Rustic Dance* and any number of Currier and Ives prints. I suggest, however, that we temper this interpretation with an awareness of the role played by the once-African banjo in creating a docile type: we should understand that this cultural explanation entails aural as well as visual contexts. Like the instruments they hold, the individuals in the later pictures are transformed from "sonic" to "social."

NOTES

1. Charles Piot, "Atlantic Aporias: Africa and Gilroy's Black Atlantic," *The South Atlantic Quarterly* 100, no. 1 (2001): 156. Piot charges that Paul Gilroy's *Black Atlantic*—a canonical work in Atlantic studies—fails to position understandings of the African diaspora as themselves products of the slave trade.

2. See Dena J. Epstein, "The Folk Banjo: A Documentary History," *Ethnomusicology* 19 (September 1975): 352–56, and Michael Theodore Coolen, "Senegambian Archetypes for the American Folk Banjo," *Western Folklore* 43 (April 1984): 117–32. On *The Old Plantation,* see Epstein, "The Folk Banjo," 351, 354, and Maria Franklin, "Early Black Spirituality and the Cultural Strategy of Protective Symbolism: Evidence from Art and Archaeology," in *African Impact on the Material Culture of the Americas,* conference proceedings (Winston-Salem, N.C.: The Museum of Early Southern Decorative Arts, 1998), irregularly paginated. For a survey of musical imagery in American art, see *The Art of Music: American Paintings and Musical Instruments, 1770–1910* (Clinton, N.Y.: Hamilton College, Fred L. Emerson Art Gallery, 1984), and *Musical Instruments and Their Portrayal in Art* (Baltimore: Baltimore Museum of Art, 1946), 14–21.

3. The comments of Fairfax, the Jamaican visitor, Creswell, Kennedy, the Frenchman in Louisiana, and the 1621 report are quoted in Epstein, "The Folk Banjo," 354, 352, 353, 356, and 350, respectively.

4. Cecelia Conway, *African Banjo Echoes in Appalachia: A Study of Folk Traditions* (Knoxville: University of Tennessee Press,

1995), 103. See Philip F. Gura and James F. Bollman, "From the Plantation to the Stage: Bringing the Banjo to Market," in Gura and Bollman, *America's Instrument: The Banjo in the Nineteenth Century* (Chapel Hill: University of North Carolina Press, 1999), 11–73, and Robert B. Winans and Elias J. Kaufman, "Minstrel and Classic Banjo: American and English Connections," *American Music* 12 (Spring 1994): 1–30.

5. For the instrument's post–Civil War development, see Robert Lloyd Webb, ed., *Ring the Banjar! The Banjo in America from Folklore to Factory* (Cambridge, Mass.: MIT Museum, 1984), and Gura and Bollman, "From the Plantation to the Stage."

6. Peter H. Wood, "The Calabash Estate: Gourds in African American Life and Thought," in *African Impact on the Material Culture of the Americas,* 1–8.

7. Conway, *African Banjo Echoes,* 72. In 1848, John Belton O'Neall, a staunch Quaker South Carolinian, was among those who rallied to overturn the state's anti-noise laws. See O'Neall, *The Negro Law of South Carolina* (Columbia, S.C.: Printed by John G. Bowman, 1848), 26. William A. Hotchkiss, *A Codification of the Statute Law of Georgia, Including the English Statutes of Force . . .* Savannah: J. M. Cooper; New York: J. F. Trow, 1845). Lewis W. Paine, *Six Years in a Georgia Prison . . .* (Boston: B. Marsh, 1852), 141.

8. Conway, *African Banjo Echoes,* 55–56.

9. My understanding of northern and southern soundscapes is heavily indebted to Mark M. Smith, *Listening to Nineteenth-*

Century America (Chapel Hill: University of North Carolina Press, 2001).

10. On the manner in which musical imagery physically "embodies" meaning, see Richard D. Leppert, *The Sight of Sound: Music, Representation, and the History of the Body* (Berkeley and Los Angeles: University of California Press, 1993). Frances Ann Kemble, *Journal of a Residence on a Georgia Plantation in 1838–1839* (New York, 1863; rpt., New York: Knopf, 1961), 131, as quoted in Conway, *African Banjo Echoes,* 100. John Michael Vlach, *By the Work of their Hands: Studies in Afro-American Folklife* (Charlottesville: University Press of Virginia, 1991), 24. Epstein, "The Folk Banjo," 351.

11. See Smith, *Listening to Nineteenth-Century America,* 19–20ff.

12. Judith Wilson, "Lifting 'The Veil': Henry O. Tanner's *The Banjo Lesson* and *The Thankful Poor,*" in *Critical Issues in American Art: A Book of Readings,* ed. Mary Ann Calo (Boulder: Westview Press, 1998), 199–219; Albert Boime, *The Art of Exclusion: Representing Blacks in the Nineteenth Century* (Washington, D.C.: Smithsonian Institution Press, 1990), 102; and Eileen Southern and Josephine Wright, *Images: Iconography of Music in African-American Culture* (New York: Garland, 2000), 22. On Tanner's painting as cultural subversion, see Boime, "Henry Ossawa Tanner's Subversion of Genre," *Art Bulletin* 75 (September 1993): 415–42.

13. Boime, "Henry Ossawa Tanner's Subversion," 418. Wilson, "Lifting 'The Veil,'" 202.

14. Wilson, "Lifting 'The Veil,'" 199.

15. See Avon [pseud.], "Inside Southern Cabins: II—Georgia," *Harper's Weekly* 24 (20 November 1880): 749–50, and "Inside Southern Cabins: III—South Carolina," *Harper's Weekly* 24 (27 November 1880): 765–66. See also Orra Langhorne, "Colored Religion," *Independent* 35 (30 August 1883): 1091; Walter Hines Page [Nicholas Worth, pseud.], "Religious Progress of the Negroes," *Independent* 33 (1 September 1881): 7; and Edward Windsor Kemble's illustration *The Bamboula*, engraving in George W. Cable, "The Dance in Place Congo," *Century Magazine* 31 (February 1886): 524. Sheppard's *The Shucking* is reproduced in David C. Barrow, "A Georgia Corn-Shucking," *Century Magazine* 24 (October 1882): 874. Similar complaints were waged as late as the early 1900s; see Orishatukeh Faduma, "The Defects of the Negro Church," Occasional Paper no. 10 in *The American Negro Academy Occasional Papers*, 1–22 (Washington, D.C.: Printed by the Academy, 1904). Jeffrey Richardson Brackett, *The Negro in Maryland* (Baltimore: Johns Hopkins University Press, 1889), 204.

16. Ruth M. Stuart, "Uncle Tim's Compromise on Christmas," *Harper's Young People: An Illustrated Weekly* 15 (1893), reproduced on 84; reprinted in Stuart, *Solomon Crow's Christmas Pockets and Other Tales* (New York: Harper and Brothers, 1897). I have found the print reproduced in only one modern source: Southern and Wright, *Images,* 213. The authors state that the print is after a painting that "has escaped the attention of Tanner art scholars up to the present" (271n21), including the contributors to the exhibition catalogue *Henry Ossawa Tanner* by Dewey F. Mosby (Philadelphia: Philadelphia Museum of Art; New York: Rizzoli International Publications, 1991). The catalogue reproduces what Mosby labels a "study photograph for *The Banjo Lesson*" on 116. But with the pivoting of banjo and bodies to the right, the close-up focus on the foreground figures, and even the angles of the cast shadows, the photograph is almost identical not to *The Banjo Lesson* but to the engraving published by Stuart in *Harper's Young People* and *Solomon Crow's Christmas Pockets,* 34.

17. There is, of course, nothing new in the equation of musical harmony and animal hierarchy. Indeed, as historian Richard Leppert has observed, a remarkable range of eighteenth- and nineteenth-century philosophers, politicians, musicians, and painters sought to classify the world in such sonorous terms. See Leppert, *Sight of Sound,* 100–101, 255–56.

18. See Eric Lott, *Love and Theft: Blackface Minstrelsy and the American Working Class* (New York: Oxford University Press, 1993).

19. I thank Rachael DeLue for these insights.

20. "Sam Will Oblige" (New York: Edwin S. Brill, 1905), 2, 5.

21. Bayard Taylor, "John Reed" (1876), in *The Poetic Works* (New York: Houghton Mifflin, 1907), 241. Paul Laurence Dunbar, "The Concert," in *The Collected Poetry* (Charlottesville: University Press of Virginia, 1993), 303. Daniel Webster Davis, "When De Sun Shines Hot," in *Weh Down Souf and Other Poems* (Cleveland: Helman-Taylor, 1897), 35.

22. Dunbar, "A Summer Night," in *The Collected Poetry,* 262. On northern quietude, see Smith, *Listening to Nineteenth-Century America,* 21–22, 92–94, 140.

23. Frederick Douglass, *Narrative of the Life of an American Slave* (1845; rpt., New York: Signet, 1966), 99–100, as quoted in Conway, *African Banjo Echoes,* 101–2.

24. For the Mint version, see Franklin, "Early Black Spirituality."

25. Ibid.

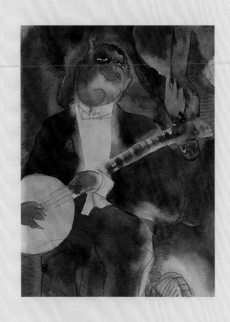

Misery is when your own mother

won't let you play your new banjo

in front of the *other* race.

—LANGSTON HUGHES,
Black Misery, 1969

JOYCE HENRI ROBINSON

5

Harlem Renaissance, Plantation Formulas, and the Dialect(ic) of the Banjo

JUST BEFORE HIS DEATH in May 1967, Langston Hughes penned a series of short prose statements for an illustrated children's book. The book, published two years later, was intended as a race-specific version of a benign series of popular picture books by the white author Suzanne Heller. But *Black Misery* hardly seems appropriate for a young readership. Throughout the brief text, Hughes revisits a lifetime of shame brought about by enforced segregation and systemic racism—in other words, the social and psychological realities of a life lived on the other side of the color line. In 1903, just one year after Hughes was born, philosopher W. E. B. Du Bois had written presciently about the divisive demarcation of the races, anticipating that the century that lay ahead would be dominated by what he termed "the problem of

(opposite)
Charles Demuth, *Marshall's,* 1915, watercolor on paper, 12¾ × 7¾ inches (detail of fig. 104). Private collection. Photo courtesy of Kennedy Galleries, New York.

the color-line, the relation of the darker to the lighter races of men in Asia and Africa, in America." In these statements, Du Bois and Hughes appear to view the world in binary terms, literally in black and white, the oppositional poles of race.[1]

What *Black Misery* makes clear is that the tragedy of racism was inextricably enmeshed in the web of stereotype and caricature that had permeated the psyche of a nation built on the *terra infirma* of slavery for at least a century. Hughes writes:

> Misery is when somebody
> meaning no harm called
> your little black dog "Nigger"
> and he just wagged his tail
> and wiggled.

Hughes turns his attention to other expressions of everyday racism as well:

> Misery is when your white teacher
> tells the class that all Negroes
> can sing and you can't
> even carry a tune.

> Misery is when you learn
> that you are not supposed
> to like watermelon
> but you do.

And, he adds,

> Misery is when you can see
> all the other kids in the dark
> but they claim they can't see you.

Embedded in Hughes's narrative is a simple, devastating equation operating in a world in which the hegemonic power of whites is at least the practice, if not the law, of the land: blackness begets stereotype begets misery.

The most wrenching statement in Hughes's mournful litany is quite possibly the declaration that opens this essay:

> Misery is when your own mother
> won't let you play your new banjo
> in front of the *other* race.

The italics are Hughes's—and in that act of underscoring a once-benign word, today so theoretically laden, the poet succinctly encapsulates the problematic history of the banjo, this vexed symbol of both black folk culture and white racist caricature. In Hughes's narrative, a child's treasured possession—a *new* banjo, a gift or perhaps a purchase long saved for—carries with it a shameful legacy. Moreover, his lines suggest that what should be a source of pride has become a source of pain.

Nearly a half-century before he wrote the poignant text of *Black Misery*, Hughes had argued passionately for the artistic and cultural viability of black folk expressions. In his 1926 essay "The Negro Artist and the Racial Mountain," the author directed his comments toward both class-conscious blacks and disbelieving whites. Appearing in *The Nation* and deemed by one writer "the finest essay of Hughes' life," the article chided those black writers who sought to "pour racial individuality into the mold of American standardization, and to be as little Negro and as much American as possible." Hughes, in essence, outlined an agenda for the black artist.

> Let the blare of Negro jazz bands and the bellowing voice of Bessie Smith singing Blues penetrate the closed ears of the colored near-intellectuals until they listen and perhaps understand. Let Paul Robeson singing "Water Boy," and Rudolph Fisher writing about the streets of Harlem, and Jean Toomer holding the heart of Georgia in his hands, and Aaron Douglas drawing strange black fantasies cause the smug Negro middle class to turn from their white, respectable, ordinary books and papers to catch a glimmer of their own beauty. We younger Negro artists who create now intend to express our individual dark-skinned selves without fear or shame.[2]

This excerpt underscores Hughes's belief that Harlem Renaissance writers, musicians, and artists should unabashedly express their "dark-skinned selves" by drawing on material from both urban and rural vernacular sources. This agenda of mining black vernacular culture for high-art expressivity would not be without its detractors, in large part because the contested territory of the black folk hovered dangerously close to (and indeed was deeply entangled in) the legacy of the southern plantation and blackface minstrelsy. Problematic, too, was Hughes's embrace of vernacular speech, a distant and somewhat-more-respectable second cousin to the dialect literature first penned by whites in the mid-nineteenth century and later reclaimed by black poets in the decades leading up to the Harlem Renaissance. As a key literary architect of that movement, Hughes would make his reputation accenting his poems with the dialect and content of black folk culture, boldly expressing his "dark-skinned" self in literary settings as diverse as the

fig. 100
"Plantation Darkey Savings Bank," 1888,
painted tin, 5½ × 3¾ × 3¾ inches. Collection
of Joseph D. and Janet M. Shein, Philadelphia.

Congo, the plantation, and the jazz club. "If white people are pleased we are glad,"
he concluded in his now-famous essay. "If they are not, it doesn't matter."

Although Hughes himself was noticeably light-skinned and self-described as a
"brown" Negro, he had experienced the psychologically debilitating effects of
racism very early on in life. He understood well the risks associated with expressing
a racial self in a world in which blackness was almost universally vilified. Hughes's
biographer recounts a childhood incident in which one of the poet's schoolteach-
ers in Topeka, Kansas, reprimanded a white student for eating licorice sticks in
class. "You don't want to eat these," she said to her students. "They'll make you
black like Langston. You don't want to be black, do you?" A similar childhood
experience during "the early days of rollicking boyhood" profoundly affected the
young Du Bois, who, like Hughes, would later have an abiding interest in black
folk music, albeit of a more spiritual nature. Describing a painful incident involv-
ing the exchange of visiting cards with white classmates in the hills of New Eng-
land, Du Bois later recounted: "Then it dawned upon me with a certain sudden-

ness that I was different from the others; or like, mayhap, in heart and life and longing, but shut out from their world by a vast veil."[3]

Du Bois and Hughes, like the fictional child in *Black Misery*, understood to the very core of their being what it meant to be black in a white world. And although Hughes had, decades earlier, publicly touted his disregard for white opinion, the fictional child's mother deemed it necessary to restrict the overt expression of black folk identity—exemplified by playing the seemingly innocuous banjo—to the private confines of her home, far removed from the fractured and mediated gaze of white culture. Even in the midst of this nation's civil rights struggle, both mother and child intuitively knew what Du Bois had famously described at the dawn of the twentieth century: the peculiar sensation of "double consciousness, this sense of always looking at one's self through the eyes of others. . . . two souls, two thoughts, two unreconciled strivings; two warring ideals in one dark body."

The story of the banjo, perhaps more than any other narrative of black culture, has embedded within it Du Bois's sense of *twoness,* or what one scholar writing about Hughes has termed the "dialectical tension between the two worlds in which the black man lived." A relic of minstrelsy as well as an indigenous musical link to black folk expressions, the instrument embodies the conflicted attitudes that "New Negro" artists brought to the minefield of the vernacular. One of those writers, Claude McKay, voiced this ambivalence (not unexpectedly, perhaps) through his leading character in *Banjo: A Story Without a Plot* (1929):

> "Banjo! That's what you play?" exclaimed Goosey.
>
> "Sure that's what I play," replied Banjo. "Don't you like it?"
>
> "No. Banjo is bondage. It's the instrument of slavery. Banjo is Dixie. The Dixie of the land of cotton and massa and missus and the black mammy. We colored folks have got to get away from all that in these enlightened progressive days. Let us play piano and violin, harp and flute. Let the white folks play the banjo if they want to keep on remembering all the Black Joes singing and the hell they made them live in."
>
> "That ain't got nothing to do with me, nigger," replied Banjo. "I play that theah instrument becaz I likes it. I don't play no Black Joe hymns. I play lively tunes . . ."

In this telling passage, Banjo's folksy embrace of the instrument is pointedly expressed in supposed southern black dialect. As we will see, the vernacular dialect of the banjo inflected the artistic expressions—both literary and visual—of black artists and writers in the first several decades of the twentieth century, carrying with it resonances both of an outdated minstrel past and a distinguished, racially distinctive jazz future. Both modes, ultimately, would remain deeply mired in the black-and-white dialectic of race and representation.[4]

The Plantation Formula

[U]ntil quite recently, the plan-
tation formula dominated the
Negro subject in American
art . . . it helped mould the typi-
cal popular American concep-
tion of the Negro. A plague of
low-genre interest multiplied the
superficial types of uncles, aun-
ties and pickaninnies almost
endlessly, echoing even today in
the minstrel and the vaudeville
stereotypes of a Negro half-
clown, half-troubadour.

—ALAIN LOCKE,
The Negro in Art, 1940

On 7 August 1888, a New Englander by the name of William N. Weeden was granted a patent for a mechanical-action "Plantation Darkey Savings Bank" (fig. 100). Weeden operated a highly successful steam-toy company out of Bedford, Massachusetts, and although he was ultimately best known for such toys, his firm also produced a number of metal penny banks activated by windup mechanisms. Advertisements claimed that Weeden's hand-painted tin bank was made "in exact imitation of a plantation shanty." It was marketed as a premium give-away item for children selling *Youth's Companion* magazine subscriptions. Among the most popular toys in the decades following the Civil War, mechanical banks such as this one, scholars have suggested, represented Yankee ingenuity as well as thrift—and to that list we might also add Yankee perceptions of southern blacks. Touted as being artistically designed and thus suitable for the parlor table, Weeden's plantation bank was considered an appropriate enticement for childhood frugality. An advertisement for the toy announced that "everyone wants to see the darkey dance and play on the banjo." Like the nineteenth-century minstrel shows on which this tableau was based, the mechanical performers were activated by money. In this case, the deposit of a penny or a nickel enabled the banjo player to "pick on de ole banjo" and the "other darkey" to "dance a real breakdown in perfect time, with a great variety of lifelike comical steps."[5]

From its inception in the early decades of the nineteenth century, blackface minstrelsy had carried with it a purported authenticity. Performers, songwriters, and managers alike boasted of their familiarity with southern plantation life, the native habitat of blacks in the minds of most Americans in this period. As many have noted, Thomas D. Rice, the "Father of American Minstrelsy," ostensibly based his "Jump Jim Crow" routine on the contorted movements of an elderly, disabled black stable-hand whom he reportedly observed while traveling in Kentucky and Ohio in the late 1820s. Indeed, the "life of the plantation darky," according to minstrel entrepreneur E. P. Christy, was the heart and soul of the blackface enterprise, and its practitioners often constructed first-person narratives of plantation encounters—supposed eyewitness accounts—to validate their minstrel reenactments. Ben Cotton, a minstrel who later in the century specialized in delineating the southern Negro, recounted in an interview: "I used to sit with them in front of the cabins, and we would start the banjo twanging, and their voices would ring out in the quiet night air in their weird melodies. They did not understand me. I was the first white man they had seen who sang as they did; but we were brothers for the time being and were perfectly happy."[6]

Much like Cotton's sentimental account, Weeden's plantation bank reduces black life in the antebellum South to its barest essentials, all centered on the nos-

talgic yet derogatory image of the banjo player and his raucous musical culture. As a physical object—a child's toy—rather than a literary trope, Weeden's mechanical bank relies principally on visual stereotypes borrowed from the blackface tradition, particularly the darkened skin and caricatured features of the performers, to achieve its putative authenticity. The promotional materials produced in conjunction with the bank promised "a very comical performance lasting over a minute." Much like the minstrel tradition from which such imagery derived, then, it presented indigenous black culture as a humorous source of entertainment. Inscribed on one side of the shanty are the words "Jig Dancin'," and on the other, "Banjo Lessuns—One Cent." Purposefully misspelled, undoubtedly tongue-in-cheek, the words pointedly sneer at the notion of a black musical legacy worthy of cross- or even intra-cultural transmission.

The homespun text adorning the shack immediately calls to mind Henry Ossawa Tanner's nearly contemporaneous and virtually iconic rendering of the same subject, *The Banjo Lesson* (see fig. 112), now in the Hampton University Museum. In this remarkably gutsy painting, Tanner revisited the much-maligned, stereotypical imagery of the shanty and its caricatured minstrel inhabitants, shifting attention away from the public, performative mask of blackface entertainment to a private, intergenerational pedagogical exchange between a child and an esteemed elder. According to his own testimony, Tanner felt compelled as a black artist to counter the malignant representation of what he termed the "comic" and "ludicrous" aspect of black culture, those ubiquitous echoes of the plantation found in everything from sheet-music covers, popular prints and illustrations, and fine art to children's toys. Although Tanner's respectful delineation of black folk culture in this now-much-revered masterwork represented what one scholar has called a "profound psychic break-through," the highly regarded expatriate artist turned his back on "Negro subjects" in the mid-1890s, preferring to spend the last several decades of his career painting from within the less problematic and seemingly race-neutral arena of religious subject matter and Orientalist fantasy.[7]

During those very same decades, another expatriate black artist, Albert Alexander Smith, attempted to navigate the problematic terrain of black folk traditions. His images appear, on the one hand, to pay homage to indigenous culture; on the other, they also seem to pander to white expectations. Born in 1896 (just about the time Tanner was retreating from his racially charged subjects), Smith was raised in New York by parents who had immigrated to the city from Bermuda, no doubt in search of better economic and cultural opportunities. Smith was the first African American to study at the National Academy of Design, one of the country's most venerable art schools, which he began attending in 1915. Although military service during World War I took him overseas in 1917, Smith eventually continued his training at the Academy and earned a number of prestigious awards, including a

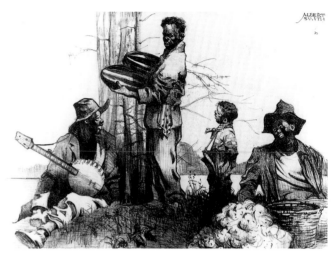

fig. 101 *(left)*
Albert Alexander Smith, *Do That Thing,* 1930,
lithograph, 8¾ × 11½ inches. Photographs
and Prints Division, Schomburg Center for
Research in Black Culture, The New York Pub-
lic Library, Astor, Lenox and Tilden Foundations.

fig. 102 *(right)*
Albert Alexander Smith, *Temptation,* 1930, lith-
ograph, 8 × 10⅞ inches. Photographs and
Prints Division, Schomburg Center for
Research in Black Culture, The New York Pub-
lic Library, Astor, Lenox and Tilden Foundations.

prize in etching, during his tenure there. In 1920 Smith returned to Europe. He
would remain there for the rest of his life, based primarily in Paris, a city that was
home to a thriving expatriate African American community. Smith was an avid
printmaker in an era when black artists were relatively unknown as such. He was
also a jazz musician—a banjo player, in fact. Part of his time abroad was spent gig-
ging as a singer and player in a variety of itinerant bands.[8]

As Theresa Leininger-Miller has argued, Smith was at heart a performer. A
sense of "theatricality"—that is, a sense of being aware of one's audience—
permeates his artistic output. *Do That Thing,* a lithograph from 1930, is one of sev-
eral depictions of black musicians and dancers in Smith's oeuvre likely targeted to
a white European audience fascinated by images of the Deep South (fig. 101). Alter-
nately titled *Les Danseurs,* the image depicts two young children dancing on the
battered boards of a boat dock, their musical accompaniment provided by a banjo-
wielding older gentleman and another figure, his face eclipsed by his hat, who claps
in rhythm to the instrument's frolicsome continuo. Like many of Smith's depic-
tions of southern black culture, this print has troubled scholars, many of whom
have difficulty aligning Smith's own racial heritage and his persona as a cosmopol-
itan expatriate with his seeming perpetuation of minstrel stereotypes, particularly
the wiry-haired "pickaninny" type. In *Temptation,* another lithograph from 1930, a
less obviously caricatured child stands amid a pyramidal triumvirate of racist
stereotypes: the banjo player, the hoarder of watermelons, and the grinning cotton
picker forever distracted from his work (fig. 102). All are variants in some form of
the clownish Sambo, a minstrel figure whose comical stage presence hinged on
indolence and inarticulate buffoonery. The child, whose inquisitive gaze echoes
the vector of the momentarily silenced banjo, is situated firmly—both composi-
tionally and by birthright—within this minstrel legacy, an unwitting pawn in a
predetermined future.[9]

Unlike the blackface entertainers who provided the models for such stage types (based on their purported visits to the plantation), Smith, as an immigrant, a northerner, and an expatriate who likely never visited the South, could make no claims to such authenticity. He thus appears to filter and mediate his black folk imagery through the lens of popular culture, thereby reifying mythologies of southern blackness. One of his most successful prints, *Plantation Melodies (Sud des Etats Unis)*, was clearly directed toward a French-speaking audience. It was featured, without its French subtitle, in the August 1920 issue of *The Crisis*, the literary journal of the NAACP that was edited by W. E. B. Du Bois. Reproduced alongside a brief notice touting Smith's accomplishments, the etching features homespun plantation figures, among them a banjo-playing elder parenthetically framed by a silhouetted mother and child on one side and a resting farmhand on the other. One refrains from labeling them "uncle," "mammy," "pickaninny," and "Sambo," although all four figures, along with the other stock characters in this plantation tableau, waver dangerously close to caricatured types. Scholars past and present (including Du Bois, apparently) have interpreted *Plantation Melodies* as a respectful portrayal of ordinary folk inhabiting a private "black" space in which the veil of minstrelsy is lifted to make way for authentic vernacular expression. Yet this problematic space, as Laural Weintraub has pointed out, remains permeable and "the tone of the narrative unstable, because Smith's plantation scenario retains its link to the visual legacy of minstrelsy, even as it subverts its essential stereotypes."[10]

Smith forged a career as a printmaker in part by parading Negro content in front of both black and white audiences, despite his own ever-growing distance from that cultural reality. As Leininger-Miller has noted, Smith's relationship to his source material was "conflicted," and the light-skinned artist-musician often used disparaging epithets to describe African Americans. One might argue, then, that Smith was performing a kind of racial masquerade, to borrow Michael North's wording—donning a minstrel mask and visiting the plantation as needed. As North argues in *The Dialect of Modernism: Race, Language, and Twentieth-Century Literature,* many white poets and writers in the 1920s—e. e. cummings, Ezra Pound, and T. S. Eliot among them—assumed similar masks as they mimicked the strategies of black dialect in their modernist reworking of language. In essence, they performed a kind of "racial ventriloquism" as a form of avant-garde rebellion.[11] Carl Van Vechten, the white author of the infamous novel *Nigger Heaven,* wrote to Gertrude Stein in 1926 that "the race is getting more popular everyday." "New York," the writer informed his expatriate friend, "has gone almost completely native."[12]

For most white New Yorkers, going "native" in the 1920s implied traveling uptown to Harlem to venues like the Cotton Club or the Congo Room to partake of the sights and sounds of urban black culture, albeit in the form of ersatz replica-

tions of plantation or jungle. It could also mean venturing over to Broadway, where all-black revues like *Shuffle Along* (1921), *Plantation Revue* (1922), and *Hearts in Dixie* (1929) played to amused and enthralled houses, adding a richer complexion and a southern accent to the Great White Way. While not a minstrel show per se, the all-black musical comedy had nonetheless grown out of Reconstruction-era black minstrelsy (that is, blacks performing in burnt cork) via the entertainment vehicles of burlesque and vaudeville. The vaudevillian concept of a string of fast-paced specialty acts had indeed emerged out of the "olio" or "varieties" section of the minstrel show. The southern plantation had literally provided the backdrop for this interlude of minstrel "comicalities" as well as the full-cast production numbers—the "walk-around"—that typically concluded the blackface show.[13]

Well into the twentieth century, the plantation continued to be the preferred mise-en-scène for the black revue. As white educator Francis Pendleton Gaines argued in *The Southern Plantation: A Study in the Development and the Accuracy of a Tradition* (1925), "The plantation romance remains our chief social idyl [*sic*] of the past." "It was possible during the season of 1922–1923," Gaines noted, "to witness in New York alone half a dozen plays or pageants which featured plantation customs" as well as "an uninterrupted presentation of spectacles in which this material received minor elaboration." Writing fully in the midst of the Harlem Renaissance, Gaines understood that humor, burlesqued well beyond any pretensions to authenticity, provided the driving force behind the parodic stage version of plantation life. "The theater-going public," he perceptively concluded, "does not, in any considerable proportion, want racial distinctiveness; it wants the standard portrayal of plantation characteristics as developed by the tradition."[14]

The stereotyped denizens of the southern plantation could be found cavorting, gamboling, and jigging across Manhattan throughout the early decades of the twentieth century. Shows like *Hearts in Dixie* and musical revues such as those presented at the Plantation Club, which opened on Broadway in 1923 complete with an enormous rendering of a watermelon suspended over the dance floor, perpetuated what one historian has termed the "blackface fixation" in American popular culture.[15] This ongoing linkage of black performance and minstrelsy, so apparent in theater productions and in early film, can also be seen in the paintings and drawings by white American modernist painters. Like many of their literary counterparts, artists like the urban realist Everett Shinn and, somewhat later, Charles Demuth enacted a kind of racial masquerade as they scoured black entertainment sites—both high- and lowbrow—for subject matter. In Shinn's *Bowery Music Hall* (1904, fig. 103), a singer with his back to an upright piano wears the faux-formal attire, including the white gloves, of blackface performance. His indeterminate features, in keeping with the sketchily muddled scene, are difficult to read. Yet his identity as a *black* performer—masked or not—is clear.

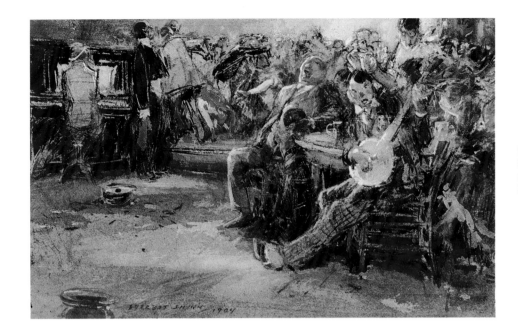

fig. 103
Everett Shinn, *Bowery Music Hall,* 1904, mixed
media on paper, 8 × 12¾ inches. Private col-
lection.

Situated in lower Manhattan, the Bowery area became renowned in the nine-
teenth century for its theaters specializing in what one modern scholar calls "working-
class entertainment." The district was as famous for its raucous plays and rowdy
characters as for the colorful cast of orphans and other rough-hewn individuals
attending the productions.[16] By the early twentieth century, several theaters in the
Bowery specialized in the songs, skits, comedy monologues, and sing-alongs that
characterized the genre of vaudeville entertainment. Thanks as well to films such
as *A Bowery Café* (1897) and *The Bowery Waiter and the Old Time Ball Player*
(1898), the district's reputation for bawdiness (food fights, public inebriation,
police raids) lingered well into the twentieth century.

Shinn reminisced about the participatory nature of the entertainment in the
Bowery dance halls he visited. As if warning of the uproarious atmosphere, he
advised, "Bring your own instrument of musical torture, it will be welcomed or
splintered over your head."[17] With its irregular pastel hatching, unexpected dabs of
white gouache, and summarily modeled forms, *Bowery Music Hall* may be consid-
ered "splintered" in form and tone. Ultimately, the real focal point of the compo-
sition is not the dignified, straight-backed performer but the debauched white
habitués in the foreground, decidedly askew, one of whom plays a banjo—surely
an "instrument of musical torture" in those hands. Meeting our gaze in a gesture
of both resistance and irritation, this rumpled, probably inebriated figure per-
forms a kind of ribald, confrontational blackness, strumming on his old banjo,
seconding—and likely drowning out—the piano accompaniment, while his
heavyset friend adds his own vocal input.

fig. 104
Charles Demuth, *Marshall's,* 1915, watercolor
on paper, 12¾ × 7¾ inches. Private collection.
Photo courtesy Kennedy Galleries, New York.

Shinn was drawn, as one critic at the time noted, to the "artificial life of the folk
at the cheaper theaters and concert halls," making him "a modern of moderns."
Another "modern" in search of the rhythmic diversion of black entertainment was
Charles Demuth, whose favorite "Negro club" in the mid-1910s was further

uptown and catered to a less raunchy, racially mixed crowd. *Marshall's* (1915, fig. 104), part of a series of intimate watercolors documenting the artist's private evening escapades, pays homage to one of the era's most significant black-owned jazz clubs. Located in the basement of the Marshall Hotel on West Fifty-third in a section of town then known as "Black Bohemia," Marshall's was a crucial gathering place for black intellectuals and professional musicians from the vaudevillian minstrel stage, including figures like the comedic actor Bert Williams, composer Will Marion Cook, and Ernst Hogan, best known for his popular song "All Coons Look Alike to Me." For poet James Weldon Johnson (who boarded at the hotel, along with other leading black artistic figures), Marshall's was more than a "sight." "[I]ts importance as the radiant point of the forces that cleared the way for the Negro on the New York stage," he later wrote, "cannot be overestimated."[18]

Although it was an important stomping ground and meeting place for black performers, Marshall's also attracted white bohemians like Demuth and his pals Marsden Hartley, Marcel Duchamp, and Carl Van Vechten, all of whom no doubt found the exotic setting of such "nigger parlors"—Demuth's colorful phrasing—liberating and daringly antiestablishment. According to black entertainer Tom Fletcher, the club "attracted the best people of both races who rubbed elbows there nightly." "On Sundays," he recalled, "after-theater parties there brought out the top-ranking members of the elite and the place was filled with members of both races, all in proper evening attire, mingling and having a good time."[19]

As in several of Demuth's other watercolors of the famous club, the "Negro jazz band," as he called it—more properly, jazz trio, featuring piano, banjo, and drums—is the focus of *Marshall's,* rather than the joint's sketchily indicated, racially integrated clientele. The dark face of the piano player acts as a menacing foil to the more comical, almost supplicating demeanor of the banjo player, whose caricatured presence suggests that the line demarcating minstrel stage and jazz floor was a porous one in the decades leading up to the Harlem Renaissance. The eccentric moves of the solemn-faced but oddly out of kilter "Negro girl dancer" (to borrow another of Demuth's titles) may have owed something to the plantation despite their reenactment in this urbane setting. "The most notable of the [recent] American dances are derived from the negro of the old slave days, the buck and wing, the cakewalks, and rag-times," Caroline and Charles H. Caffin noted in their 1912 study, *Dancing and Dancers of Today*. "In all these there is the curious mixture of careless gaiety and ultra self-consciousness, the freakish vivacity with solemnity of self-importance, the true sense of humour with a frank appeal for approbation."[20] Although the racial identity of these fluidly rendered, multi-hued black players is certain, their position as black entertainers in a white world still enamored by the sights, sounds, and rhythms of the minstrel stage remained problematic.

Harlem Renaissance and the Dialect of Jazz

I am interested in Negro poets and Jazz pianists. There is always something in New York, and this winter it is decidedly Negro poets and Jazz pianists.

—CARL VAN VECHTEN, letter to Gertrude Stein, 15 November 1924

For many black performers in the transitional years leading up to the Harlem Renaissance, the "frank appeal for approbation" or approval remained tied to playing the stereotype and donning an increasingly indeterminate minstrel mask. In the 1920s, as the white literati were reading New Negro poetry and traipsing uptown to hear jazz music, black artists and writers were working valiantly to subvert the "half-clown, half-troubadour" stereotype as they strove to foster what Alain Locke termed "a racial idiom of expression." "Nothing is more galvanizing than the sense of a cultural past," Locke proclaimed, but that past—inexorably linked to the southern plantation, the cradle of black folk culture—was both rich with possibility and fraught with problems.[21]

As a "mid-wife" of the New Negro movement, Locke, along with Du Bois, James Weldon Johnson, and other leading intellectuals, optimistically believed that the demonstration of cultural parity—accomplished largely via the recasting of the Negro as a creative individual instead of a minstrel clown—through racially distinctive literature, music, and art would factor significantly in the quest for social equality and "justice for all." Locke well understood that decades of misrepresentations of African Americans, perpetuated by what he called the "plantation formula," had resulted in a seemingly endless stream of "vaudeville stereotypes." The ubiquity and popularity of these stereotypes made it extremely difficult for both blacks and whites to "break through this cotton-patch and cabin-quarters formula." Johnson had voiced similar sentiments, reiterating in his 1930 *Black Manhattan* that minstrelsy and its theatrical progeny had codified the tradition of the Negro as "only an irresponsible, happy-go-lucky, wide-grinning, loud-laughing, shuffling, banjo-playing, singing, dancing sort of being."[22]

Like his younger compatriot Langston Hughes, Johnson crafted a career as a Harlem Renaissance writer and poet by immersing himself in black vernacular culture, and in so doing, he took on a vexed minstrel past. Johnson well understood that minstrelsy was, as he put it, "a caricature of Negro life," yet he also acknowledged that the blackface stage tradition had provided numerous African American musicians with vital and "essential" training and theatrical experience. He himself had undergone a kind of minstrel apprenticeship some twenty years prior to the full blossoming of the New Negro ethos in the 1920s, writing plantation or "coon" songs for both the all-black and white stage in partnership with the remarkably talented composer Bob Cole. One of their ditties, "Sambo and Dinah," written for the 1904 holiday production of *Humpty Dumpty,* a children's show, features a banjo-playing Sambo.

No doubt you've heard of Sambo
The lad who plays the banjo,

And sings sweet songs to his dusky lady love.
You've heard also of Dinah,
The gal from Carolina,
With pearly teeth and eyes just like the stars above;

.

Suppose you could be list'ning,
While Dinah's eyes are glistening
And Mister Sambo plunks his banjo, while he tries to woo;
Their love you'd hear them stammer,
Without respect to grammar,
For this is how these dusky lovers bill and coo.[23]

In these verses penned by Johnson and Cole, black folk culture (represented by the banjo) is clearly tied to minstrelsy, personified by the figure of Sambo, and to dialect ("without respect to grammar"). The enormously popular tradition of dialect poetry in the late nineteenth century, initially fabricated and perpetuated by white writers, was—like the minstrel characters who typically spouted such broken language—a grotesque caricature of vernacular folk material.[24]

Although Johnson and Cole's "Sambo and Dinah" text flags rather boldly its dusky minstrel ancestry via its lead characters and stage props, the language of this love song is only moderately "dialected." The authors' sophistication is pointedly and playfully evident in the "grammar/stammer" rhyme and in the witty phraseology of the second verse: "Oh! Dinah, no gal am mo'divinah." The supposed "phonetic decay" of black dialect is more evident in Johnson's self-designated "jingles and croons." A number of these, including "A Plantation Bacchanal," "Possum Song," and "Brer Rabbit, You'se de Cutes' of 'Em All," were included in the poet's *Fifty Years and Other Poems* (1917). Among them was Johnson's "Banjo Song."

W'en de banjos wuz a-ringin',
An' de darkies wuz a-singin',
Oh, wuzen dem de good times sho!
All de ole folks would be chattin',
An' de pickaninnies pattin',
As dey heah'd de feet a-shufflin' 'cross de flo'.

.

W'ile de banjos dey go plunka, plunka, plunk,
We'll dance tel de ole flo' shake;
W'ile de feet keep a-goin' chooka chooka chook,
We'll dance tel de day done break.[25]

As is evident from these stanzas, in which the banjo's rhythmic accompaniment is conveyed through a form of onomatopoeic dialect, masking sophistication was the strategy typically adopted by the black dialect poet at the turn of the century. One of the best-known and most influential of these poets, Paul Laurence Dunbar, trenchantly described writing dialect material from behind a "mask that grins and lies" in his most famous poem, "We Wear the Mask."

> We wear the mask that grins and lies,
> It hides our cheeks and shades our eyes,—
> This debt we pay to human guile;
> With torn and bleeding hearts we smile,
> And mouth with myriad subtleties.[26]

As literary scholar Peter Revell has noted, Dunbar's poem is essentially an apologia for what the author and later generations would condemn in his work, namely "the grin of minstrelsy and the lie of the plantation tradition that Dunbar felt himself bound to adopt as part of the 'myriad subtleties' required to find a voice and be heard." Dunbar, a son of former slaves, made a name for himself almost entirely based on his Negro dialect poetic oeuvre. (Inspired by Dunbar's example, a young Langston Hughes would later try his hand at dialect poetry.) Dunbar's body of work included such pieces as "The Deserted Plantation," "A Plantation Melody," "When de Co'n Pone's Hot," and, of course, his own "Banjo Song."

> Oh, dere's lots o' keer an' trouble
> In dis world to swaller down;
> An' ol' Sorrer's purty lively
> In her way o' gittin roun'.
> Yet dere's times when I furgit 'em,—
> Aches an' pains an' troubles all,—
> An' it's when I tek at ebenin'
> My ol' banjo f'om de wall.
>
> 'Bout de time dat night is fallin'
> An' my daily wu'k is done,
> An' above de shady hilltops
> I kin see de settin' sun;
> When de quiet, restful shadders
> Is beginnin' jes' to fall,—
> Den I take de little banjo
> F'om its place upon de wall.

Den my fam'ly gadders roun' me
In de fadin' o' de light,
Ez I strike de strings to try 'em
Ef dey all is tuned er-right.
An' it seems we're so nigh heaben
We kin hyeah de angels sing
When de music o' dat banjo
Sets my cabin all er-ring.[27]

This "jingle in a broken tongue," which continues for several more stammered stanzas, has embedded within its visually and linguistically off-putting text the essential components of a meaningfully rich vernacular past—one in which the banjo, that most stereotyped of minstrel and dialect images, is realigned with solace, family, and spirituality.[28] Buried deep within the deformative parlance masking these iambic verses lie the "myriad subtleties" of a folk instrument redolent with meaning beyond the comic. As a dialect poet, the quintessentially eloquent Dunbar was caught in a seemingly no-win situation, mired in white expectations. "I've got to write dialect poetry," he complained to Johnson, adding, "it's the only way I can get them to listen to me."[29]

Although Johnson considered Dunbar to be the first black American poet of "real literary distinction," he nonetheless grouped him with other dialect poets whose prosody, he believed, remained tied to the characters and demeanor of the minstrel tradition. In his preface to *The Book of American Negro Poetry* (1921), Johnson noted that "Negro dialect is naturally and by long association the exact instrument for voicing this [minstrel] phase of Negro life." By virtue of that association, he argued, "it is an instrument with but two full stops, humor and pathos." Drawing on another musical metaphor nine years later in *Black Manhattan*, he described how more progressive-minded poets had recently begun rejecting this minstrel past by discarding "traditional dialect and the stereotyped material of Negro poetry." These poets, he wrote, "did not concern themselves with the *sound of the old banjo* and the singing round the cabin door," but broke away from the limitations of the narrowly circumscribed "sentimental" plantation tradition. Thus, he would argue, young writers such as Langston Hughes and Sterling A. Brown were turning to more contemporary subjects and, more important perhaps, to contemporary sounds. They "*do* use a dialect," he commented, "but it is not the dialect of the comic minstrel tradition . . . ; it is the common, racy, living, authentic speech of the Negro in certain phases of real life."[30]

For Johnson, real life—at least for the creative minds behind the burgeoning of the New Negro artistic movement—meant Harlem and not the southern plantation, or to put it more precisely, the jazz club and not the minstrel shanty. We would do well to remember that Hughes had placed the "blare of jazz bands" at the

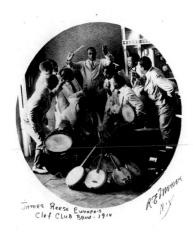

fig. 105

R. E. Mercer, *James Reese Europe with One of the Clef Club Bands*, c. 1914–1917, photograph. Photographs and Prints Division, Schomburg Center for Research in Black Culture, The New York Public Library, Astor, Lenox and Tilden Foundations.

top of his list of ethnically specific subjects available to the dark-skinned artist in his race-declamatory essay of 1926. Hughes's choice of words is telling, for *blare* is not *twang*. Blare suggests that which is boisterously modern and rhythmically syncopated. Blare embodies the qualities—"awakening," "provoking," "audacious"— used by Johnson to characterize the compelling power of ragtime, jazz's somewhat funky maiden aunt.[31] And blare, finally, aurally captures the sound of jazz—the sound of horns, the sound of drums, the sound of hammered ivories, and, let us not forget, the sound of the banjo.

That the banjo was a critical instrument in the formative years of jazz is apparent in the era's popular illustrations and caricatures as well as in photographs of small jazz combos and orchestras from the early decades of the twentieth century (see fig. 120).[32] In one such photograph from the mid-teens, a lively group portrait of arguably one of the most important and influential of these early jazz groups, the Clef Club Band, the banjo clearly holds pride of place (fig. 105). Carefully arranged in the foreground are several types of banjos, from the cello to the piccolo varieties. This quick visual survey—not so different from ethnographic displays or natural science illustrations (see figs. 22, 23)—demonstrates the varied complexity of the instrument. A world removed from the unidimensional minstrel prop, this artful pyramid of banjos functions as a kind of heraldic device, artfully embodying the group's identity as modern *jazz* musicians and directing the viewer's attention to the band's self-possessed leader.

James Reese Europe assumes the traditional posture of the orchestral conductor in this staged photograph, taking a position of power and control, forthrightly meeting the gaze of his audience. Originally from Washington, D.C., Europe came to New York in 1903 and took up residence at the Marshall Hotel. For the next several years, he traveled on the vaudeville circuit as an orchestra leader for black musical comedies. Europe was one of the original members of the "Memphis Students," a song and dance group formed in early 1905 and later credited as being "the first modern jazz band."[33] (Oddly enough, as has been pointed out, the performers were neither students nor from Memphis.) That group of some twenty players had been dominated by an aggregate of plucked and strummed string instruments, notably mandolins, harp guitars, and banjos, a configuration that would factor heavily in Europe's famed jazz orchestra formed in 1910. Early that year, apparently at the prompting of Jimmie Marshall, the proprietor of the well-known hotel and club, a group of black musicians (including Europe) founded the Clef Club across the street from Marshall's, where they had long been congregating, networking, and even awaiting calls for gigs. Functioning essentially as a union and booking agency for black performers, the Club also supported a "Symphony Orchestra" in which the banjo and its string cousins, as might be surmised, would play a leading role.

A remarkable photograph of one of the Clef Club Orchestra's earliest concerts, possibly the "Musical Melange and Dancefest" held in 1910 at the Manhattan

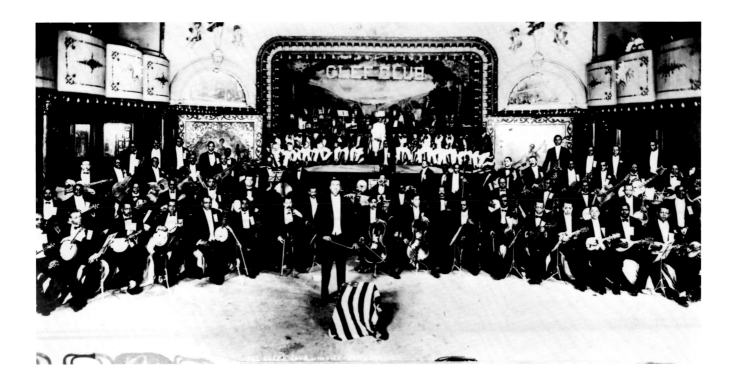

fig. 106
James Reese Europe's Clef Club Orchestra in
concert at the Manhattan Casino, c. 1910–13,
photograph. Photographs and Prints Division,
Schomburg Center for Research in Black Cul-
ture, The New York Public Library, Astor, Lenox
and Tilden Foundations.

Casino club in Harlem, strongly attests to the role of the banjo as a rhythmic jazz instrument and to the positioning of this New Negro music in relation to its minstrel past (fig. 106). In what today seems like an impossible gathering of players, at least one of these concerts featured some sixty-nine strummers on a variety of stringed instruments. Thirty-seven mandolins and *bandoris* (a banjo-mandolin hybrid, divided like violins into firsts and seconds), nine tenor banjos, twenty-three harp guitars, and a smattering of violins and cellos were all sonically backed by a triumphant cavalcade of ten pianos. Europe acknowledged that some audience members would "doubtless laugh heartily" at this unusual orchestration, although, for him, it was the "peculiar steady strumming accompaniment" of the vernacular strings that made the music distinctive and racial. Most interesting, perhaps, is the positioning of a number of the banjo players (apparently in blackface) on the stage in a configuration that recalls the opening "interlocutor" act of the standard minstrel show. Although relegated to the background, these minstrel players occupy the same performance space as the modern jazz orchestra, whose peculiar rhythms are rooted in this minstrel lineage. Of all the original "Ethiopian" instruments—the banjo, bones, tambourine, and fiddle—the banjo alone serves as the missing vernacular link between a toe-tapping past and a syncopated future.[34]

For the famed (and appropriately named) jazz bandleader Paul Whiteman, the "clear, snappy," penetrating sonority of the banjo was a crucial component of the jazz sound. In his book *Jazz* (1926), he credited this "instrument of highest

importance" with providing the unifying "ground rhythm" holding the jazz combo together. As Whiteman put it, jazz represented a new musical language, a method of saying old things "with a twist, with a bang, with a rhythm that makes them seem new." In jazz, it's not so much what you say, he argued, but how you say it. Harlem Renaissance poets, including Hughes, were likewise inspired by this new "language," capitalizing on its syncopated rhythms and its ties to the arena of black folk culture. In "Ma Man," Hughes breathed new life into the vernacular by calling on the banjo, reinvigorating what many might have viewed as an outmoded artifact of the minstrel past.[35]

> He kin play a banjo
> Lordy, he kin plunk, plunk, plunk.
> He kin play a banjo.
> I mean plunk, plunk . . . plunk, plunk.
> He plays good when he's sober
> An' better, better, better when he's drunk.[36]

In this stanza—which, like most of his Harlem cabaret poems, was penned in the 1920s—the author purposefully syncopates the text, accentuating the offbeat in the fourth line via the "plunk" of the banjo. That potent ellipsis functions essentially as kind of musical rest, deflecting the verse's rhythm away from the downbeat, a common characteristic of jazz syncopation. The language itself is tinged with the earthy hues of vernacular speech.

> When ma man looks at me
> He knocks me off ma feet
>
>
>
> De way he shocks me sho is sweet

Although Hughes did have his elitist detractors, critics and supporters like Johnson applauded this "common, racy, living, authentic speech of the Negro," captured in real-life situations. For Johnson, such was the "genuine folk stuff" of which the race-conscious poetry of the New Negro was made.[37]

For that other vocal proponent of a "racial idiom" of expression, Alain Locke, such low-life material was potentially problematic, situated as it was on the slippery slope of racist typecasting. Although he championed black American folk music, and Negro spirituals in particular, Locke was troubled by the minstrel origins of jazz. It was apparently with a sigh of relief that he noted its evolution "out of a broken, musically-illiterate dialect" into a "national and international music with its own peculiar idioms of harmony, instrumentation and technical style of playing" between 1905 and 1912. Locke likely designated the latter date because of

its association with the Clef Club Orchestra's famed concert at Carnegie Hall on 2 May 1912—the "night the Cinderella of Negro folk music found royal favor and recognition and under the wand of Negro musicians put off her kitchen rags."[38]

The quick embrace of jazz by white composers and musicians was, for Locke, a sure sign that Cinderella had indeed arrived at the ball. Further recognition of the new black music would come at the hands of such royalty as George Gershwin, whose epoch-making *Rhapsody in Blue* made its debut as part of "An Experiment in Modern Music" at Aeolian Hall in midtown Manhattan in 1924. The piece was originally scored for solo piano and a small jazz band, including a banjo, and thus the unique timbre of that instrument was as much a part of the work's modern sound as the now-famous opening wail of the clarinet. Yet by the time of its realization for symphonic orchestra in the late 1930s, the guise in which *Rhapsody* is best known today, both the banjo and saxophone parts would be listed as optional. And tellingly, in Gershwin's black folk opera, *Porgy and Bess,* which premiered in 1935, the stringed instrument is demoted to a stage prop for Porgy's "banjo song" ("I Got Plenty O' Nuttin'"). No longer the urbane voice of jazz, the instrument is once again linked with the patois of southern black culture.[39]

The banjo's uneasy and, ultimately, unstable identity is also evident in the paintings of a number of artists associated with the Harlem Renaissance, among them Aaron Douglas, Malvin Gray Johnson, and Archibald Motley. In *An Idyll of the Deep South* (1934, fig. 107), one of four panels in Douglas's monumental mural series delineating the history of black Americans, a banjo player occupies center stage, highlighted, indeed targeted, by the artist's signature radiating bands. This so-called idyll, built around the focal point of black folk culture, is problematized both by the backbreaking work of the rural laborers at right and the grieving figures at left, who mourn the death of a lynching victim. A ray of light penetrates this disturbed scene of southern life, linking its vernacular core with a hopeful future located, to paraphrase Hughes, any place that is not Dixie. The final panel of the series, *Song of the Towers,* is built around the assertive silhouette of a northern jazz player, who triumphantly holds a saxophone in his hand against an urban backdrop.[40] In Douglas's visual synopsis of black history, which culminates in the very moment it was painted, the banjo—although linked with the black expressivity of the New Negro—has been expurgated from the master narrative of jazz, consigned to the troubled past (and pastoral) of the plantation.

The unsettling mask of minstrelsy also haunts Malvin Gray Johnson's *Harmony* (c. 1930, fig. 108) and Archibald Motley's *Stomp* (1927, collection of William H. and Camille O. Cosby), two paintings devoted to the rhythms of black music and dance. Johnson's banjo-wielding performers, their bent bodies jauntily echoing the club's angular décor, are, as one recent scholar has commented, "multiplied, serialized, and generalized into a pattern as uniform as the floor planks beneath their feet."[41] Framed by a proscenium-like opening, this shuffling trio performs

blackness on stage before a vaudeville or cabaret audience. The artist's supposed modernity, one might argue, is rather superficially tied to the abstract echoing of forms on the painting's flattened surface and undeniably linked both conceptually and visually to a minstrel masquerade.

Misery Loves Stereotype

Mr. Bayley and I went to see a Negro Ball. Sundays being the only days these poor creatures have to themselves, they generally meet together and amuse themselves with Dancing to the Banjo. . . . They all appear to be exceedingly happy at these merrymakings and seem if they had forgot or were not sensible of their miserable condition.

—NICHOLAS CRESSWELL,
Journal, 1774

In music they are more generally gifted than the whites with accurate ears for tune and time. . . . Misery is often the parent of the most affecting touches in poetry.—Among the blacks is misery enough, God knows, but no poetry.

—THOMAS JEFFERSON, *Notes on the State of Virginia*, 1781

The linkage of black Americans with an innate performative musicality—despite their "miserable condition"—runs deep in this country's scripted cultural beliefs and history, and the banjo has long played a leading part in that narrative. "The instrument proper to them," Thomas Jefferson famously noted in the formative years of this chattel-supported democracy, "is the Banjar, which they brought hither from Africa." The future president was well aware of his slaves' abilities on this transplanted indigenous instrument, yet he was unable to concede any notion of poetry or expressivity to black vernacular music. Jefferson could thus characterize the slave countenance—the black face, as it were—as an "eternal monotony . . . that *immoveable veil of black* which covers all the emotions of the *other* race."[42] In this profoundly revealing statement, which uncannily presages both Du Bois and Hughes, Jefferson unwittingly gives voice to the masking of emotion so critical to the blackface tradition.

Over a century later, the Harlem Renaissance poet would likewise give voice to those veiled emotions through a fictive but obviously historically based blackface performer in his poem entitled "Minstrel Man."

> Because my mouth
> Is wide with laughter
> And my throat
> Is deep with song,
> You do not think
> I suffer after
> I have held my pain
> So long?
>
> Because my mouth
> Is wide with laughter,
> You do not hear
> My inner cry?
> Because my feet
> Are gay with dancing,
> You do not know
> I die?[43]

In this trenchant little poem, Hughes captures the anguish and misery behind the minstrel masquerade. One might argue, however, that his black colleagues in the visual arts often gave the lie to the jovial blackface mask as they created—indeed, performed—for a predominantly white audience accustomed to framing black cultural expression as liberatory entertainment. Ultimately it took the galvanizing empowerment of the civil rights movement and the legally mandated overthrow of Jim Crow segregation for African American artists to truly remove that unyielding "veil."

The lie of the minstrel mask is fully exposed in Betye Saar's *Let Me Entertain You*, a mixed-media assemblage from her "Exploding the Myth" series of 1972 (fig. 109). In the left compartment of this homespun triptych, Saar enshrines what appears to be an inexpensive lithographic reproduction of a blackface banjo player, the colorful vestiges of a minstrel show toy. What was once child's play emerges as a black-and-white simulacrum in the central panel, the specter of minstrelsy witnessing the atrocities of black genocide. At right, the seething anger hitherto kept in check by the minstrel mask is embodied in the assertive, confrontational figure of an armed black militant, his instrument of entertainment replaced by an instrument of warfare. The work's title references the well-known vaudeville ditty, sung by "Baby June," that opens the Broadway musical *Gypsy*. The innocent song is transformed by the second act into a burlesque striptease in which June's sister, Louise, assumes the performative mask of the future Gypsy Rose Lee, uttering what we might term the mantra of the singing and dancing minstrel: "Let me entertain you, let me make you smile."

Saar is one of many black artists—among them Michael Ray Charles and Robert Colescott (fig. 110)—who have enlisted potent black stereotypes in their constructions of postmodern and post-minstrel identities. Probably the most con-

fig. 107 *(top)*
Aaron Douglas, *Aspects of Negro Life: An Idyll of the Deep South*, 1934, oil on canvas, 60 × 139 inches. Art and Artifacts Division, Schomburg Center for Research in Black Culture, The New York Public Library, Astor, Lenox and Tilden Foundations.

fig. 108 *(above)*
Malvin Gray Johnson, *Harmony*, c. 1930, oil on canvas, 24 × 30 inches. Fisk University Galleries, Nashville, Tennessee. Gift of the Harmon Foundation.

fig. 109 *(below)*
Betye Saar, *Let Me Entertain You,* 1972, mixed
media assemblage, 14¾ × 24 × 1¾ inches.
National Afro-American Museum and Cultural
Center, Wilberforce, Ohio. © Betye Saar.
Photo courtesy Michael Rosenfeld Gallery,
LLC, New York.

fig. 110 *(right)*
Robert Colescott, *George Washington Carver
Crossing the Delaware: Page from American
History,* 1975, acrylic on canvas, 84 × 108
inches. Collection of Mr. and Mrs. Robert H.
Orchard.

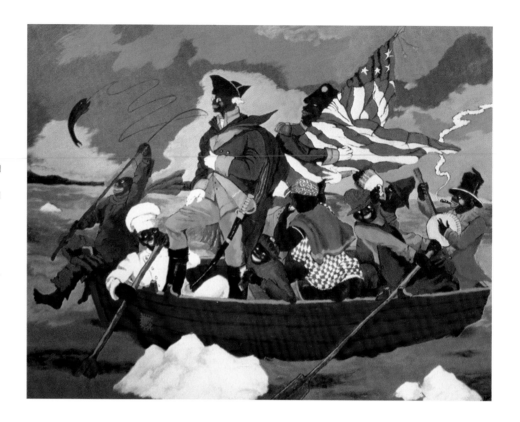

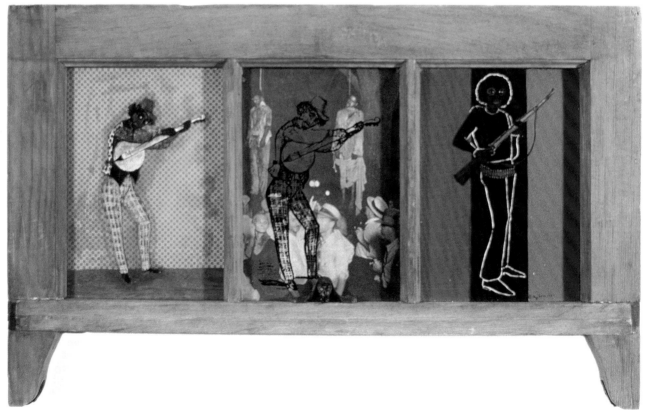

fig. 111
Kara Walker, *Untitled,* 2002, graphite drawing,
65 × 70 inches. Brooklyn Museum, 2003.15.
Courtesy Brent Sikkema, New York.

troversial of those figures is Kara Walker, whose silhouetted plantation tableaux
have earned her both critical acclaim and opprobrium as well as institutional and
market favor (fig. 111). In this monumentally scaled drawing from 2002, Walker
takes on the blackface legacy via its most familiar and disturbing characters, the jig
dancer and the banjo player, who cavort in a pool of blood draining from an evis-
cerated pickaninny. Inappropriately exposed, maimed, and scarred for life, these
minstrel characters will likely drown in the tainted blood of their minstrel fore-
bears, consigned as they are to perform in a white world in which blackness forever
signifies a debased form of humanity. "Part of my project," Walker explains, "has
really been about simplifying, reducing to very easily graspable pairs of opposites,
object/ground, figure/ground, black/white, sex/death, love/hate, good/bad."[44]

In Walker's powerful drawing, the banjo inhabits the center stage of a dialecti-
cal world in which blackness is conflated with stereotype and stereotype gives way
to horror. Hughes did his part to unmask the minstrel past and affirm the probity
and power of black vernacular culture, thereby unsettling the comfortable posi-
tions formerly inhabited by black performer and white viewer. Some would claim
that Walker—who has described herself as a "nigger wench"—is merely a minstrel
in postmodern disguise and that her scandalous reworking of the plantation myth
panders to white expectations and consumerism. I think Walker would, ironically,
agree with Francis Pendleton Gaines, who in 1925 reminded his readers that the
plantation myth remains the most "spacious and gracious" of America's nostalgic
ideals. Despite Walker's framing of this nostalgic past in such stark terms, her work
encourages us to "explode the myth," to look beneath—and ideally, beyond—the
dialectic of race. Writer James Baldwin cautioned us in 1963 to look beyond the
black-and-white construction of racial identity and to be cognizant of the shades
of gray that make up our world. As Baldwin put it, "So where we are now is that a
whole country of people believe I'm a 'nigger,' and I *don't,* and the battle's on!
Because if I am not what I've been told I am, then it means that *you're* not what
you thought *you* were *either!*"[45]

NOTES

1. Langston Hughes, *Black Misery*, with illustrations by Arouni [Lynette Logan] (New York: Paul S. Eriksson, 1969). The text is reprinted in *The Collected Works of Langston Hughes*, vol. 11, *Works for Children and Young Adults: Poetry, Fiction, and Other Writing*, ed. Dianne Johnson (Columbia: University of Missouri Press, 2003), 171–76. See Robert G. O'Meally's afterword to the 1994 reprint of *Black Misery* (New York: Oxford University Press). The Heller books are entitled *Misery* (1964), *More Misery* (1965), and *Misery Loves Company* (1967). W. E. B. Du Bois, *The Souls of Black Folk* (1903; New York: Penguin Books, 1982), 54.

2. Arnold Rampersad, *The Life of Langston Hughes, Vol. 1: 1902–1941* (New York: Oxford University Press, 1986), 130. Hughes's essay "The Negro Artist and the Racial Mountain" was published in *The Nation* 122 (23 June 1926): 692–94.

3. Langston Hughes, *The Big Sea* (1940; New York: Hill and Wang, 1963), 11. Rampersad, *Life*, 12–13. Du Bois, *Souls of Black Folk*, 44.

4. Du Bois, *Souls of Black Folk*, 45. Edward J. Mullen, introduction, *Critical Essays on Langston Hughes* (Boston: G. K. Hall, 1986), 8. Theresa Leininger-Miller quotes this lengthy passage from McKay's novel in her examination of banjo imagery in the work of Albert Alexander Smith. This essay is indebted to many of the ideas set forth in her study. See Theresa Leininger-Miller, *New Negro Artists in Paris: African American Painters and Sculptors in the City of Light, 1922–1934* (New Brunswick, N.J.: Rutgers University Press, 2001), particularly 228–33.

5. Richard O'Brien, *The Story of American Toys from the Puritans to the Present* (New York: Abbeville Press, 1990), 41–46. F. H. Griffith, "Weeden's Plantation Saving Bank," *Hobbies*, August 1963. Philip F. Gura and James F. Bollman, *America's Instrument: The Banjo in the Nineteenth Century* (Chapel Hill: University of North Carolina Press, 1999), plate 3-14.

6. "Interview with Ben Cotton," *New York Mirror* (1897), quoted in Robert C. Toll, *Blacking Up: The Minstrel Show in Nineteenth-Century America* (New York: Oxford University Press, 1974), 46. See also Roger D. Abrahams, *Singing the Master: The Emergence of African American Culture in the Plantation South* (New York: Pantheon Books, 1992), 139–43, and Eileen Southern, *The Music of Black Americans: A History*, 3rd ed. (New York: W. W. Norton, 1997), 91–94. According to Cecelia Conway, many white minstrel performers did attempt to immerse themselves in the plantation culture of the South in order to impersonate blacks with more authenticity. Conway refers to this as a kind of "apprenticeship." See Conway, *African Banjo Echoes in Appalachia: A Study of Folk Traditions* (Knoxville: University of Tennessee Press, 1995).

7. Statement in Tanner's hand in the files of the Pennsylvania School for the Deaf, Philadelphia; as quoted in Dewey F. Mosby, *Henry Ossawa Tanner* (Philadelphia: Philadelphia Museum of Art; New York: Rizzoli International Publications, 1991), 116. See Judith Wilson, "Lifting 'The Veil': Henry O. Tanner's *The Banjo Lesson* and *The Thankful Poor*," *Contributions in Black Studies* 9–10 (1990–92): 31–54.

8. See Leininger-Miller, *New Negro Artists*, chap. 7.

9. Ibid., 202. Lisa Gail Collins, entry on *Les Danseurs* in Lisa Mintz Messinger, Lisa Gail Collins, and Rachel Mustalish, *African-American Artists, 1929–1945: Prints, Drawings, and Paintings in The Metropolitan Museum of Art* (New Haven, Conn.: Yale University Press, 2003), 70.

10. Laural Weintraub, "Albert A. Smith's Plantation Melodies: The American South as Musical Heartland," *The International Review of African American Art* 19 (Spring 2003): 17. Weintraub's discussion of a private "black" space for the enactment of black entertainment is indebted to John Davis's reading of Eastman Johnson's *Negro Life at the South*. See Davis, "Eastman Johnson's *Negro Life at the South* and Urban Slavery in Washington, D.C.," *Art Bulletin* 80 (March 1998): 76–92.

11. Michael North, *The Dialect of Modernism: Race, Language, and Twentieth-Century Literature* (New York: Oxford University Press, 1994), preface.

12. Van Vechten, letter to Gertrude Stein, 10 December 1926, in *The Letters of Gertrude Stein and Carl Van Vechten, 1913–1946*, ed. Edward Burns (New York: Columbia University Press, 1986), 1:138.

13. Bandleader Cab Calloway recalled that the set of the Cotton Club "was like a sleepy-time down South during slavery [and]

the idea was to make whites who came feel like they were being catered to and entertained by black slaves." As quoted by Joel Dinerstein, "Lester Young and the Birth of Cool," in *Signifyin(g), Sanctifyin', and Slam Dunking: A Reader in African American Expressive Culture*, ed. Gena Dagel Caponi (Amherst: University of Massachusetts Press, 1999), 245. Albert F. McClean Jr., *American Vaudeville as Ritual* (Lexington: University of Kentucky Press, 1965), 24–28.

14. Francis Pendleton Gaines, *The Southern Plantation: A Study in the Development and the Accuracy of a Tradition* (New York: Columbia University Press, 1925), 4–5.

15. Contemporary accounts of the Plantation Club are revealing.

> A huge sliced watermelon forms the ceiling above the dance floor and a back-drop, depicting the Swanee River, on which a papier maché steamboat plies its hesitating course, is directly behind [the] jazz-band orchestra. A bandannaed mammy juggles flap-jacks and waffles in a property log-cabin on the left as you enter. Almost everyone is in evening things. One comes to dance rather than to sup, yet to view the show rather than to dance.

See Charles G. Shaw, "11:30 to 3:00 (A Text Book for Students of Insomnia)," *Smart Set* 1 (June 1923): 70. See also Lewis A. Erenberg, *Steppin' Out: New York Nightlife and the Transformation of American Culture, 1890–1930* (Westport, Conn.: Greenwood Press, 1981), 254–55. The term "blackface fixation" is taken from Donald Bogle, *Toms, Coons, Mulattoes, Mammies, and Bucks: An Interpretive History of Blacks in American Films*, 4th ed. (New York: Continuum, 2001), 27.

16. Stuart M. Blumin, *The Emergence of the Middle Class: Social Experience in the American City, 1760–1900* (Ithaca, N.Y.: Cornell University Press, 1989), 145.

17. Everett Shinn, "A Bowery Dance Hall," as quoted in Janay Wong, *Everett Shinn: The Spectacle of Life* (New York: Berry-Hill Galleries, 2000), 77.

18. Helen W. Henderson, "Philadelphia Artists Exhibiting in New York," *Philadelphia North American*, 11 March 1903; as quoted in Sylvia Yount, "Everett Shinn and the Intimate Spectacle of Vaudeville," in Patricia McDonnell, *On the Edge of Your Seat: Popular Theater and Film in Early Twentieth-Century American Art* (New Haven, Conn.: Yale University Press, 2002), 166. James Weldon Johnson, *Along This Way: The Autobiography of James Weldon Johnson* (1933; New York: Viking Press, 1968), 171.

19. Demuth, letter to Agnes Boulton and Eugene O'Neill, 17 September 1921, in *Letters of Charles Demuth: American Artist, 1883–1935*, ed. Bruce Kellner (Philadelphia: Temple University Press, 2000), 25. Johnson colorfully describes seeing whites dancing to the sounds of a Negro band, "attempting to throw off the crusts and layers of inhibitions laid on by sophisticated civilization; striving to yield to the feel and experience of abandon; seeking to recapture a state of primitive joy in life and living; trying to work their way back into that jungle which was the original Garden of Eden; in a word, doing their best to pass for colored." See Johnson, *Along This Way*, 328. Tom Fletcher, *100 Years of the Negro in Show Business* (New York: Burdge, 1954): 251–52.

20. Caroline and Charles H. Caffin, *Dancing and Dancers of Today: The Modern Revival of Dancing as an Art* (1912; New York: Da Capo Press, 1978), 255–56. For a discussion of Demuth's interest in vaudeville, see Laural Weintraub, "Charles Demuth's Vaudeville Watercolors and the Rhythm and Spectacle of Modern Life," in McDonnell, *On the Edge of Your Seat*, 124–35.

21. Alain Locke, "A Note on African Art," *Opportunity*, May 1924, 138, as quoted in Beryl J. Wright, "The Harmon Foundation in Context: Early Exhibitions and Alain Locke's Concept of a Racial Idiom of Expression," in Gary A. Reynolds and Beryl J. Wright, *Against the Odds: African-American Artists and the Harmon Foundation* (Newark, N.J.: The Newark Museum, 1989), 25. See also Alain Locke, ed., *The New Negro* (1925), intro. Arnold Rampersad (New York: Atheneum, 1992).

22. Alain Locke, ed., *The Negro in Art: A Pictorial Record of the Negro Artist and of the Negro Theme in Art* (1940; New York: Hacker Art Books, 1968), 139. See also Alain Locke, *Negro Art: Past and Present* (Washington, D.C.: Associates in Negro Folk Education, 1936), 43–44. James Weldon Johnson, *Black Manhattan* (1930; New York: Arno Press, 1968), 93.

23. The sheet music for "Sambo and Dinah" is reproduced in Thomas L. Riis, *Just Before Jazz: Black Musical Theater in New York, 1890–1915* (Washington, D.C.: Smithsonian Institution Press, 1989), facsimile 6.4, pp. 263–65. See also pp. 109–11.

24. Banjo songs written in black dialect can be found in late-eighteenth-century English comic operas, including "The Negro and His Banja," first performed in 1790.

> One negro wi my banjer,
> Me from Jenny come,
> Wid cunning yiei
> Me savez spy
> De buckra world one hum,
> As troo a street a stranger
> Me my banjer strum.

See Charles Hamm, *Yesterdays: Popular Song in America* (New York: W. W. Norton, 1979), 110.

25. Marcel [W. F. Allen], "The Negro Dialect," *The Nation* 1 (14 December 1865): 744–45; reprinted in *The Negro and His Folklore in Nineteenth-Century Periodicals,* ed. Bruce Jackson (Austin: University of Texas Press, 1967), 74–75. James Weldon Johnson, *Fifty Years and Other Poems* (Boston: The Cornhill Company, 1917), 74.

26. "We Wear the Mask," in *The Complete Poems of Paul Laurence Dunbar,* intro. W. D. Howells (1895; New York: Dodd, Mead, 1970), 112–13.

27. Peter Revell, *Paul Laurence Dunbar* (Boston: Twayne Publishers, 1979), 71–72. Dunbar, *Complete Poems,* 30–32.

28. In a self-referential poem simply entitled "The Poet" (*Complete Poems,* 309), Dunbar set forth the conundrum facing the black artist writing for a white audience.

He sang of life, serenely sweet,
 With, now and then, a deeper note.
 From some high peak, nigh yet remote,
He voiced the world's absorbing beat.

He sang of love when earth was young,
 And Love, itself, was in his lays.
 But ah, the world, it turned to praise
A jingle in a broken tongue.

29. As quoted in Houston A. Baker Jr., *Modernism and the Harlem Renaissance* (Chicago: University of Chicago Press, 1987), 38. Dunbar also noted, "You know, of course, that I didn't start as a dialect poet. I simply came to the conclusion that I could write it as well, if not better, than anyone else I knew of, and that by doing it I should gain a hearing. I gained a hearing, and now they don't want me to write anything but dialect." As quoted in Riis, *Just Before Jazz,* 54.

30. James Weldon Johnson, *The Book of American Negro Poetry* (New York: Harcourt, Brace and World, 1958). This publication includes both the preface to the original edition (1921) and the preface to the revised edition (1931). Emphasis added.

31. Kathy J. Ogren, "Controversial Sounds: Jazz Performance as Theme and Language in the Harlem Renaissance," in *The Harlem Renaissance: Revaluations,* ed. Amritjit Singh, William S. Shiver, and Stanley Brodwin (New York: Garland, 1989), 163. One should not, however, confuse the blare of early jazz orchestration with the noise so many eighteenth-century observers claimed they heard in the *bandore* and early banjo (and that, because it signified things African, they sought to quell). See Leo Mazow's "From Sonic to Social" in this volume for a survey of the earlier accounts.

32. See, for instance, photographs of Duke Ellington's Cotton Club band in Edward Kennedy Ellington, *Music Is My Mistress* (Garden City, N.Y.: Doubleday, 1973), 76.

33. Johnson, *Black Manhattan,* 120.

34. See Maurice Peress, *Dvořák to Duke Ellington: A Conductor Explores America's Music and Its African American Roots* (New York: Oxford University Press, 2004), chap. 11. The Clef Club's official coming out was its similarly orchestrated Carnegie Hall concert with 125 players in 1912. Peress recreated the 1912 concert with "thirty eager strummers" at Carnegie Hall in 1989. See also Reid Badger, *A Life in Ragtime: A Biography of James Reese Europe* (New York: Oxford University Press, 1995), particularly chap. 5. Europe later exported the jazz sound to Paris as a bandleader for the famous 369th Infantry "Hellfighters" Band. James Reese Europe, "Negro's Place in Music," *New York Evening Post,* 13 March 1914; as quoted in Eileen Southern, *The Music of Black Americans: A History,* 3rd ed. (New York: W. W. Norton, 1997), 293. See also Fletcher, *100 Years,* chap. 29. For a photograph of the typical "interlocutor" opening of the minstrel show, see Herbert Preston Powell, *The World's Best Book of Minstrelsy* (Philadelphia: Penn Publishing, 1926), frontispiece.

35. Paul Whiteman and Mary Margaret McBride, *Jazz* (1926; New York: Arno Press, 1974), 118–19, 208, 225. The phrasing here is borrowed from Arnold Rampersad's introduction to *The Collected Poems of Langston Hughes,* ed. Rampersad (New York: Alfred A. Knopf, 1994), 8.

36. From Hughes, "Ma Man," in *Collected Poems,* ed. Rampersad, 66–67. In another poem, "The Cat and the Saxophone," Hughes alternates lowercase letters and capitals to create what Ogren calls a "syncopated cadence":

EVERYBODY
Half-pint,—
Gin?
No, make it
LOVES MY BABY
corn. You like
liquor,
Don't you honey?
BUT MY BABY

See Ogren, "Controversial Sounds," 172. See also Arnold Rampersad, "Langston Hughes and Approaches to Modernism in the Harlem Renaissance," in *Harlem Renaissance,* ed. Singh, Shiver, and Brodwin, 49–71, and Rampersad's introduction to *The Collected Works of Langston Hughes,* vol. 1, *The Poems: 1921–1940* (Columbia: University of Missouri Press, 2001).

37. Johnson, preface (1931) to *Book of American Negro Poetry,* 4, 6.

38. Alain Locke, *The Negro and His Music* (Port Washington, N.Y.: Kennikat Press, 1936), 65–66, 68. See Paul Joseph Burgett, "Vindication as a Thematic Principle in Alain Locke's Writings on the Music of Black Americans," in *Harlem Renaissance,* ed. Singh, Shiver, and Brodwin, 139–57.

39. See David Schiff, *Gershwin: Rhapsody in Blue* (New York: Cambridge University Press, 1997).

40. Hughes, "One-Way Ticket." See Rampersad, *Collected Poems,* 361, for the full text. For a discussion of the mural series within the context of the artist's career, see Amy Helene Kirschke, *Aaron Douglas: Art, Race, and the Harlem Renaissance* (Jackson: University Press of Mississippi, 1995), 123–23.

41. Jacqueline Francis, entry on *Harmony* in Richard J. Powell and Jock Reynolds, *To Conserve a Legacy: American Art from Historically Black Colleges and Universities* (Cambridge, Mass.: MIT Press, 1999), 202.

42. Thomas Jefferson, *Notes on the State of Virginia,* ed. William Peden (1781; Chapel Hill: University of North Carolina Press, 1954), 288n10, 138, emphasis added.

43. Hughes, "Minstrel Man," in *Collected Poems,* ed. Rampersad, 61.

44. Hans-Ulrich Obrist, "Interview with Kara Walker," in *Safety Curtain: Kara Walker,* ed. Johannes Schlebrügge (Vienna: Museum in Progress in cooperation with Vienna State Opera House; Vienna: P & S, 2000), 14; as quoted in Michele Wallace, "The Enigma of the Negress: Kara Walker," in *Kara Walker: Narratives of a Negress,* ed. Ian Berry, Darby English, Vivian Patterson, and Mark Reinhardt (Cambridge, Mass.: MIT Press, 2003), 176.

45. "The Negro Child—His Self-Image" was delivered by Baldwin on 16 October 1963 at Public School 180 in Harlem, and originally published in *The Saturday Review,* 21 December 1963, 42–44, 60. It is reprinted as "A Talk to Teachers" in *The Graywolf Annual Five: Multi-Cultural Literacy,* ed. Rick Simonson and Scott Walker (St. Paul, Minn.: Graywolf Press, 1988), 3–12.

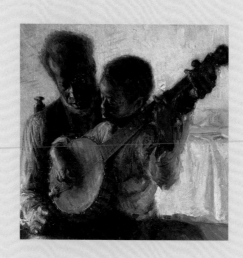

What he wanted was your song.

He wanted to have that song be

his. He thought by catching you

he could learn that song.

—AUGUST WILSON,
Joe Turner's Come and Gone, 1988

From *The Banjo Lesson* to *The Piano Lesson:* Reclaiming the Song

MICHAEL D. HARRIS

6

IN HIS PLAY *Joe Turner's Come and Gone,* set in 1911, August Wilson suggests that the very music with which blacks have defined themselves has, paradoxically, placed them in jeopardy. A white character in the play, Joe Turner, tries to kidnap and enslave blacks in order to possess their "song." In Wilson's *The Piano Lesson,* a play set in 1936, a white man, always offstage, is still trying to capture that song. Playwright and theater historian Kim Pereira notes that "there are several references in the play to a mysterious white man who is 'going around to all the colored people's houses looking to buy up musical instruments.' The process of trying to rob the black man of the source of his identity—and power—continues."[1] As they meditate on the many attempts by whites to capture, contain, and redefine black culture, Wilson's works

(opposite)
Henry Ossawa Tanner, *The Banjo Lesson,* 1893, oil on canvas, 49 × 35½ inches (detail of fig. 112). Hampton University Museum, Hampton, Virginia.

suggest a strategy for understanding much of the banjo imagery reproduced in this volume.

In nineteenth-century America, the banjo often functioned as a sign for all things black. The name of the instrument derived from an African term; in the Caribbean, it was known as *banza* (Martinique), *bangil* (Barbados), *banshaw* (St. Kitts), and *bonja* (Jamaica). The name appears as *bangio* in South Carolina and *banjou* in Philadelphia as early as 1749. It probably evolved from the Kimbundu *mbanza,* a plucked string instrument constructed of a gourd, tanned skins, and hemp or gut strings.[2]

Because the instrument was originally made with a gourd and was African in origin, it became a trope for black culture during the antebellum period. Indeed, black performance was characterized as intuitive, even natural. Imagery depicting a black musician, and especially a banjo player, reinforced notions of a "happy darkey"—a slave performing his ethnicity.

The banjo was certainly not the only instrument fraught with racial considerations in nineteenth-century American visual culture, but its African origins probably added a point of emphasis, and an element of authenticity, to any given picture. On isolated eighteenth- and nineteenth-century farms and plantations, entertainments were welcome events. In his book *Singing the Master,* Roger Abrahams describes slaves providing evening amusements. The slaves' grueling toil transpired behind the big house, and Abrahams notes that "there the playing broke out as well, the singing and the ring-play dancing that were later to be elaborated into the 'plantation scenes' of the American stage"—or minstrelsy. Black performance was entertaining and exotic; it provided another, albeit somewhat symbolic, type of black labor for white benefit. Additionally, it confirmed in the planter's mind the happiness of the slaves. "Singing and dancing," Abrahams observes, "were regarded as signs of happiness, in spite of the fact that many whites could understand that the songs were often about the agonies of separation and alienation. . . . For the working seemed to go better when it was accompanied by singing, and the play that broke out provided the planters with home entertainments." Abrahams argues that performance was an aspect of what we can call "black style." Certain kinds of team labor, especially when tools and movements were in unison, created regular sounds that could be incorporated into the music.[3]

This style and its exotic, even mysterious aspects, which fascinated whites, undoubtedly became the foundations for minstrelsy. Blacks (or whites in blackface) played the banjo in minstrel performances. In fact, the comical banjo-playing black, content with his lot in life, became a staple of minstrel shows in the United States from the 1840s to the Civil War.[4]

Given this cultural context, white audiences often saw representations of the banjo in artworks as signifying stereotypical black plantation performances. But

after Emancipation, as we will see, the banjo would become a different sort of symbol. Many individuals at the time, both black and white, sought to integrate freedmen into society through education, seeing it as a path to liberation. And when Henry Ossawa Tanner became one of the first African American artists to engage banjo imagery, he used pedagogy to undermine the old trope of the cheerful banjo-playing slave. His deceptively simple *The Banjo Lesson* of 1893 became a counter-hegemonic image, and it joined a liberation discourse already decades old. Through it he reclaimed the song that had been stolen, misused, and distorted. He recovered his cultural patrimony and visualized its retention in the teaching of the young by the elderly.

That liberation discourse continued well into the twentieth century. The artist Romare Bearden reprised the idea of education as fostering liberation and cultural continuity when he created his images of banjo players in the 1960s and his *Piano Lesson* two decades later. By 1983, when he completed *The Piano Lesson*, African Americans were several generations removed from slavery. Many felt deeply American, having spent their lives sweating and bleeding and singing their songs in this society. The banjo had been reclaimed, and black musicianship had been redefined; hence a piano, an instrument more identified with middle-class aspirations, would replace the folk instrument long associated with the plantation. The fierce musicianship and artistic complexity of post–World War II jazz had undermined old notions of intuitive or natural musical ability in blacks. Bearden's important work—like the play it inspired—suggests a new set of assumptions and instruments for the song, the cultural patrimony so long contested.

Prelude: Eastman Johnson's *Negro Life at the South*

Eastman Johnson's notable painting *Negro Life at the South* (1859, fig. 45), which established his career, also undermined the banjo-playing stereotype of blacks with nuances that became fully developed in Henry Tanner's *Banjo Lesson* just over thirty years later. Patricia Hills points out that the range of skin tones in *Negro Life* is especially remarkable, because it "coded the reality of slave and free-black life." She observes further that the mixed-race couple, courting on the left, "[makes] explicit to a white audience the reality of love between African American men and women." Such relationships, she notes, were "dimly recognized, if at all, by the majority of the white middle classes, conditioned by years of blackface, minstrel-show stereotypes."[5]

Significantly, the banjo-playing man near the center of the scene is closely watched by a boy on his right and another youth sitting in front of him. The musician is not playing to entertain anyone. The only white audience is the woman entering the yard on the far right who turns to gaze at him (capturing the song?).

The man plays a banjo, not a violin or flute, suggesting that this scene means to provide the viewer, like the white woman, a chance to observe the "true" interior life of slaves—not only inside the yard behind the house but also inside their personal lives, when they supposedly no longer wear the behavioral masks demanded by the master and mistress.

Johnson's work was interpreted as a visual *Uncle Tom's Cabin* of stock black characters by one reviewer, who found Topsy and Uncle Tom in the work. It was first shown in New York at the National Academy of Design in April 1859. The reviewer, discussing the work in the *Home Journal* of 27 August 1859, referred to the older woman in the work as Aunt Dinah. When it was shown at the Boston Athenaeum that summer, the work was retitled *Kentucky Home,* and it came to be known popularly as *Old Kentucky Home.*[6]

Negro Life was, in fact, a commentary on the debate surrounding slavery in Washington, D.C., in the 1850s. As John Davis has observed, the painting depicts "some of the black inhabitants of [Johnson's] father's block on F Street [in Washington]." The work joined a controversial dialogue about slavery in the District that had gone on for nearly thirty years. Although many observers deemed slavery in the nation's capital an embarrassment and called for its abolition, some southerners felt that eliminating slavery in Washington represented a dangerous "entering wedge." Giving way on the issue, they thought, would mean the loss of their cause in the end. The conflict was further inflamed by a practice in Washington of capturing free blacks and selling them into bondage in the South. Slaves were held in hidden alleys, where their cries and moans could be muffled, and Johnson's painting depicts one of these spaces.[7]

Johnson had abolitionist leanings and his painting broke with some of the conventions of the day. Still, many of his contemporaries only saw reflections of their own sensibilities in the painting. Johnson's use of the banjo player complicated the existing stereotype, but the image functioned as a trope so easily for viewers that many missed the nuance and the antislavery critique. They simply assumed that the work was a southern plantation scene evoking stereotypical notions of blacks. Indeed, art historian Elizabeth Johns writes that the work supported arguments at the time for paternal control of African Americans. Similarly, art historian Judith Wilson has commented that white artists, "whether they meant well or ill . . . generally pictured Blacks patronizingly." According to Wilson, their works "seldom threatened racist beliefs in the innate inferiority of people of African descent." Such artworks often simply observed black people and culture, depicting their subjects as "Negroes," not as individuals—a fact confirmed by the title of Johnson's painting. It was only at the end of the century that Henry Ossawa Tanner could challenge such orthodoxy.[8]

The Banjo Lesson: From Stereotype to Pedagogy

Thirty-four years after Johnson's painting debuted at the National Academy, Henry Ossawa Tanner returned to the United States from Paris to recover from typhoid fever and to renew his funds. He attended the Chicago Conference on Africa, which opened on 14 August 1893 and lasted a week. The Africanist Olisan-wuche Esedebe contends that this event "may be taken as the beginning of Pan-Africanism as a movement." Among those in attendance were a representative of the American Colonization Society; Alexander Crummell; and Bishop Henry Turner, "an ardent advocate of the back-to-Africa movement and founder of the African Methodist Episcopal [A.M.E.] churches in Sierra Leone and Liberia."[9]

Henry Tanner's father, Bishop Benjamin Tanner, was a prominent leader in the A.M.E. Church and participated in the conference as well. The A.M.E. Church had a reputation for promoting black pride, self-help, and self-determination. It also worked to develop international ties between people of African descent. Judith Wilson suggests that Benjamin Tanner's "views on racial matters . . . exhibit[ed] a tension between assimilationist and Black nationalist ideals that was prevalent in his denomination." Bishop Tanner gave his son the middle name Ossawa, a short-ened version of Ossawatomie, the name of the town in Kansas where, in 1856, John Brown killed proslavery vigilantes who were attacking antislavery homesteaders. Henry Tanner's participation in the conference—he gave a talk on "The Negro in American Art"—likely stemmed from his father's involvement. About a year after his speech in Chicago, Tanner further explained his having painted Negro subjects by asserting that "many of the artists who have represented Negro life have only seen the comic, the ludicrous side of it, and have lacked sympathy with and appre-ciation for the warm big heart that dwells within such a rough exterior."[10]

During the summer of 1893 Henry Tanner painted *The Banjo Lesson* (fig. 112), and it was first exhibited at a Philadelphia gallery in October of that year. The painting builds upon a theme found in the work of Thomas Eakins, Tanner's teacher at the Pennsylvania Academy of the Fine Arts. (Eakins's 1878 *Negro Boy Dancing* depicts an elder supervising a young man playing the banjo for a boy who is apparently learning to dance [fig. 113].) The pedagogical aspects only hinted at in Eastman Johnson's *Negro Life at the South* become more explicit in Tanner's work, with the elder man's supervisory posture and the intergenerational familial rela-tions suggested by a framed photograph of Abraham Lincoln and his son Tad in the upper left corner. The image implies black agency; no white figures are present. The work's emphasis on *teaching* also frayed assumptions widely held at the time about the "natural" performative and musical abilities of African Americans. In *The Banjo Lesson,* Tanner takes on the delicate task of reclaiming the banjo from its sad work as a sign of demeaned blackness and restores it as a cultural icon. Musical

fig. 112
Henry Ossawa Tanner, *The Banjo Lesson,*
1893, oil on canvas, 49 × 35½ inches. Hampton University Museum, Hampton, Virginia.

performance was an empowering act for blacks, a place of refuge and self-expression, and a means for enacting critical resistance to slavery and oppression.

Tanner developed *The Banjo Lesson* from sketches and photographs made during his visits to rural Georgia and North Carolina in the summer of 1889, while he was residing in Atlanta. He had come from a family of middle-class free blacks in

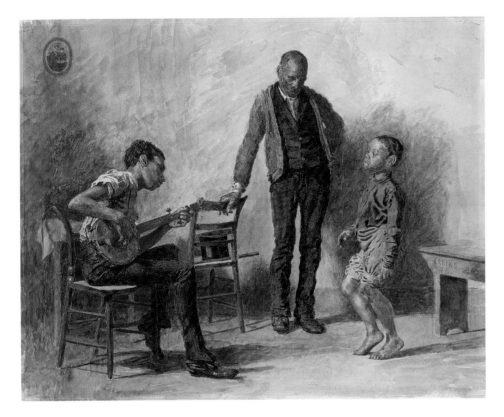

fig. 113
Thomas Eakins, *Negro Boy Dancing,* 1878,
watercolor, 18¹/₁₆ × 22⁹/₁₆ inches. The Metro-
politan Museum of Art, New York. Fletcher
Fund, 1925 (25.97.1). Photo © 1994 The Metro-
politan Museum of Art.

Philadelphia, but the common experience of racial oppression overcame personal,
class, and regional differences as he traveled in the South. (Ten years after *The
Banjo Lesson,* W. E. B. Du Bois expressed in *The Souls of Black Folk* sentiments sim-
ilar to Tanner's, but he seemed far less comfortable with common folk. "The
innate love of harmony and beauty that set the ruder souls of his people a-dancing
and a-singing," Du Bois wrote, "raised but confusion and doubt in the soul of the
black artist; for the beauty revealed to him was the soul-beauty of a race which his
larger audience despised.")[11]

 The Banjo Lesson (and the related painting *The Thankful Poor* [1894, collection
of William H. and Camille O. Cosby]) expands upon the pedagogical elements of
the Johnson and Eakins paintings. Tanner's picture of 1893 operates within an
African American context of education as liberation. Johnson's painting, despite
its sympathies, succumbed to what Judith Wilson describes as white artists' ten-
dency "to depict Blacks as . . . anonymous figures in group scenes." White artists
seemed to imagine African Americans, whether free or enslaved, as "a nation of
servants, musicians and rural laborers." Tanner's work, in contrast, individualizes
the two subjects, undermines prevailing stereotypes about the nature of black per-
formance, and suggests the "central role" of education "in shaping Black self-
hood."[12] The intimate interaction between the grandfather and the young boy

humanizes them and manifests an emotional and intellectual life not present in Johnson's paintings *Negro Life at the South* and *Negro Boy.*

With *The Banjo Lesson,* Tanner created a work that was counter-hegemonic in its destabilization of stereotypical imagery, its challenge to the banjo trope, and its elevation of otherwise dehumanized folk types. Tanner countered notions about the natural musicianship of African Americans with an emblematic moment of teaching. This pedagogical emphasis not only introduced intellectual exchange into the discourse but also produced an image of black male responsibility in an intergenerational exchange.

Moreover, Tanner engaged African American culture as an insider, not as an observer. In so doing, he began to reclaim the song, the heritage of performed culture that had been disfigured by grotesque stereotyping. The harsh racial climate that developed after the collapse of Reconstruction was exacerbated by the 1896 *Plessy v. Ferguson* decision, which abandoned blacks to segregation, racial violence, and virtual reenslavement in the southern sharecropping system. It reinforced the need for sanctuary—places where one would be safe from whites. Such sanctuary might be found in churches, in dancehalls and roadhouses, and in other venues where spirituals, blues, gospel, and jazz music provided outlets for entertainment and release. The figures in *The Banjo Lesson* are not minstrel performers preparing for the stage. Rather, with its depiction of the older banjoist educating his successor, Tanner's work is a document of protest, liberation, and transformation.

Two Piano Lessons: The Song Reclaimed

Tanner's important painting initiated a new discourse in African American art and helped shape a new artistic vocabulary for black visual representation. Ninety years later, Romare Bearden—a master of that vocabulary—articulated a blues and jazz version of Tanner's *Banjo Lesson,* one inspired by the jazz pianist Mary Lou Williams (1910–1981).[13]

Bearden met Williams in Atlanta around 1980, when the artist and his wife, Nanette, were to receive an award from the local chapter of the NAACP. Richard Long, a good friend of the Beardens, recalled the event.

> It was at the time Julian Bond was the local president of the NAACP, and Billie Aaron, Hank Aaron's wife, was the person who organized the banquet. So they came down, Nanette and Romy, and of course they stayed with me, and I went with them to the banquet. Another honoree was Mary Lou Williams. . . . I don't think the Beardens had met her previously at all, but they fell into conversation. Of course, Mrs. Bearden had a dance company, ultimately called The Nanette Bearden Con-

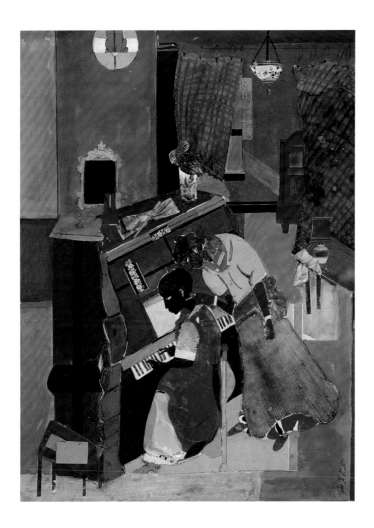

fig. 114
Romare Bearden, *The Piano Lesson,* 1983, collage of various papers with paint, ink, and graphite on fiberboard, 29 × 22 inches. The Walter O. Evans Collection of African American Art. Art © Romare Bearden Foundation/ Licensed by VAGA, New York.

temporary Dance Company, and she was always looking for things to make her company interesting and distinctive, and so it occurred to her right then and there to ask if she could use some of the music that Mary Lou Williams had to create an evening of dancing. So that's how Mary Lou Williams and the Beardens came together. . . . But Nanette remained in touch with Mary Lou Williams. They agreed ultimately upon a program of music that would be choreographed. . . . At any rate, as they got ready for the program, Romy created a poster for it, and the poster started off with the collage *The Piano Lesson.*[14]

Long points out that Williams, though born in Atlanta, moved to Pittsburgh when she was five—and Bearden's painting, of course, shows her as a young player. Bearden lived in Pittsburgh during his high school years. (When August Wilson, inspired by Bearden's artwork, wrote his own *Piano Lesson,* he gave the play a Pittsburgh setting as well.)

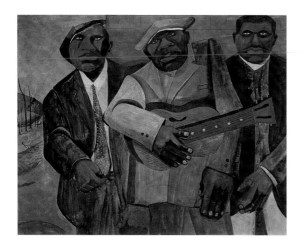

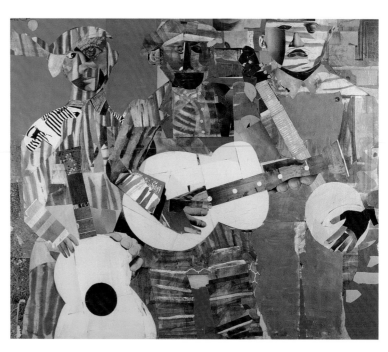

By the time Bearden completed *The Piano Lesson* (1983, fig. 114), the stereotypes of African Americans Tanner had undermined so precisely in *The Banjo Lesson* no longer prevailed, but the "lessons" remained related to one another. In Bearden's works, banjo players tended to signify folk musicians, not racial archetypes. Folk, blues, and jazz musicians, in fact, appear in his works throughout Bearden's artistic career.

His 1941–42 painting *Folk Musicians* (fig. 115), for example, depicts three figures facing the viewer. The central one holds a guitar. A red brick wall forms a rectangular block behind the men on about two-thirds of the right portion of the painting. Bearden later reprised *Folk Musicians* as a much smaller, 23-by-28-inch mixed-media piece called *Trio* (1964, private collection), this time giving the figure at left a guitar and the figure at right a banjo. All three figures have wide-open eyes and look directly at the viewer, but that changes in the 1967 version, *Three Folk Musicians*, now grown to 50 ⅛ × 60 inches (fig. 116). The downcast eyes of the central musician and banjo player suggest somber introspection, and the countenance of the banjoist may be a self-portrait. The banjo player is left-handed in both works, providing an angular counterpoint to the rightward thrust of the guitar neck, returning the viewer's gaze to the center of the composition. The monumental hands in the 1941–42 *Folk Musicians* were reduced in the later works, giving way to the relatively lightly colored (though still solid) shapes of the instruments.

In Bearden's oeuvre, the banjo player no longer figures as a racial trope, but rather as a blues/folk allusion and an intriguing artistic subject. Indeed, he sought out the rural and folk references that were so assiduously avoided by generations of

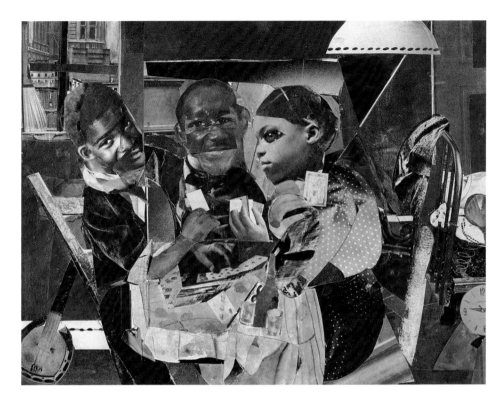

fig. 117
Romare Bearden, *Evening, 9:10, 461 Lenox Avenue,* 1964, collage of various papers with paint, ink, and graphite on cardboard, 8⅜ × 11 inches. Van Every/Smith Galleries, Davidson College, Davidson, North Carolina. Art © Romare Bearden Foundation/Licensed by VAGA, New York.

African American artists because of their nearness to plantation stereotypes. His biographer Myron Schwartzman suggests a southern context for *The Piano Lesson:* "Romare's flower-patterned Aeolian windows, the chandelier, the furniture, the piano, and each detail of costume are unmistakably from a southern parlor." [15] (Bearden also addressed his North Carolina origins in the collage *Evening, 9:10, 461 Lenox Avenue* [1964, fig. 117] and in the series *Mecklenburg Autumn* from 1983.)

Schwartzman's "southern" reading of the artwork notwithstanding, Bearden may well have intended a northern setting for *The Piano Lesson.* As Long suggests, Pittsburgh is likely the site depicted, as Mary Lou Williams (the model for the pianist) lived in the city at the time. Williams's family typifies the millions of African Americans who, upon migrating to the North, would only deepen their engagement with southern cultural models. In the foreword to Schwartzman's book on Bearden, playwright August Wilson described his own Pittsburgh encounter with that transplanted southern world.

> In 1965, as a twenty-year-old poet living in a rooming house in Pittsburgh, I discovered Bessie Smith and the blues. It was a watershed event in my life. It gave me a history. It provided me with a cultural response to the world as well as the knowledge that the text and content of my life were worthy of the highest celebration and occasion of art. [16]

Indeed, Wilson's career provides a lens through which we can understand further Bearden's musical subjects and helps us see the metaphorical richness of the shift from the "banjo lesson" to the "piano lesson."

After his discovery of the blues and Bessie Smith, Wilson's next "watershed event" was his introduction to Bearden's work. He was shown a copy of *The Prevalence of Ritual* (1964, Hirshhorn Museum and Sculpture Garden) by a friend one evening and experienced something akin to an epiphany.

> What for me had been so difficult, Bearden made seem so simple, so easy. What I saw was black life presented on its own terms, on a grand and epic scale, with all its richness and fullness, in a language that was vibrant and which, made attendant to everyday life, ennobled it, affirmed its value, and exalted its presence. . . . I don't recall what I said as I looked at it. My response was visceral. I was looking at myself in ways I hadn't thought of before and have never ceased to think of since.[17]

Bearden's work *Mill Hand's Lunch Bucket* (1978, Collection Romare Bearden Foundation, New York) inspired Wilson's play *Joe Turner's Come and Gone,* and Bearden's *The Piano Lesson* spawned the play of the same name. Two of Wilson's characters, Seth and Bertha, were taken from another Bearden painting, *Mr. Seth and Miss Bertha.* (In this context, the painter and playwright's shared Pittsburgh backdrop probably deserves yet further exploration. Wilson never met Bearden, although he reminisced that, one day, he "stood outside [Bearden's studio at] 357 Canal Street in silent homage, daring myself to knock on his door.")[18]

As Wilson has noted, his *Piano Lesson* focuses on two related questions: "What do you do with your legacy, and how do you best put it to use?" Wilson has commented that he "got the idea from the painting that there would be a woman and a little girl in the play." The woman "would be a character who was trying to acquire a sense of self-worth by denying her past. And I felt that she couldn't do that. She had to confront the past." Wilson's plays set in earlier decades, such as *Joe Turner's Come and Gone,* deal with the migration from the South to the North, but *The Piano Lesson* began to contemplate the movement back to the South to claim a heritage there.[19]

The scholar of African American literature Sandra Shannon posits that the precepts in Wilson's *The Piano Lesson* are complex and nuanced. "In considering what one should do with a legacy," she writes, "the play reveals more than one teacher and more than one lesson. For example, the teacher-pupil relationship portrayed in Bearden's collage models the relation between Wilson and his audience." She further observes that the characters teach "both directly and indirectly, as their

words and their actions signal their regard for their legacy." The pedagogy in *The Piano Lesson,* we may conclude, concerns heritage, dignity, and intergenerational legacies transferred. Shannon suggests that the impulse driving all of Wilson's plays is his "desire to change attitudes about the importance of one's culture and heritage." In his work, blues music often functions metaphorically to articulate soul struggles. Though the music keeps alive the pain of a brutal experience, "in one magnificent leap it elevates black people from the status of slaves to the level of artists."[20]

Beginning with Tanner's *Banjo Lesson,* then, artists from within the culture extolled the folk legacies and foundations that root and define African American life. Tanner's painting lifted the folk instrument from Africa to an instrument of art—and showed the process of art as well. The instrument and the music are complex, suggesting traditions and techniques to study, just as with any art form. Tanner simultaneously builds upon the past, produces a uniquely African American art, and visually wipes the cork off the blackface minstrel.

Bearden's work presents black life, as Wilson says, on its own terms. There is no posturing for sanction and approval by whites as a part of an integrationist effort. The work is rooted in the experience of conjure women, trains and train whistles signaling the potential of migration, and movement, as well as quiet rural moments, blues songs, jazz clubs, and urban streets. Yet Bearden's art also makes a call to reclaim the song, to embrace the banjo and the blues and that southern soil, dark with black blood.

Bearden's *Piano Lesson* is part of a creative enterprise that included music, dance, art history, quiet pedagogy, and classical artistic sensibilities and techniques. It engages a hybrid matrix of late-twentieth-century African American culture. The trope had been trumped—and the banjo, at last, became a sign of culture, not a tool for its mockery. The subjects were no longer rural and impoverished but urban dwellers, men and women who carried southern histories in the framework of their identities. August Wilson's *Piano Lesson,* inspired by Bearden, became a sort of backstory for the artwork. The lesson of the banjo, long learned, would be succeeded by a second verse—one in a different key.

NOTES

1. Kim Pereira, *August Wilson and the African-American Odyssey* (Urbana: University of Illinois Press, 1995), 88–89.

2. Philip F. Gura and James F. Bollman, *America's Instrument: The Banjo in the Nineteenth Century* (Chapel Hill: University of North Carolina Press, 1999), 13–14.

3. Roger Abrahams, *Singing the Master: The Emergence of African American Culture in the Plantation South* (New York: Pantheon Books, 1992), xviii, xxii, 47, 86–95.

4. These performances, of course, were not simply focused on mimicking plantation stereotypes. Literary historian W. T. Lhamon Jr. argues that in minstrelsy, blackness itself signified the mark of Cain—the first angry young man who took action against "preferential differentiation." An outsider bearing a discrediting mark, Cain came to be linked to blacks but also became the "signified" of blackface signification, allowing whites to identify with minstrels metaphorically. The black figure, in other words, became a metaphor for the outsider *and* a means by which even working-class whites could resist the downtown Knickerbockers and stiff necks. As Lhamon puts it, "Irish, German, French, Welsh, and English recent immigrants as well as American rustics, could all together identify in the 1830s with Jim Crow, Bone Squash, and Jumbo Jim, then in the forties with Tambo and Bones. . . . Precisely because middle-class aspirants disdained the black jitterbug in every region, the black figure appealed all across the Atlantic as an organizational emblem for workers and the unemployed. Hated everywhere, he could be championed everywhere alike." See W. T. Lhamon Jr., *Raising Cain: Blackface Performance from Jim Crow to Hip Hop* (Cambridge, Mass.: Harvard University Press, 1998), 44, 118–26.

Blacked-up performers played against Mr. Interlocutor, whom Mark Twain described as a figure "clothed in the faultless evening costume of the white society gentleman [who] used a stilted, courtly, artificial and painfully grammatical form of speech" (Mark Twain cited in Abrahams, *Singing the Master*, 135). The hypercorrect upper-class white trying to keep order was laughed at as much as the speech and wild dances of the end men in blackface. Whites, then, found liberation behind the minstrel mask: using blackface allowed poor whites to escape their dreary lives and to say and do things they normally could not. By stealing the song, they freed themselves and called attention to their social condition. This theft, though, simultaneously muted the black voice.

5. See Patricia Hills, "Painting Race: Eastman Johnson's Pictures of Slaves, Ex-Slaves, and Freedmen," in Teresa A. Carbone and Patricia Hills, *Eastman Johnson: Painting America* (New York: Brooklyn Museum of Art in association with Rizzoli International Publications, 1999), 128. Hills further notes that Eastman Johnson's 1860 painting *Negro Boy* (National Academy Museum, New York) "would have probably appealed to other Academicians, since he plays a flute, an instrument of artistic expression" (133, 136).

6. See ibid. Hills argues that the new title may have owed more to the association of the painting with *Uncle Tom's Cabin*, which opens on a Kentucky plantation, than with Stephen Foster's popular "My Old Kentucky Home, Good Night" minstrel song.

7. John Davis, "Eastman Johnson's *Negro Life at the South* and Urban Slavery in Washington, D.C.," *Art Bulletin* 80 (March 1998): 67–73.

8. Johns comments, "While seeming to exculpate Southerners from horrid treatment of their slaves, however, the image also indicts blacks for all the faults that whites had been ascribing to them for decades. Johnson scattered his blacks across a space that impresses the viewer with its barrenness, clutter, and lack of function. This backyard is a mess. . . . The world of the black is one of decay, disorder, and moment-by-moment activity. Left to themselves, blacks pass the time rather than use the time." See Elizabeth Johns, *American Genre Painting: The Politics of Everyday Life* (New Haven, Conn.: Yale University Press, 1991), 128. For Judith Wilson's remarks, see her "Lifting 'The Veil': Henry O. Tanner's *The Banjo Lesson* and *The Thankful Poor*," *Contributions in Black Studies* 9–10 (1990–92): 44.

9. Also participating in the conference were "European scientists, explorers, and missionaries, most of whom had come to Chicago primarily for the World Columbian Exposition held there that summer." See Olisanwuche Esedebe, *Pan-Africanism: The Idea and Movement, 1776–1991*, 2nd ed. (Washington, D.C.: Howard University Press, 1994), 39. On earlier Pan-Africanist sentiments in the United States, see Sterling Stuckey, *Slave Culture: Nationalist Theory*

and the Foundations of Black America (New York: Oxford University Press, 1987).

10. Judith Wilson, "Lifting 'The Veil,'" 36. Statement in Tanner's hand in the files of the Pennsylvania School for the Deaf, Philadelphia; quoted in Dewey F. Mosby, *Henry Ossawa Tanner* (Philadelphia: Philadelphia Museum of Art; New York: Rizzoli International Publications, 1991), 116.

11. W. E. B. Du Bois, *The Souls of Black Folk* (1903; New York: New American Library, 1969), 46–47.

12. Judith Wilson, "Lifting 'The Veil,'" 38, 43–44.

13. Richard Long, telephone interview with the author, tape recording, 4 December 2004.

14. Ibid.

15. See Myron Schwartzman, *Romare Bearden: His Life and Art* (New York: Harry N. Abrams, 1990), 34. Schwartzman saw similarities between Bearden's *Piano Lesson* and Henri Matisse's *Piano Lesson* from 1916 (Museum of Modern Art, New York) and *Music Lesson* from 1917 (Barnes Foundation, Merion, Pennsylvania). While talking with Schwartzman about the work, Bearden revealed his remarkable awareness of art and art history, discussing how Goya, Manet, and the Old Masters let some of the ground play through in their works:

> I've seen some of Goya's paintings where the underneath ground predominated over half the painting and then he would, say, weave a certain blue color here and then develop those things he wanted to be highlighted. This was an Italian technique from the Venetian painters—Tiepolo, Veronese, Tintoretto painted very much in that way. So I let the ground play through. . . . And then in this, I did something I don't usually do. You see I tipped it to lay the piano in a kind of perspective going this way, and to compensate for that I had to . . . bring things back on the frontal plane—you see the blue?—because this is going this way and the other blue is for that reason: to carry you back to the front. (Schwartzman, *Romare Bearden,* 34)

16. August Wilson, "Foreword," in ibid., 8.

17. Ibid., 8–9.

18. Ibid., 9.

19. Sandra G. Shannon, *The Dramatic Vision of August Wilson* (Washington, D.C.: Howard University Press, 1995), 146. As Pereira notes, "The play depicts a growing realization by blacks that they can call the South their home, because several generations of their families grew up there and paid a great price on the plantations that built the South. They have discovered that the North is not as rosy as it once looked" (Pereira, *August Wilson,* 94).

20. Shannon, *Dramatic Vision,* 147, 144; Pereira, *August Wilson,* 87–88.

Unknown photographer, *Robert Lane,
Weston,* [Massachusetts], 1886, albumen
photograph, 4¼ × 5¼ inches. Collection
of James F. Bollman.

CECELIA TICHI

Afterword: The State and Fate of an Icon

PICTURING THE BANJO locates its ostensibly artistic subject
firmly in a genre of cultural studies of single emblems and solitary
historical tropes. It appears at a moment when scholars in allied
fields in the humanities are demonstrating how the single object
or icon—whether it be salt or the banana or Marilyn Monroe or
the U.S. dollar—splays into complex meanings susceptible to
shaping as social history. So it is with the banjo, as the exhibition
curator, Leo Mazow, shows in "Banjo Cultures," his wide-ranging
and thoroughly researched introduction to the exhibition cata-
logue. Mazow and the essayists in this volume "unpack" the banjo
to disclose its story or narrative in U.S. art and culture. The banjo,
in fact, proves to be a culturally and artistically obsessive subject
over more than two centuries of U.S. history. The narrative that

emerges puts the banjo at the center of evolving social mores, political conflicts, high and popular culture—and aesthetics. *Picturing the Banjo* reveals artistic opportunities and prerogatives as artists, artisans, photographers, and illustrators continually reimagine and redefine the banjo in an ongoing dialogue of the present with the past.

Americanized from its origins as an African instrument introduced by slaves, the banjo has stood as a measure of contested values and norms, as the contributors to this volume amply demonstrate (see figs. 22, 23, 97). The banjo reappears in media from oil and watercolor to photography, ink, wood, and pencil, with each image a chapter of a chronicle of social change focused though region, race, gender, and class. In addition, the banjo marks the shift from agrarian to industrial and jazz-age America forward to the present moment, when the instrument is deployed to signify the fatality of war and militarism.

Fundamental to the banjo's identity in the U.S. are black minstrelsy and the southern antebellum plantation. Images of both abound in *Picturing the Banjo*. The exhibition necessarily features numerous portrayals of African Americans, most of them males, playing banjos while alone and with others—as if doing so were, to echo Eastman Johnson's title, a racial "musical instinct" (1860s, private collection). The typical image shows the banjo as played by a boy or elderly black man, as in *Oh Carry Me Back to Ole Virginny* (1859, see fig. 46), which evokes an idyllic and sentimental "Old South" cabin where a mammy, a second adult woman, and two happy children enjoy the music of a banjo played by a placid, wraith-thin older man in the center of the lithograph. A much-replicated figure of racialized sentimentality, the African American banjo player entertains himself and others, including whites, and is thus necessarily a staple of this exhibition.

The essays in this volume go far to correct viewers' cursory impressions of these images by directing attention below their blatantly stereotypical surfaces. John Davis, in "A Change of Key: The Banjo During the Civil War and Reconstruction," reveals the underlying anxieties and repressed sexual tensions and miscegenation evident in numerous nineteenth-century banjo pictures. In "Harlem Renaissance, Plantation Formulas, and the Dialect(ic) of the Banjo," Joyce Henri Robinson shows the pernicious toll exacted by recurrent "darkey" images, which inscribed and reinscribed plantation-era racism, even in the Harlem Renaissance of the 1920s and 1930s. Robinson's discussion reveals the injury done to black males straitjacketed in the identity of jester/tunester. The persistence of the tradition of "darkey" songs, she argues, masked the devastation of racism and lingering malice in the face of delayed civil rights initiatives for blacks.

The subversive complexity of some of these apparently normative images also commands attention in Michael D. Harris's "From *The Banjo Lesson* to *The Piano Lesson*: Reclaiming the Song," which, like Davis's "Change of Key," differentiates a

number of seemingly similar representations. Harris indicates, moreover, that African American artists, whether musicians or playwrights, have felt jeopardized by larcenous whites eager to appropriate the black "song," meaning the arts of and by black Americans. The "song," a reference from August Wilson's *Piano Lesson,* thus refers to the whole of African American art, whose ownership and authorship are contested by whites and must be defended.

One image of black masculinity is conspicuously missing from the plantation-era figures of male banjo players, however: the virile black man. As Tanner's well-known *Banjo Lesson* (1893, see fig. 112) indicates, the banjo belongs to the old man and the child (or childlike), not to the African American male in his prime. Such pacific images as Tanner's, that is, efface young black men by combining childhood and advanced age in the affectionate teacher-pupil relation. Produced in a decade of repressive Jim Crow laws and of lynchings chronicled by the crusading black journalist Ida B. Wells, Tanner's painting implies that successive generations of docile black boys will learn the instrument and, in turn, will become grandfatherly (or great-avuncular) teachers of a new generation of such boys.[1]

Nonetheless, the lineage of black insurrectionists Nat Turner, Denmark Vesey, Malcolm X, or the Black Power movement of the 1960s reverts, perhaps unsurprisingly, to the banjo. In Betye Saar's 1972 *Let Me Entertain You,* the far right panel features the armed young Black Panther standing in triumphant repudiation of banjo minstrelsy and its genocidal complement, lynching (see fig. 109). Other artists in *Picturing the Banjo* also repudiate the racialized musical idyll of boys and old men and expose its crippling legacy in expressions of righteous anger. The banjos of Kara Walker and Robert Gwathmey, for example, express outrage at this chronic racial injustice (see figs. 111, 118). Especially noteworthy in Walker's oeuvre is the 1997 *Presenting Negro Scenes Drawn Upon My Passage Through the So. & Reconfigured for the Benefit of Enlightened Audiences Wherever They May Be Found, By Myself, Misses K. E. B. Walker, Colored* (Museum of Contemporary Art, Chicago). Titled in reference to slave narratives of the eighteenth and nineteenth centuries, Walker's image insists that the black male is not the creative musician but a wind-up toy for the amusement of whites (and perhaps blacks as well).[2] The key in his back is a dagger. Each turn—by the coerced and collusive young Negro mammy—animates the banjo toy but kills the man trapped inside him.

The banjo of the 1890s, as *Picturing the Banjo* reveals, belongs not only to Henry Tanner but also to a certain privileged segment of American women. Numerous images show an enthusiastic and sensual female fondness for the instrument. The c. 1895 photograph by Frances Benjamin Johnston, ["Miss Apperson" playing banjo beside statue of "Flora" in niche of Sen. George Hearst's residence, Washington, D.C.] (see fig. 67), stands as a splendid example. Sarah Burns's essay in this

fig. 118
Robert Gwathmey, *Non-Fiction,* 1943, oil on
canvas, 29 × 24 inches. Memorial Art Gallery
of the University of Rochester, Rochester, New
York. Marion Stratton Gould Fund, 51.7. Art ©
Estate of Robert Gwathmey/Licensed by
VAGA, New York. Photo: James Via.

volume, "Whiteface: Art, Women, and the Banjo in Late-Nineteenth-Century
America," details the ways in which the banjo gained legitimacy as a musical
instrument worthy of the attention of white women as instrumentalists, listeners,
and dancers. As Burns succinctly states, the banjo was "aestheticized, modernized,
feminized, and trivialized . . . [and] whitewashed," its connotations signifying a
complex and modern femininity and leisure even as the banjo retained an "under-
tone" of "blackness, wildness, instinct."

The banjo was thus integral to the late-nineteenth- and early-twentieth-
century era of the New Woman, a movement of middle- and upper-class white

women who "demanded full engagement with the world" sexually, professionally, artistically—and ultimately politically, through the Suffragist movement.[3] From work outside the home to leisure activities, the New Woman declared herself venturesome, ambitious, and physically bold. In the Johnston photograph, Miss Apperson seems to be dancing, her banjo both partner and musical accompaniment. Indeed, she seems sprung from the pedestal that elevated and yet fixed its sculptural subject(s) in place earlier in the century. The New Woman rejected that pedestal, and for all the reasons that Burns enumerates, the banjo moved into the middle class, the privileged white woman's America.

Some of these women may have purchased banjos from the Sears, Roebuck and Co. catalogue, whose 1897 edition describes the banjo as "a popular instrument" that "deserves to be" designated as such (fig. 119). In mercantile terms, Sears promised "fine trade" with all of its fourteen models. The catalogue copy, however, is particularly telling of a shift in cultural sensibility. Sears neither promoted the banjo in musical terms nor linked it to its African American origins. The Chicago-based mass-market retailer sold the banjo, instead, as an excellent machine. "Tone of a penetrating quality" is the sole indicator of its musical identity. Otherwise, the catalogue features descriptions of screw brackets, heavy nickel shell, rabbeted heavy strainer hoop, wired edges, and patented tailpiece. A few pages further on, a customer can find separate replacement parts—tailpieces, pegs, brackets, patented heads, and wrenches, with each of the component metals named (e.g., cast brass, nickel plate).[4]

These descriptors are indicative of a machine-age sensibility. Prior to the twentieth century, the instrument varied in sonic quality according to its construction materials (including gourds), as Leo Mazow points out in "From Sonic to Social: Noise, Quiet, and Nineteenth-Century American Banjo Imagery." The sonic quality sought—and finally achieved—was a uniform sweetness. The late-nineteenth- and twentieth-century American zest for mechanism in a "gear-and-girder" world of machines and structures changed the desired sound. Implicit in this change is the Sears copy text on the banjo, which insists upon its pivotal definition in machine-age America. In *Picturing the Banjo,* it points the viewer toward Thomas Eakins's *Cowboy Singing* (1888, see fig. 77), which appears to represent a moment of reverie of a male icon of the American West. Eakins's well-understood preoccupation with mechanism, however, including anatomical bases of motion, impels a viewer to reconsider *Cowboy Singing,* which takes its place with Eakins's guitarist cowboy of *Home Ranch* (c. 1892, Philadelphia Museum of Art) and with his *Elizabeth at the Piano* (1875, Addison Gallery of American Art, Phillips Academy, Andover), *Negro Boy Dancing* (1878, see fig. 113), *The Oboe Player* (1903, Philadelphia Museum of Art), and other texts. These are not solely images of musical instruments and instrumentalists. They also represent combined mechanistic and

BEST BARGAINS IN BANJOS.

The banjo is a popular instrument. It deserves to be. The main reason for its comparatively little use lies in the fact that retail prices have been so outrageously high, that most people have been kept from buying. It gives us pleasure to announce **AN ENORMOUS DEAL**, putting us in possession of our season's supply of banjos at a price far below any other price ever named to wholesale buyers. Our season's contracts cover only the finest output of the factory. Our expert buyer made a personal selection to meet the demands of the most critical player, and we are now putting in the hands of the user a line of banjos never seen in retail stores outside of large cities. Or, if found at all the prices asked were at least double what we name. Our aim is to supply our trade with banjos that have intrinsic musical value. The perfect Scale, artistically Shaped Neck, first quality Head, as well as the accurately made and fitted metal parts, are features that distinguish our banjos from all others sold. These distinguishing features apply to our cheapest instruments as well as to our best. The manufacturers with whom we have contracted for our entire stock have unlimited facilities and the finest machinery known, as well as the most skillful workmen, enabling them to turn out the most exquisite productions of modern musical instruments at the lowest cost of production. The prices we name for these highest grade banjos are the lowest ever known. Our economic, factory-to-consumer plan revolutionizes trade relations, cuts off the constantly increasing expenses and profits of middlemen and enables the user of the article to procure it at the very door of the factory that makes it. By the time-worn system—manufacturing, wholesaling and retailing—it costs twice as much to sell an article as it originally cost to make it. Every customer who purchases on our method of merchandising has learned the lesson of economy as we teach it. Aside from the matter of price, our terms are so liberal that the most skeptical can readily be convinced that we have harnessed price and quality together, and that our goods are as superior as our prices are low. **On Receipt of $1.00** we send any banjo **C. O. D., Subject to Examination.** You inspect the banjo at your express office, and see that it is just as represented and entirely satisfactory, and pay the express agent the balance and charges and the banjo is yours at half the retail price. If it is not as represented, you return the banjo and we refund your money. This is the most liberal offer ever made. You can't say you buy a "pig in a poke." We combine quality, price and fair and easy terms to such a degree that we deserve the liberal patronage of every reader of this catalogue. With every banjo we include free an excellent Instruction Book. Each instrument is full strung with fine strings and ready to play.

No. 7120. Banjo, maple shell with nickel band, imitation cherry neck, 10-inch calfskin head, 6 screw brackets, full strung, accurately fretted. Weight, boxed, 18 lbs. **Our Special Price**.....$2.10

No. 7122. Banjo with nickel shell, wood lined, stained imitation cherry neck, with 7 nickel plated hexagon brackets, 10-inch calfskin head, accurately fretted, full strung. Weight, boxed, 18 lbs. **Our Special Price**$2.75

No. 7124. Banjo with nickel shell, 13 nickel plated hexagon brackets, wood lined shell, 11-inch calfskin head, birch neck, raised frets, superior quality tailpiece. This banjo possesses qualities of tone and finish found only in the case of high grade instruments. Weight, boxed, 18 lbs. **Our Special Price**.....$3.70

No. 7126. Nickel shell, wood lined, birch neck, raised frets, 25 brass hexagon brackets, 11-inch calfskin head. A superior instrument at a very low price. Weight, boxed, 18 lbs. **Our Special Price**$4.35

No. 7127. Banjo with extra heavy nickel shell, wood lined, wire edge, French polished birch neck, scroll head, imitation ebony fingerboard, raised frets, inlaid position dots. Best quality 11-inch calfskin head. A splendid banjo. See illustration above; 31 nickel plated hexagon brackets. Weight, boxed, 18 lbs. **Our Special Price**.....$6.35

No. 7129. Professional Banjo. 11-inch heavy nickel shell, wood lined, wired edges, heavy strainer hoop rabbeted, 25 brackets and patent tailpiece. Finely decorated head, finely polished mahogany neck, solid ebony fingerboard, decorated with fancy inlayings of pearl and metal, raised frets. This banjo is made with extra care, is handsomely ornamented, carefully adjusted and is intended to supply the want for a thoroughly desirable professional instrument at a medium price. Weight, boxed, 18 lbs. **Our Special Price**$9.80

No. 7130. Professional Banjo, suitable alike to amateurs and experts, although designed especially for the use of the latter. Metal parts are all of extra weight. Extra heavy German silver shell, fully nickel plated. Both edges wired, heavy maple hoops (inside), ebonized and polished. Finely polished birch neck, raised frets, extra heavy rabbetted strainer hoops, brass bracket screws, with hexagon heads and washers nickel plated. Extra heavy ebony fingerboard, neck handsomely ornamented with pearl, 7-inch head and 13 elbow brackets. Weight, boxed, 18 lbs. **Our Special Price**$10.95

No. 7132. Same as No. 7130 with 9-inch head and 15 brackets. **Our Special Price, $14.10**

No. 7134. Same as No. 7130 with 10-inch head and 17 brackets. **Our Special Price, $15.95**

No. 7135. Same as No. 7130 with 11-inch head and 21 brackets. **Our Special Price, $17.80**

No. 7136. Same as No. 7130 with 12-inch head and 29 brackets. **Our Special Price, $19.35**

No. 7127.

No. 7137. Same as No. 7130 with 13-inch head and 31 brackets. **Our Special Price**$21.00

No. 7139. Semi-Professional Banjo, with 12-inch extra quality calfskin head. A special instrument designed for fine trade at a very reasonable price. Retails at $25.00. Has fine heavy German silver shell, wood lined, rosewood veneered inside. Both edges wired, rabbeted strainer hoops, French polished birch neck, with metal stay pieces, rosewood fingerboard, pearl position ornaments, raised frets, celluloid imitation ivory pegs, 19-inch neck, 31 nickel globe brackets, with safety nuts. Weight, boxed, 18 lbs. **Our Special Price**$16.10

BANJORINE.

This instrument is intended for use with one or more Banjos as a leading instrument; the tone being of a penetrating quality is consequently prominent in duets, quartettes, etc. The neck is made short, being less in length than the diameter of the shell, the Fingerboard extending over the head similar to a guitar. It is very easy of execution, the frets, of course, being nearer together than on the ordinary banjo neck. The instrument is tuned differently from the regular banjo—being a fourth higher. For instance: When the banjorine is played in Key of E, the regular banjo should be tuned to A.

12-Inch German Silver Shell.

No. 7140. Wood lined, finished in black inside, both edges wired, plain strainer hoop, birch neck, ebony finger board, with pearl position dots and raised frets, black pegs, 25 nickel plated hexagon brackets.....$13.35

12 1-2 Inch German Silver Shell.

No. 7142. Wood lined, rosewood, veneered inside, both edges wired, rabbeted strainer hoop, French polished birch neck and metal stay piece, heavy ebony finger board,

Banjorine. position ornaments and raised frets, imitation ivory pegs, 31 nickel globe brackets with safety nuts. **Our special price**$18.65

It is past the comprehension of our competitors how it is possible for us to offer such liberal terms of shipment of goods. The explanation is simple. We do not try to make all the profit on one order. The smallest possible margin is all we ask on each order, and customers come again.

31

anatomical means of the production of sound. Two mechanisms—the human and the inanimate—together become a sound machine.

Indeed, one irony of the banjo's rural identity is its expression of the mechanistic industrial sounds and rhythms of the twentieth century. The presence of the banjo in jazz is doubtless the instrument's primary expression of urbanism, as seen in Miguel Covarrubias's [*Orchestra*] (1926, fig. 120) or Malvin Gray Johnson's *Harmony* (c. 1930, see fig. 108). But the vernacular, rural identity of the instrument inadvertently reveals its alliance with urban modernity, and in this it parallels the history of the mandolin. The latter instrument was arguably reinvented as a hard-driving lead instrument as a result of bluegrass music founder Bill Monroe's exposure to industrial culture when he worked for the Sinclair Oil Company in the upper Midwest in 1929. Similarly, the gentle frailing style of banjo strumming gave way to the clear-cut, hard plectonics of premier banjo player Earl Scruggs, who joined Monroe's Bluegrass Boys in 1945 and, with Lester Flatt, performed with the Foggy Mountain Boys.

Self-taught with his late father's and brother Junie's banjos in the Piedmont area of North Carolina, Scruggs brought the regional three-finger style of playing into bluegrass music. The speed, drive, and definitional clarity of his technique established the banjo as a lead instrument. Late-twentieth-century audiences for this putative "old-time" music are really devotees of instrumental sounds fashioned in response to—and in accordance with—an era of ubiquitous industrial machinery. The picture behind the picture, so to speak, from Eakins's *Cowboy Singing* to Steve Carver's 1998 *Corn Bread When I'm Hungry* (see fig. 44), is as urban and fast-paced as the energies portrayed in [*Orchestra*] and *Harmony*. Nostalgia for the old-time banjo persisted through the twentieth century and beyond, with banjos played and sold at folk and bluegrass music festivals (especially those attended by whites) in places earmarked as rural or preindustrial. In the closing decades of the twentieth century, the white riverboat pilot banjo player John Hartford performed on steamboat-style boat decks, while the white banjo virtuoso of TV's long-running *Hee Haw,* Roy Clark, performed on a farm-themed stage set. Both musicians entered into pictorial identities of a nineteenth-century agrarian and riparian America and appeared to sustain it onstage. (It may be that the white banjo instrumentalist Béla Fleck, who is named for Bela Bartók, "outs" the rural-themed performer when he plays Bach on a bluegrass and folk festival porch [MerlFest, North Carolina, 1999] or performs with the Nashville Symphony [2003].)

Returning to the white male banjo player of Eakins's *Cowboy Singing,* another, disturbing heritage of the banjo emerges. The pictorially placid moment of the cowboy's reverie may be deceptive. He pauses to relax with his banjo, the viewer infers, when his day's or week's work is done, when the cattle have been driven or

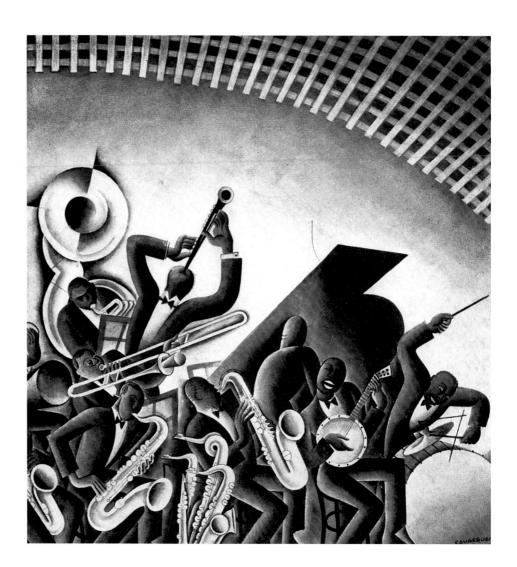

fig. 120
Miguel Covarrubias, [*Orchestra*], 1926, reproductive engraving, 5⅞ × 7⅛ inches. In *Blues: An Anthology,* ed. W. C. Handy (New York: A. and C. Boni, 1926), plate 1. Special Collections, The Pennsylvania State University Libraries, University Park, Pennsylvania.

the calves branded or fences repaired. His work, however, advances the demarcation of whites' private property and the growth of corporate capitalism throughout westward tribal lands, as Alan Trachtenberg argued in his 1982 *Incorporation of America* and as Vivien Green Fryd has more recently shown in her 1992 *Art and Empire.* The cowboy is representative of white expansionism westward into Native American territory, as one version of the refrain of the folk song "Oh! Susanna" reminds us: "Don't you cry, Susanna, / Don't you cry for me. / I'm going off to Oregon, / With my banjo on my knee."⁵ The banjo is implicated in the ranching— and by extension, homesteading and corporate business—that continued the ideology of American white expansionism under the mantle of Manifest Destiny.

Significantly, Eakins's cowboy is a generic figure. The artist's model for *Home Ranch* and *Cowboy Singing* was his student and assistant Franklin Schenck, a painter, sometime musician, and so-called bohemian. But in these works Schenck

wears a cowboy outfit Eakins purchased on an 1887 trip to the Badlands, effectively becoming a visual corollary of the ubiquitous western type increasingly found in the painting and sculpture of Frederic Remington and Charles M. Russell, the novels of Zane Gray and Owen Wister, and elsewhere.[6] This artist whose many portraits individualized subjects from numerous walks of life, including the medical profession, chose to paint a representative cowboy whose identity is conveyed by his clothing, itself so standardized as to be a uniform. Eakins's cowboy with banjo thus anticipates Daniel K. Tennant's *Marine's Life* (2004, see fig. 36) in this crucial regard. The United States Marine Corps jacket against which the huge banjo rests in Tennant's composition produces meanings consonant with those implied in *Cowboy Singing*. The objects surrounding the banjo are a virtual allegory of U.S. imperial expansion: the railroad, the sailing ship, cookware, tools, a Colt revolver, and paper U.S. currency.

Allegorizing armed force "from the halls of Montezuma to the shores of Tripoli," *A Marine's Life* was executed in the midst of a U.S. war of choice, one initiated by the U.S. government in spring 2003 with the collusion of identifiably American multinational companies. As Mazow notes in "Banjo Cultures," the individual providing the subject matter for *A Marine's Life* is in fact alive. Yet the composition transcends personal reference and suggests a sort of interpretive open-endedness, with its ultimate message hovering somewhere between life and death. The marine, like his predecessor the cowboy, is an unwitting instrument of imperial power and force. In this context, the *musical* instrument—the banjo—takes on an elegiac tone, joining the dog tags and handgun in an evocation of loss. In Tennant's impromptu shrine, the banjo is but one of several signature identifiers of a soldier's life. Stripped of their nostalgia, these symbols form a vocabulary speaking to the present and future, for the timepiece in the lower left corner suggests that time has run out.

NOTES

1. Michael J. Klarman, *From Jim Crow to Civil Rights: The Supreme Court and the Struggle for Racial Equality* (New York: Oxford University Press, 2004). Jacqueline Jones Royster, ed., *Southern Horrors and Other Writings: The Anti-Lynching Campaign of Ida B. Wells, 1892–1900* (Boston: Bedford Books, 1997).

2. The detail from Walker's monumental piece depicting the wind-up banjo player is reproduced in "Extreme Times Call for Extreme Heroes," *International Review of African American Art* 14, no. 3 (1997): 3.

3. Linda J. Lumsden, *Inez: The Life and Times of Inez Milholland* (Bloomington: Indiana University Press, 2004), 5.

4. Sears, Roebuck catalogue (1897; rpt., New York: Chelsea House Publishers, 1968), 519, 535–36.

5. Alan Trachtenberg, *The Incorporation of America: Culture and Society in the Gilded Age* (New York: Hill and Wang, 1982); Vivien Green Fryd, *Art and Empire: The Politics of Ethnicity in the United States Capitol, 1815–1860* (New Haven, Conn.: Yale University Press, 1992). Mark Sullivan, *Our Times, 1900–1925* (1926; rpt., New York: Charles Scribner's Sons, 1971), 1:146.

6. See Lloyd Goodrich, *Thomas Eakins* (Cambridge, Mass.: Published for the National Gallery of Art by Harvard University Press, 1982), 1:299–300; Darrel Sewell, *Thomas Eakins: Artist of Philadelphia* (Philadelphia: Philadelphia Museum of Art, 1982), 95; and Theodor Siegl, *The Thomas Eakins Collection* (Philadelphia: Philadelphia Museum of Art, 1978), 124. On Eakins's ten-week jaunt in the Badlands, see Cheryl Leibold, "Thomas Eakins in the Badlands," *Archives of American Art Journal* 28, no. 2 (1988): 2–15.

SELECTED BIBLIOGRAPHY

African Impact on the Material Culture of the Americas. Conference proceedings. Winston-Salem: The Museum of Early Southern Decorative Arts, 1998.

The Art of Music: American Paintings and Musical Instruments, 1770–1910. Exhibition catalogue. Clinton, N.Y.: Hamilton College, Fred L. Emerson Art Gallery, 1984.

The Birth of the Banjo. Exhibition catalogue. Katonah, N.Y.: Katonah Museum of Art, 2003.

Cantwell, Robert. *Bluegrass Breakdown: The Making of the Old Southern Sound.* Urbana: University of Illinois Press, 1984.

Conway, Cecelia. *African Banjo Echoes in Appalachia: A Study of Folk Traditions.* Knoxville: University of Tennessee Press, 1995.

Davis, John. "Eastman Johnson's *Negro Life at the South* and Urban Slavery in Washington, D.C." *Art Bulletin* 80 (March 1998): 67–92.

Epstein, Dena J. "The Folk Banjo: A Documentary History." *Ethnomusicology* 19 (September 1975): 347–71.

Fryd, Vivien Green. "'The Sad Twang of Mountain Voices': Thomas Hart Benton's *Sources of Country Music.*" *The South Atlantic Quarterly* 94 (Winter 1995): 301–35.

Gura, Philip F., and James F. Bollman. *America's Instrument: The Banjo in the Nineteenth Century.* Chapel Hill: University of North Carolina Press, 1999.

Kriz, Kay Dian. "Curiosities, Commodities, and Transplanted Bodies in Hans Sloane's *Natural History of Jamaica.*" *William and Mary Quarterly* 57 (January 2000): 35–78.

Linn, Karen S. *That Half-Barbaric Twang: The Banjo in American Popular Culture.* Urbana: University of Illinois Press, 1991.

Lott, Eric. *Love and Theft: Blackface Minstrelsy and the American Working Class.* New York: Oxford University Press, 1993.

Smith, Harry, ed. *Anthology of American Folk Music.* Washington, D.C.: Smithsonian Folkways/Sony Music Special Products, 1997 (SFW 40090). Originally released by Folkways Records, 1952 (FP 25-FP 253).

Smith, Mark M. *Listening to Nineteenth-Century America.* Chapel Hill: University of North Carolina Press, 2001.

Southern, Eileen. *African-American Traditions in Song, Sermon, Tale, and Dance, 1600s–1920: An Annotated Bibliography of Literature, Collections, and Artworks.* New York: Greenwood Press, 1990.

Southern, Eileen, and Josephine Wright. *Images: Iconography of Music in African-American Culture.* New York: Garland, 2000.

Webb, Robert Lloyd, ed. *Ring the Banjar! The Banjo from Folklore to Factory.* Exhibition catalogue. Cambridge, Mass.: MIT Museum, 1984.

Wilson, Judith. "Lifting 'The Veil': Henry O. Tanner's *The Banjo Lesson* and *The Thankful Poor.*" In *Critical Issues in American Art: A Book of Readings,* ed. Mary Ann Calo. Boulder: Westview Press, 1998.

Jimmy Lee Sudduth, *The Banjo Player,* early 1990s, mud and craft paint on plywood, 48 × 36 ¼ inches. Collection of Joseph M. and Janet D. Shein, Philadelphia.†

INDEX